The "Bird Girl"

The Story of a Sculpture by Sylvia Shaw Judson

Sandra L. Underwood

4880 Lower Valley Road, Atglen, PA 19310 USA

Published by Schiffer Publishing Ltd.
4880 Lower Valley Road
Atglen, PA 19310
Phone: (610) 593-1777; Fax: (610) 593-2002
E-mail: Info@schifferbooks.com

For the largest selection of fine reference books on this and related subjects, please visit our web site
at **www.schifferbooks.com**
We are always looking for people to write books on new and related subjects. If you have an idea for
a book please contact us at the above address.

This book may be purchased from the publisher.
Include $3.95 for shipping.
Please try your bookstore first.
You may write for a free catalog.

In Europe, Schiffer books are distributed by
Bushwood Books
6 Marksbury Ave.
Kew Gardens
Surrey TW9 4JF England
Phone: 44 (0) 20 8392-8585; Fax: 44 (0) 20 8392-9876
E-mail: info@bushwoodbooks.co.uk
Free postage in the U.K., Europe; air mail at cost.

Front Cover. "Bird Girl" (1936, bronze), front view. Telfair Museum of Art, Savannah, Georgia.
Sculpture on loan by the Descendants of Lucy Boyd Trosdal.

Back Cover. "Bird Girl" (1936, bronze), back view. Telfair Museum of Art, Savannah, Georgia.
Sculpture on loan by the Descendants of Lucy Boyd Trosdal.

Designed by Mark David Bowyer
Type set in Bodoni Bd BT / Souvenir Lt BT

ISBN: 0-7643-2370-9
Printed in China

Dedication

To John, with whom I share a life filled with adventures.
To Judy, who suggested this one.

Contents

List of Illustrations

Front Cover. "Bird Girl" (1936, bronze), front view. Telfair Museum of Art, Savannah, Georgia. Sculpture on loan by the Descendants of Lucy Boyd Trosdal. Catherine Cardarelli, photographer.
Back Cover. "Bird Girl," back view. Catherine Cardarelli, photographer.

Photographs of the "Bird Girl" by Catherine Cardarelli were taken with the permission of the Telfair Museum of Art, Savannah, Georgia. This sculpture is on loan to the museum by the Descendants of Lucy Boyd Trosdal.

Preface

In the early spring of 1994, a hurricane of a sort hit Savannah, Georgia. Her timbers were rattled, and her landscape was strewn with debris. In the accompanying tidal wave, one innocent resident, who had lived in Savannah peacefully for over fifty years, was swamped, robbed of her comfort of place. She was forced to flee.

The event was the appearance of John Berendt's book, *Midnight in the Garden of Good and Evil: A Savannah Story*, an exposé of some (but only some) of Savannah's secrets. "The Book," as it is still known in Savannah, revealed that here was a city like no other: rich in history, draped with Spanish moss, and occupied by an astonishing array of eccentric characters. The tale was so beguiling that tourists, who had come by the dozens in the past to see the lovely old homes and squares of Savannah, now came by the hundreds and then by the thousands, in search of new delights: the rattle of cocktail glasses and the promise of boundless Southern generosity of a very particular sort offered by some people living and by some people no longer living.

The tumult was distressing, at first. But many came to benefit from this attention. The inns of Savannah were full, the restaurants were bulging with patrons, and the merchants prospered. And scores of tour buses followed one another in a daily parade of the city streets.

But for one sweet thing, none of this attention was welcome, or happy. The innocent victim was a statue presiding over a family burial plot in Bonaventure Cemetery. She played no role in Mr. Berendt's book, but she caught the eye of a local photographer commissioned to provide a cover for that book. So, when "The Book" hit the shelves, there she was, front and center, and the perfect evidence that we do "judge a book by its cover."

She was the image of a child, arms aloft, holding shallow bowls, standing straight as a rod but with her head gracefully, even playfully, tilted. She had been designed as a garden statue and was called, among several other names, the "Bird Girl," ready to bear food for the birds in those saucers. She had come to Savannah, to Bonaventure Cemetery. Bonaventure is not so much a cemetery as a "garden," a lush and leafy environment said by many to be one of the most beautiful cemeteries in the country, a place you would be glad to enjoy a Sunday stroll or be interred for all time. The "Bird

Girl" had been brought here to attend a family plot, and, although she was quite unlike the other funeral monuments in this place, she settled in and took her duties quite seriously.

For reasons that are the topic of this book, the "Bird Girl" caught the imagination of the public. Waves of tourists began to seek her out, to her peril and that of neighboring graves. So she was removed from Bonaventure by the family that she had served all of these years, taken to safety at a home some distance away. And only after she had been spirited away from the cemetery was it learned in Savannah that she had been made by Sylvia Shaw Judson, a sculptor of considerable accomplishment but whose history was not well known, like the history of many artists–and, in particular the history of many artists who are women.

At first, it was thought (or hoped) that the fury would calm, that the little bronze statue could be returned to its proper place. But the image of that child so captured the popular imagination that the family members who owned her, for her safety and well being, gave her on loan to the custody of the Telfair Museum of Art in Savannah. She's there now. The most unwitting and unrewarded of all of the characters who came to play a part in this story. And now, of all of them, she may be the most famous.

Occasionally in the history of art an image will speak with such conviction that it is consumed by the popular culture. The "Bird Girl" is one of these. Now she is so familiar as an emblem of Savannah that she is recognized far and wide, and her image has been copied in countless forms. She is identified by the Savannah Tourist Bureau as one of the "top ten sights' to see in this city filled with sights worth seeing.

And what's to account for the fame of the "Bird Girl?" Of course, Mr Berendt's book and, certainly, the now famous photograph taken by Jack Leigh. And surely, the city of Savannah played a role, embracing this little figure and taking her in as one of its own. But what is not well known is the genesis of this figure in the mind and hands of her creator, Sylvia Shaw Judson. What follows is the story of this artist, her life and her work; her conception of this particular sculpture; and the several adventures of the "Bird Girl," including what would come of her in Savannah, Georgia.

A Note About the Sources for This Story

Most of the sources for this story are noted as they appear in the text, and these are named in the "List of Works Consulted." There were these special contributions:

Much of this story relies on conversations (by telephone or by e-mail) with Alice Judson Hayes, the daughter of the artist, Sylvia Shaw Judson; Francie Shaw, Hayes' daughter and the granddaughter of the artist; and Lorraine Greenman Ganz, the model for the statue that would come to be known as the "Bird Girl." When these conversations are cited or quoted, the sources may be inferred as communications with these persons by the author, which took place in October 2004 through March 2005.

Alice Judson Hayes, a poet and writer, shared with the author an essay which captures many of her unique observations of these events. Portions of this unpublished essay, titled "How Savannah Made My Mother Famous," are quoted here and cited as "Hayes 2004."

There are abundant references to documents from two archives: The Sylvia Shaw Judson Papers at the Archives of American Art, Smithsonian Institution, Washington, D.C., are used with the permission of the Archives of American Art. Materials from the Roman Bronze Works Archives at the Amon Carter Museum, Fort Worth, Texas, are used with the permission of the Amon Carter Museum Archives.

"Cologne Cathedral"

By Frances Wells Shaw

The little white prayers
Of Elspeth Fry
Float up the arches
Into the sky.

A little black bird
On the belfry high
Pecks at them
As they go by.

Frances Wells Shaw (1872-1937) was the mother of Sylvia Shaw Judson. A gifted poet and playwright, Shaw and her husband, Howard Van Doren Shaw, were members of several artistic and literary circles in Chicago. Among their associates was Harriet Monroe (1869-1936), poet and founder of *Poetry*, a monthly magazine edited by her in the years 1912 to 1936. Monroe and her magazine were central to the "Renaissance" of American poetry in the early decades of the twentieth century.

This verse by Shaw echoes the poetic sensibility of the sculpture of her daughter. Judson credited both her mother, a poet, and her father, an architect, as the most important influences on her life as an artist.

The poetry of Frances Wells Shaw appeared in the *Ragdale Book of Verse* (privately printed, Lake Forest, Illinois, 1911), in various editions of *Poetry* magazine edited by Harriet Monroe, and in a number of anthologies. "Cologne Cathedral" is printed here by permission of Alice Judson Hayes.

Illustration 1. "Bird Girl" by Sylvia Shaw Judson (1936, bronze) at the home of Mrs Frederick A. Preston, Lake Forest, Illinois, photographed in 1958 by Hedrich-Blessing Chicago. *Courtesy of the Chicago Historical Society.* The Prestons lived next door to Ragdale, the summer home designed and built in 1897 by Howard Van Doren Shaw for his young family. So, while there was no "Bird Girl" at Ragdale during Judson' lifetime, she was always right next door being cared for by Mrs. Preston

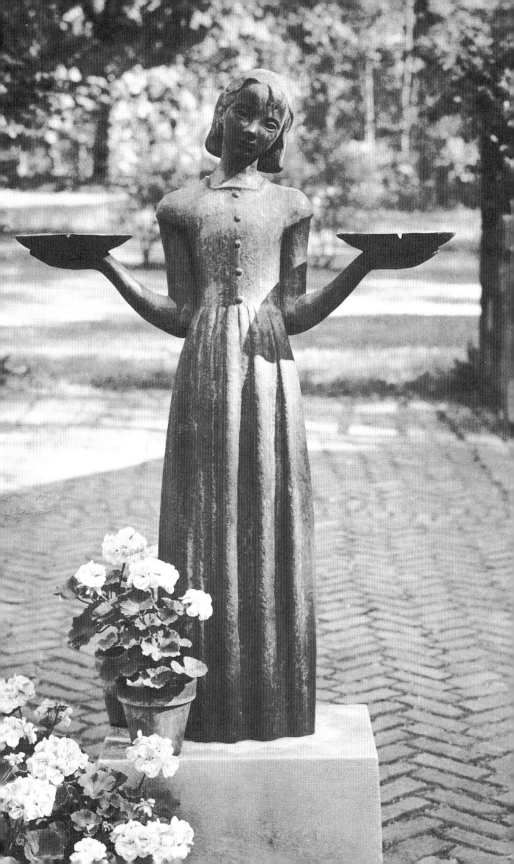

"Bird Girl" Myths and Legends

When an object of interest gains a lot of attention, it is inevitable that
will come to be enveloped by fanciful stories and plain old falsehoods. Th
"Bird Girl" is no exception to this rule. Here are some of the most ofte
reported "legends" about this statue:

The artist of the "Bird Girl" is unknown.
No. The artist is Sylvia Shaw Judson, a Chicago sculptor who was cla
sically trained.

This is the only work the artist ever made.
No. Judson was active as an artist throughout her adult life. Most of he
work was made on commission, both private and public.

There are three "Bird Girls."
No. Some accounts identify four bronze castings of this figure by Judso
But, very recent evidence shows that there were six casts of this figure, on
in lead and five in bronze. All of these were made at the direction of th
artist in her lifetime, and these are considered "originals." Two bronze cas
ings made since 1994 were authorized by the estate of the artist, but thes
cannot be counted as "originals."

The figure symbolizes the "weighing" of good and evil.
No. The figure was designed as a garden sculpture. The shallow bow
were intended to hold water or food for birds. The statue may have bee
planned so that it could function as part of a fountain, because the narro
slots at the front of the bowls allow water to spill from these containers i
streams.

The statue has always been known as the "Bird Girl."
No. She was first called "Standing Figure," then "Girl with Bowls," "Fou
tain Figure," and "Peasant Girl." The name "Bird Girl" appears for the fir
time in 1967, in a book surveying Judson's work, almost thirty years afte
this sculpture was made.

The Savannah "Bird Girl" was placed in Bonaventure Cemetery as "decoration" for a grave site.

No. The statue was the central memorial element of a family plot in the cemetery.

The statue had to be removed from Bonaventure Cemetery because souvenir hunters broke off parts of the figure to carry away.

No. The figure is bronze, not stone. It can be damaged, but not by hitting the figure to break off parts. It was removed from the cemetery because crowds of noisy tourists overran adjacent graves and disturbed the sanctity of the place.

The statue was taken to an undisclosed location and has never been seen again.

Yes, and no. In March of 1994, the statue was taken to a home some distance from Savannah, where she was held in secret for safekeeping. Three years later the family brought her to the Telfair Museum of Art in Savannah and offered her for exhibition on loan, where she can now be seen.

The Savannah "Bird Girl" appears in the opening scenes of Clint Eastwood's movie version of the book *Midnight in the Garden of Good and Evil*.

No. The movie was filmed while the Savannah "Bird Girl" was in hiding. But, during that time, the original plaster model of the figure was located at a public school in Winnetka, Illinois, so a fiberglass copy was made for use in Eastwood's film.

The "Bird Girl" in the Telfair Museum of Art is not the "original" "Bird Girl."

Yes, it is an "original." The "Bird Girl" was commissioned for the seaside garden of a summer home in Massachusetts, and the first bronze casting of the figure went to that location. The six statues cast at the direction of the artist, and within her lifetime, are considered originals. The Savannah "Bird Girl" is one of this group of six.

The Story of the "Bird Girl": People and Places

The People

Sylvia Shaw Judson (1897-1978). The sculptor. Married in 1921 to Clay Judson, a Chicago attorney. They had two children, Alice and Clay, Jr. Clay Judson, Sr., died in 1960; and, in 1963, Sylvia married an old friend, Sidney Haskins, an English Quaker. For all of her working career, she was known as Sylvia Shaw Judson, and that is how she will be identified in this story.

Howard Van Doren Shaw (1860-1926). Her father, an eminent Chicago architect, responsible for the design of a number of public buildings and private residences in Chicago, the suburb of Lake Forest, and other locations across the country.

Frances Wells Shaw (1872-1937). Her mother, a poet and playwright and a devoted wife and mother. There were three children: Evelyn (1893-1977), who married the Pulitzer Prize-winning cartoonist for the Chicago Tribune, John T. McCutcheon; Sylvia (1897-1978); and France Theodora (1912-96), who married the architect John Lord King.

Alice Judson Ryerson Hayes (b. 1922). Sylvia's daughter, a poet. Her first husband was Edward L. Ryerson, Jr., and they had four children. In 1981, she married Albert McHarg Hayes, a distinguished professor of English and humanities at the University of Chicago and Registrar of the University before his retirement in 1978. As her mother's heir, Alice held the copyright to the figure of the "Bird Girl," governing the production of authorized copies and reproductions.

Francie Shaw (b. 1944). Daughter of Alice Judson Ryerson Hayes and Sylvia's granddaughter. An artist, married to the poet Bob Perelman. In 2003, she assumed responsibility for the artistic estate of Sylvia Shaw Judson, including supervision of the manufacture of commercial reproductions of the "Bird Girl."

Lorraine Greenman Ganz (b. 1927). The model for the "Bird Girl" when she was nine years old.

Lucy Boyd Trosdal (1881-1971). Resident of Savannah, who, around 1940 purchased a bronze "Bird Girl" to stand watch over the family burial plot in Bonaventure Cemetery where her husband had been interred in 1932.

John Berendt (b. 1939). Author of the best-selling book about Savannah, *Midnight in the Garden of Good and Evil,* now known familiarly as "The Book."

Jack Leigh (1948-2004). A Savannah photographer commissioned to provide a photograph for the cover of Berendt's book. The successful result of Leigh's search for a compelling image is now known as "The Photograph."

Clint Eastwood (b. 1930). Director of the movie version of *Midnight in the Garden of Good and Evil,* who cast the "Bird Girl" in cameo appearances in the opening and closing scenes of the film.

The Places

Chicago, Illinois. Birthplace of Sylvia Shaw Judson and the location of her studio when the "Bird Girl" was designed.

Chicago's North Shore. Regions north of Chicago, on or near Lake Michigan, that developed as suburbs of Chicago, which could be easily accessed by a train line built in the mid-nineteenth century. The North Shore includes the following sites that figure in the story of the "Bird Girl:"

 Lake Forest, Illinois. Site of Ragdale, designed and built in 1897 by Howard Van Doren Shaw. This was the childhood summer home of Sylvia Shaw and the home she returned to as an adult. In 1937, at the death of her mother, Sylvia inherited the house at Ragdale as her portion of the estate. She and her husband, Clay Judson, winterized it in 1942 and moved in full time. In 1971 she left Ragdale with her second husband, Sidney Haskins, to live at a Quaker retirement retreat near Philadelphia. She returned to Ragdale in 1978 in the months before her death.

 In 1976 Alice Judson Hayes was given the house by her mother. In that year, Hayes started the Ragdale Foundation so that the family home could take up a new life as a residence for artists and writers. It is now the fourth largest artist community in the United States and the largest in the midwest.

 In Lake Forest, important works by Judson may be seen at Ragdale, Market Square, and the Lake Forest Public Library.

 Deerfield, Illinois. The Ryerson "Bird Girl," the first bronze casting of the edition, is now located at Ryerson Woods, a nature conservation district.

 Winnetka, Illinois. Location of the Crow Island School, an innovative public school, where Judson donated the original plaster model of the "Bird Girl."

Highland Park, Illinois. Important works by Judson are located at the Highland Park Public Library and at the Ravinia Festival Park.

Glencoe, Illinois. Site of the Chicago Botanic Garden, where works by Judson can be seen.

Savannah, Georgia. Founded in 1733 by General James Edward Oglethorpe on a high bluff on the Savannah River, this was the first settlement of the colony of Georgia. Considered by many to be the country's most beautiful and best-preserved colonial city, Savannah is known for Ogelthorpe's elegant town plan of a series of squares, or neighborhoods, most of which survive. The city's long and textured history formed the background for the telling of tales in *Midnight in the Garden of Good and Evil* by John Berendt, which brought attention (welcome and unwelcome) to this place.

Bonaventure Cemetery. Reputed to be one of the most beautiful cemeteries in the United States, Bonaventure is located on the site of a historic plantation. Now owned by the City of Savannah, the cemetery is just three miles east of the city's downtown district.

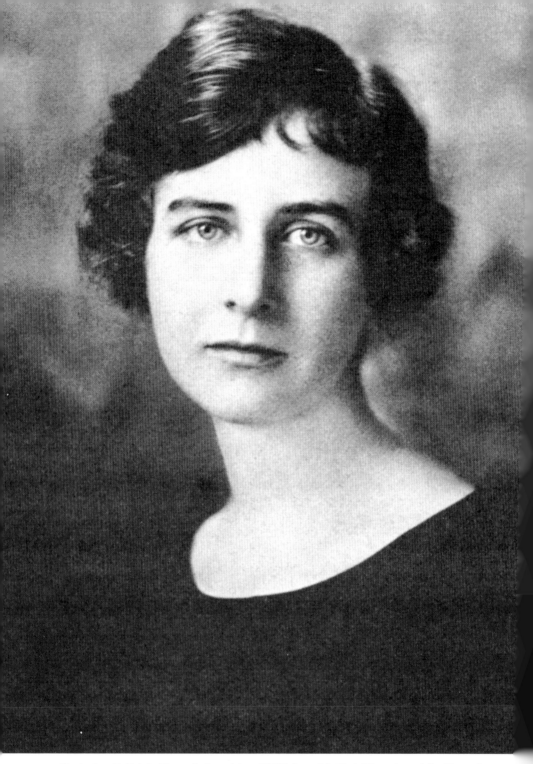

Illustration 2. Sylvia Shaw Judson (circa 1923) from *Motif: A Magazine of the Three Arts* 1, no. 3 (1923), 14. *Courtesy of The Three Arts Club of Chicago.*

Family

Professional resumes usually begin with a thorough statement of one's occupational credentials: training, positions held and works accomplished, prizes and honors. But the resume for Sylvia Shaw Judson that appears on the last page of her 1967 book, *For Gardens and Other Places,* begins, simply: "Family." Here she names her father, her mother, her husbands (Clay Judson, to whom she was married in 1921 and who died in 1960; and Sidney G. Haskins, an old friend and English Quaker, to whom she was married in 1963), and her children, Alice and Clay, Jr.

Judson worked hard to make a life as a professional artist. It took industry and focus, and she would often say that it had not been easy, this life as a sculptor. But, still, at the center of it all was "family." Her own childhood had been charmed by devoted and loving and creative parents. She made two very good marriages, both of which were a comfort to her. And she was glad for her children and grandchildren, even when there were some trials and troubles. A lasting sadness was the diagnosis of her son as a schizophrenic when he was in late adolescence; his life would be spent in institutions where the treatment and care were as good as could be found in those years. Her daughter was bright and lively, and gave her four grandchildren of whom she was immensely proud.

Still, "family" came at a certain cost. Her daughter, Alice Judson Hayes, remembers: "Sylvia wrote an artist granddaughter: 'Don't get married. It will interfere with your art.' After this young woman did get married, her grandmother wrote to her: 'Don't have children,' which she didn't do until after her grandmother died." (Hayes 2004, 2)

The extraordinary character of the home of Judson's childhood is revealed in writings by her daughter and by Susan Dart, wife of John T. McCutcheon, Jr., Judson's nephew. Both offer accounts of the lives of Howard Van Doren Shaw, his wife, their three daughters, and his parents, particularly as these lives came together in the charmed environment of the family summer home called Ragdale.

Shaw, born in 1869, was the son of Theodore A. Shaw, a successful wholesale dry goods merchant, and Sarah Van Doren, of Brooklyn, New York, a woman whose passion was travel and who was a dedicated and talented painter. According to Dart, Howard was from the start "blessed

with every advantage–money, social position, intellectual stimulation, and above all, a warm, loving family." (Dart 1984, 65)

Shaw's father, born in Indiana, came from good Presbyterian and Quake stock. Shaw's mother was descended from Van Doorns and Van Doren whose history in this country reached back into the seventeenth century. Her grandfather had graduated from Princeton in 1793, and her father was a Presbyterian minister. (Dart 1984, 65-66) Good character and earnest faith were the marks of both families.

Howard Van Doren Shaw had every advantage of education, first at the Harvard School, a preparatory school in Chicago; then at Yale, taking bachelor's degree in 1890; then at the Massachusetts Institute of Technology, completing a two-year course of architecture in just one year. In the year following his graduation from M.I.T., he did what he would continue to do throughout his life, journey abroad to study and to sketch, to learn the lessons of architectural history at first hand.

Before he left for Yale, he met Frances Wells, and they both seem to have understood that their lives would be shared from their earliest meetings. They were married soon after Shaw returned from his European tour in 1893. After his death in 1926, Frances wrote: "I have no recollection of becoming formally engaged to him. I had met him when he was the tallest boy in Bournique's dancing school on 23rd Street. I think we had an understanding, with a few ups and downs, from those days on. . . . He just took me for granted as his property, and I was pleased and flattered to be so considered." (Dart 1984, 66-67, quoting an unpublished manuscript titled "Concerning Howard Shaw in His Home" by Frances Wells Shaw)

Of the home he and his wife made for their three daughters, Alice Judson Hayes recalls that the house was filled with books. She gives the account of Evelyn McCutcheon, the eldest daughter, that in the evenings at Ragdale the family gathered in the cozy living room. In a corner of that room was Howard Shaw's desk, made to accommodate the long rolls of architectural plans. Here he worked, quite happily, on his drawings, while his wife "read Scott and Dickens and Trollope aloud to the assembled family." (Hayes and Moor 1990, 49) Sylvia would recall that as a child the pleasure of an evening was to walk in the out-of-doors and then "to return to an open fire in an oak-paneled library, and curl upon the floor with the warm head of a dog in your lap and watch the dropping embers, while a familiar voice reads aloud from some rambling novel by Charles Dickens." (Judson 1914a, n.p.)

There was travel. Hayes remembers: "There were travelers in every generation of this family, and the artifacts from all over the world that can still be seen around the house [Ragdale] attest to this." The big Delft plaques in the kitchen were brought back from Holland by Howard's mother. "On the walls of the [front] hall are trophies brought back from a trip to Italy. The stern panel of an ancient gondola hangs over the living room doorway, and a panel from a nineteenth century Sicilian donkey cart between the front windows shows a lively scene of crusaders spearing various things." And

the living room "was filled with a succession of objects brought from far journeys: over the door, a wooden phoenix from China rising out of complicated flames; on the window ledge, a wooden saint with his hands fallen off; and stained glass medallions hanging in the windows." (Hayes and Moon 1990, 26, 53, 43, 52)

There was play, the delights of child's play on the property of Ragdale that had once been a working farm. And the more serious play of performances in the Ragdale Ring, an outdoor theater that Shaw built in 1912 for his wife, an accomplished playwright. Audiences of over two hundred could be accommodated at the Ragdale Ring, and Frances Shaw enlisted as her players her children and her friends, many of whom were gifted amateur actors. (Hayes and Moon 1990, 67-68)

Of the home Sylvia Shaw Judson made with her husband, Clay, and their two children, she was sometimes ambivalent. Of being a wife, a mother, and a sculptor committed to her profession, she said, "It is not easy to keep life in balance." Still, she tried to do just that: "By the time Clay bravely took me on at the age of twenty-four (a venerable age according to contemporary custom), I was over the hump and able to carry on alone [as a sculptor]. This was the generation of newly emancipated women. You were supposed to do something. But I am not sure that this is the best thing for husbands. Mine has been wonderfully long suffering, when I miss a train, balk at giving parties, and forget engagements. Although he is a hard-working lawyer, he corrects my strange checkbook, tells me what time it is, rubs my tired back, draws up my contracts, and best of all–reads aloud to me in the evenings. When a job is done, he sometimes takes me on lovely vacations. . . . Perhaps it is a compensation to a husband for all these handicaps to have a wife who is happy in what she is doing." (Judson 1960, n.p.)

Speaking to young women at the Westover School in Middlebury, Connecticut, on the occasion of her fiftieth reunion in 1965, Judson concluded: "It is hard combining a family with a profession, and I surmise that if one were a genius it couldn't be done. But for average mortals a career can be pursued in moderation while one's children are small, without neglecting them. By working in the afternoons, I earned enough to pay to have mine taken to the park. Maybe it was a good thing for my family to have me happy." (Judson 1965, 6)

"I Know Very Well
What I Want To Do"

When did Sylvia Shaw commit to the vocation of sculpture? There is good evidence that her resolve was strong in March of 1914, when she was sixteen years old and a student at the Westover School, Middlebury, Connecticut. Her daughter, Alice Judson Hayes, says that "Sylvia was sent to a finishing school in the east for a year of polish." (Hayes 2004, 1) Polish might have been the goal, but the essential shape of the woman she was to become was already fixed.

For *The Lantern*, the Westover School magazine, Sylvia Shaw wrote an essay titled "Serious Considerations:"

> Have you ever thought of what you wanted to be when you grew up? . . . I know very well what I want to do. I used to think I'd like to be a man, so I could choose a profession–something original. Almost every boy I've ever asked, it seems to me, says he is going to be some kind of engineer, or else a lawyer. . . . But, one day it occurred to me that a woman could choose too–I don't mean the ordinary woman's occupations . . . but a real profession.
>
> For a long time it hung in the balance with me. I couldn't make up my mind between two courses. One was to live a quiet unpretentious sort of life by marrying a florist. Then I could wheel the baby up and down the greenhouse aisles in the winter time, and tend shop when my husband was out. . . . But after much careful consideration I decided on the other course–and the more I think about it, the more it grows on me. I wish to have my name inscribed on the scrolls of fame. I want to be a lady sculptor.
>
> My specialty is going to be garden pieces. I have had several inspirations already, which I put down in a little notebook I keep for the purpose. You see, my father is an architect and he specializes in large country houses with gardens. He says that there is a painful scarcity of good garden pieces. That gave me the inspiration; when I grow up I am going to supply him with fountain heads, etc.
>
> I shall live in Paris. A friend is going with me, and we are going to have a very small apartment with gable windows, on the top story of a house in the Latin quarter. . . . It is going to be very hard work, but I

mustn't get discouraged, and before I start I must make sure that I am liberally endowed with stick-to-it-iveness. Of course, I don't know yet whether the divine fire is burning in me, and I won't be able to tell for years, but if there is a single spark, I will fan it into a flame. What a wonderful thing it would be to have a life absorbing interest! . . .

I love Paris–the city–the boulevards–the gardens–the impetuous French people–the language and all. I long to work hard . . . And then–one day–I will have something in the Luxembourg [Museum]–and then you will begin to hear of your old friend. . . .

I want you to understand that this is a very private confession, and you must on no account tell anyone. (Judson 1914b, 25-27)

And so she did just that. She graduated from the Westover School in 1915, at the age of seventeen. In the following summer, she took an internship with Anna Hyatt, a sculptor of considerable reputation, at her studio in Annisquam, Massachusetts. There young Sylvia Shaw would have learned these lessons: the prospect for success for a woman working in the arduous field of sculpture, the commitment required to do that, and the rigors of this work. In the following fall, she began a course of study in sculpture at the Art Institute of Chicago, graduating in 1919. In the following year, she had the experience of living and working at her art in New York City. And in 1920-21 she realized her Westover ambition to live and study in Paris. In the following year, she returned to Chicago, was married, established a studio, and began doing just what she wanted to do. She began a life of making sculpture, a life that was successful by all of the usual criteria: frequent exhibitions, good critical reviews, steady sales, and pleased clients.

Forty-one years after the 1914 declaration of her life's occupation, Judson returned to the Westover School, to give an address as a distinguished alumna and to receive an achievement medal. Here her story is somewhat different. She says of her life after Westover:

My architect father, who had decided, rightly or wrongly, that I would make a sculptor, held my nose firmly to the grindstone–no college [no course of study in the liberal arts], no wartime nursing in World War I like my friends [an adventure she had hoped to pursue], but plenty of arduous travel with him as a mentor [he had taken her to China and Japan in 1917, to study Eastern art and culture]. I am very grateful to him, although I wasn't always at the time.

The result was that by the time I was married at twenty-four, I was able to carry on professionally without any help. In my early married years, I worked anywhere that I could–not waiting for a proper studio–a spare room, a laundry, the screened-off end of a corridor. I was able to earn enough to pay for a nurse for my children . . . and by the time I could afford an honest to goodness studio, I was ready to appreciate it. (Judson 1955, 3)

The truth is probably nestled somewhere in the middle of self-realization and parental urging. In October of 1920, Howard Shaw wrote to his daughter, whom he had just left to begin her studies in Paris: "Dearest Sylvia, . . . We [he and her mother] have great confidence in your mentality and [that you] realize your happiness is our only wish. If we have urged sculpture too much, it is because we know the joy of creation is one of the few lasting ones." (Shaw 1920)

For her own introduction to *For Gardens and Other Places*, a survey of her work published in 1967, she wrote: "When I was a child my father used to sit at his drawing board in a corner of the living room designing houses while the rest of us read around the fire. One evening I heard him chuckling to himself and then he exclaimed: 'To think that people pay me for doing this!' So I learned early from him that art was a deeply satisfying occupation." (Judson 1967a, n.p.)

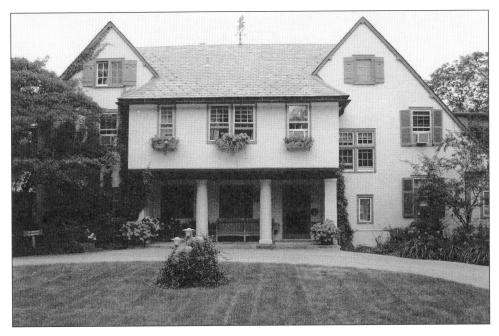

Illustration 3. Ragdale (1897), Lake Forest, Illinois. *Courtesy of the Ragdale Foundation.*

Ragdale:
A "Raggedy" Place

In Sylvia Shaw Judson's life, she would love and admire several people–family, always, and good friends. But in her whole life, she loved only one place, Ragdale, the summer home designed and built by her father in the year in which she was born. Of this place, she said: "It always interests me to learn of the influences which have helped to form an artist's work. I have lived in the place I have most loved for nearly all of my life. It is permeated for me with a sense of gentle continuity. The quiet studio looks out over prairie land, and when I make something there, it probably bears the imprint of this environment." (Judson 1967a, n.p.)

Judson observed, quite correctly, that much of the shape and character of her work was formed by her experiences, as a child and as an adult, at Ragdale. She would come to make primarily garden sculptures of a particular sort: simple, graceful, and serene, bearing the "imprint" of Ragdale. The story of this place, so important to her and to her art, is told here as it unfolds in the work of her architect father, Howard Van Doren Shaw; the Arts and Crafts Style; the architectural and landscape styles of Ragdale; and the "imprint" that Ragdale continues to have on the lives of artists at the Ragdale Foundation.

Howard Van Doren Shaw
(1869-1926)

In 1897, when Shaw purchased property in Lake Forest, Illinois, where he would build a summer home for his family, he was at the beginning of what would come to be an extraordinary career as an architect. Chicago in the late nineteenth century, when Shaw began his work there, was a place of great opportunity. Two circumstances in particular made this so. By the middle of the century, Chicago was the center for transport of goods from the east to the west, and back again; it was the hub of rail transport. As a consequence, the commercial development of the city and the region was fast and vast. Chicago became a center of wholesale and retail merchandising, and a collection point for products of the midwest, such as grain, cattle, and lumber. From these products and others, great manufacturing industries grew. All of these activities required a substantial labor force; and, in the 1860s and 1870s, the population of the city grew from 30,000 to 300,000, many of whom were immigrants glad for the opportunities of life and work in this country.

Great fortunes were made by the men and women who directed these enterprises in commerce and manufacturing, and a tradition of philanthropy grew so that quite a large number of institutions of education, welfare, health, and culture began to appear. For the architect, there was abundant work, to provide for industrial, commercial, and residential needs, as well as for cultural and religious needs. Then at the edge of this boom came the Great Fire of 1871. Now, at a time when much new building was needed, very much of what had existed had to be replaced. It was a crisis for the city, but it was an unparalleled opportunity for Chicago's architects.

Out of this opportunity grew what is often called the Chicago School of Architecture. Sometimes this is defined as a specific group of architects with specific accomplishments. But often the label is used simply to signal that here, in this place at this time, there was so much activity in the art of architecture that much could flower from it, and much did.

Howard Van Doren Shaw made his career as an architect in this extraordinary environment. He completed his training in architecture at the Massachusetts Institute of Technology in 1891, and he returned to Chicago to serve as an apprentice in the firm of Jenney and Mundie, where many of the great architects of Chicago would take their training. One of the important accomplishments of the Chicago School was the invention of skyscraper construction, brought about by the need to occupy land efficiently in the rebuilding of commercial properties following the Great Fire of 1871. William Le Baron Jenney was credited with the invention of the iron and steel frame, which could be clad with lighter materials, such as brick, allowing buildings to reach new heights. To serve in the firm of Jenney and Mundie was a propitious start for a young architect.

In 1894 Shaw established his own practice, and among his early commissions were residences in the Hyde Park area near the University of Chicago campus, an area then booming with the growth of the university, founded in 1890. Over the next thirty-three years, he would garner over two hundred commissions, including city skyscrapers and industrial plants; townhouses and apartment buildings; country houses; churches; theaters; structures for colleges and universities; and civic spaces, including Market Square in Lake Forest, Illinois, the first outdoor shopping mall in the United States. The extent and character of his accomplishments are conveyed in a book by Virginia A. Greene, *The Architecture of Howard Van Doren Shaw*, published in 1998.

Shaw had been trained at M.I.T. in the Beaux Arts tradition of architecture, an academic method which was based on learning the forms, proportions, and ornament of the great historical styles of architecture. These styles, particularly the styles of classicism, were held to be the finest accomplishments of the art of architecture; so a Beaux Arts architect could be expected to use, or to "quote," the vocabulary of these styles in new designs of fine architecture. Shaw was a master of this method, so he could as he wished "quote" these styles. Consequently his style is often described as "eclectic," a style based on "borrowing" from various sources. "Eclectic" is a troublesome word, often used to suggest some lack of originality. One of Shaw's occasional companions in the Chicago School ("colleague" seems not quite the right word) was Frank Lloyd Wright, who denigrated the Beaux Arts tradition and favored stripping architecture bare of its "old languages" to make a new style for the future. But what we have learned in very recent years is what Howard Van Doren Shaw knew all along, that references to these grand old traditions please us and connect us to our past; these beautiful and familiar forms and elements of ornament humanize architecture.

And Shaw was never a garden-variety "eclectic." Even when critics besotted with modernist styles spoke of his work, there was grudging praise: "Shaw's best architecture always had a tasteful dignity and repose, pleasant proportions and a freedom–in spite of its lineage from the past–from excessive detail." (Brooks 1972, 64) Shaw was a cerebral and ingenious architect who knew the languages of architectural history well and used them, when it was right to use them, always with restraint. It is probably better to call his style "selective," rather than "eclectic."

His accomplishments were well known in his lifetime. Just before his untimely death of pernicious anemia in 1927, he was awarded the Gold Medal by the American Institute of Architects, only the ninth such award to be granted since it was instituted in 1907. The award was given in recognition of a body of work that his peers judged would be of continuing and lasting influence in the future development of architectural theory and practice.

But in 1897 he was twenty-eight years old, married, with a three-year-old daughter, and a second daughter who would be born in that year. His father gave him the $10,000 to buy the property in Lake Forest and the money needed to build the house on the property. His father imposed no constraints on the design of the house or the landscape, only the agreement that the two families would share the household as a summer residence, as they did happily throughout their lives. From the beginning of Ragdale's history, the Shaws would spend half of the year in this gracious place.

Here, in a rural community of beautiful natural lands, including virgin prairies, Chicago's captains of industry and commerce built great country homes to escape the city's summer heat, the commute into the city facilitated by a rail line built in the mid-nineteenth century. Many of Shaw's commissions would be for these very homes, grand country estates in this picturesque region of Lake Forest. These were large, handsome houses that sat well and graciously in their landscape, with interior and exterior spaces so loved by their occupants that most of these homes have been occupied continuously and cared for well. There is no greater credit to an architect but that the house he or she designs continues to have a useful life over several generations.

In this company in Lake Forest, what Ragdale is not is grand, either in name or in shape. As his granddaughter, Alice Judson Hayes, says: "Ragdale was Shaw's first chance to build exactly the kind of house he liked best, because it was for his own family. No clients demanded marble hallways or sculptured ceilings." (Hayes and Moon 1990, 26) There was meant to be nothing fancy about it: "The meadow was called a meadow, the house was called a house, the porches were porches and the paths to the woods were lanes. There was a barn, an orchard, a fountain, a sundial, and the place was named 'Ragdale' so that no one would ever make the mistake of referring to it as an 'estate'." (Hayes 2004, 1)

This story about the name is often told: "Howard Shaw named his new country house 'Ragdale' after an old Tudor house in Leicestershire, England, more because he liked the name itself than because the house was one of his favorites." (Hayes and Moon 1990, 59) The story is certainly true. The Ragdale Hall he likely saw in Melton Mowbray, Leicestershire, was a grand old pile. Once a medieval hunting lodge, Victorian owners added castle turrets. Today it is a very grand, very popular, and very expensive spa.

The Arts and Crafts Style

In 1976 Ragdale was added to the National Register of Historic Places, cited for its significance in the three categories of art, architecture, and landscape. It is often referred to as one of the best examples of Arts and Crafts architecture in America, if not the best because it is such a fine example and because it survives without alteration. It is worth knowing how Ragdale

embodies the tradition of Arts and Crafts, because this accounts in considerable measure for why it was so loved by Sylvia Shaw Judson and why, as she suggested, it shaped her life and her art.

What is often called the Arts and Crafts Style is not so much a style as a proposal for a way of life. And what is named the Arts and Crafts Movement is not movement in one direction, but movement in at least two very different directions.

If there was a manifesto for Arts and Crafts, it was "The Nature of Gothic," a chapter of *The Stones of Venice*, written by the English art critic John Ruskin (1819-1900) and published in 1853. It is the statement to which all of his contemporaries referred in defining the character of Arts and Crafts. Ruskin began his career as an art critic at the very gentle age of twenty-four, with the first of a five volume work titled *Modern Painters*, published in 1843. The impetus for this book was the young Ruskin's passion for the work of the English painter J. M. W. Turner, whose very painterly style was often criticized. The young Ruskin was rushing to Turner's defense, for which Turner was not altogether grateful.

Ruskin proved to be a very prolific writer, and his works were read voraciously throughout the English-speaking world. They were read not so much for what they said but for how they said it. Ruskin's prose was fiery and poetic, and, in an age when the printed word was rarely accompanied by illustrations, Ruskin was the master of "word pictures." Reading a passage by Ruskin, it was easy to visualize the subject, whether it was a painting or a sculpture or a building or a landscape. In fact, frequently one would be disappointed in seeing the real thing. Soon Ruskin became the acknowledged authority on the arts, in an age when the arts were often discussed as being something very important.

By 1849 Ruskin had turned his writing to the subject of architecture, which he now regarded as the most important of the arts. With the appearance of "The Nature of Gothic" in 1853, he had extended his interest to the fundamental assertion that art is an expression of the values of a society. He observed that society (or the only society that mattered, London in the mid-nineteenth century) was morally bereft, and these were the causes:

There had been a steady decline in the quality of life since the time of the Renaissance, in the sixteenth century, because certain meaningful relationships had been lost. The fine arts of painting and sculpture were now separate from the craft arts, the arts of ornament and utility. Further, a great schism had grown between the upper class and the lower classes. Now, in the middle of the nineteenth century, these circumstances were exacerbated by the terrible afflictions of the Industrial Revolution. Good people had been displaced from the countryside into the dark, dirty, and crowded streets of the city; and they had been robbed of the satisfaction of good work by the wicked invention of "division of labor," a premise of industrial processes whereby labor was efficiently divided into meaningless segments.

Society (in particular, English society) needed reform. And Ruskin had the solutions (not surprisingly, English solutions). The rescue, he said, was to be found in the Gothic style, the great style of the cathedrals of the late Middle Ages. (There is an old quarrel about where the Gothic was invented, England or France, and Ruskin obviously subscribed to the English theory.) In this style he saw not only the true moral fiber of the English people, but also the hope for their future. The core values of the north (and that would be the English) as against the south (the feeble French and the listless Italians) were "strength of will, independence of character, resoluteness of purpose, impatience of undue control, and that general tendency to set the individual reason against authority, and the individual deed against destiny." (Ruskin 1853, 105)

Ruskin asserted, as would all of the proponents of Arts and Crafts, that what is most valued in human existence is meaningful labor. He said: "It is not that men are ill fed, but that they have no pleasure in the work by which they make their bread. . . . The great cry that rises from all our manufacturing cities, louder than their furnace blast, is all in very deed for this, –that we manufacture everything there except men; we blanch cotton, and strengthen steel, and refine sugar, and shape pottery . . . [but we do not] brighten . . . strengthen . . . refine . . . or form a single living spirit." (Ruskin 1853, 97-98)

Life, good human life, is meaningful only with satisfying labor, and the model for that life and labor is the work of the Gothic craftsmen who contributed their skills to the building and ornament of the great cathedrals of the late Middle Ages. According to Ruskin, in these buildings it is possible to see these qualities: The structure is based on the form of the pointed arch and is held together by vitality and tension, and not by the stupid sheer mass of the Greek temples. The ornament is made by the model of true nature, which always reveals flaws and imperfections; and not by the calculated perfection and symmetry of the Classical style, a mechanized style of ornament made by rule and not by natural laws, ornament made by slaves forced to follow measurements and not by the hands of free people allowed free expression. A clear culprit here was the ancient Classical tradition, much admired since its rediscovery by Italian artists in the Renaissance. Ruskin declared that the superior style was the Gothic style, a product of the northern tribes, which held perfection in no esteem but which acknowledged that irregularities were "signs of life . . . sources of beauty." (Ruskin 1853, 100)

In Ruskin's view, the culture had devolved into "thinkers" and "workers," yet the "thinkers" (those who directed industry) were deprived of the pleasure of "making," of craft; and the "workers" were deprived of the freedom to bring intellect and creativity to bear on the products they were asked to make. According to Ruskin, the way to a healthy culture was to restore to all classes of people the joy of craft.

Ruskin's criticism of contemporary culture was the rallying call. His most ardent follower was William Morris (1834-96), a good Socialist, who set

about to reform society by reviving medieval craft industries. Morris estab-lished a number of workshops, rather like medieval guilds, to recover old materials and methods of designing and making goods. He formed a com-pany, and by the mid-1870s products by Morris and Company–fabrics, wallpaper, carpets, glass, metalwork, tiles, books–could be purchased in most of the major cities in the United States. Morris promoted these goods to counter the false, pretentious, and overly refined products of the Victo-rian era (which were said to evoke the grotesqueries of French ornament, most particularly the styles of Louis XIV and Louis XV). The products of Arts and Crafts–and now the fine arts were spoken in the same breath as the crafts–would replace the debased goods made by machines and by that odious process of "division of labor."

The Arts and Crafts decorative style came to be known through these goods, and the model of "making" that Ruskin had proposed and that Morris had set into action became the basis for scores of Arts and Crafts societies in England and in the United States. The Chicago Arts and Crafts Society was founded in 1897, the very year in which Howard Van Doren Shaw raised his Ragdale. This was only the third of these societies to be estab-lished in this country, and the organization took hold in Chicago as in few other places. Founded at Hull House, the famous settlement house directed by Jane Addams, Arts and Crafts activities were immediately seen to ben-efit the great numbers of immigrants who had come to work in Chicago's industries. At the settlement houses, the immigrants were encouraged to practice the craft traditions of their native countries, to keep those traditions alive and to enrich their lives with this meaningful labor.

Arts and Crafts principles attracted progressive members of society, and among them progressive architects. There was a general concern about the state of the social fabric, and it was understood that architects had a special responsibility in addressing the needs of the culture because of the public nature of the art. There were some impediments to this program of reform. Although the movement was vigorously anti-elitist, the regrettable truth was that handcrafted materials, like the products of Morris and Company, were more expensive than the goods produced by machines. And Arts and Crafts architecture, which offered the best testimony of how art can shape every-day lives and provide for meaningful labor and pleasant play, was best expressed by homes surrounded by ample landscape, hard to find in crowded city neighborhoods.

The Arts and Crafts Movement is often acknowledged as an influential development in the late nineteenth century. But it was a curious develop-ment. In part it was a Romantic movement, a look backwards–to the medi-eval past and to the quite imaginary idyllic existence of that age–as the means to reform the future. In part it was a modern movement, reacting against social injustices and the cultural decay evident in the degraded taste of the middle class. So adherents of Arts and Crafts could, and did, move in two opposing directions. There was the Arts and Crafts Style that flowered

in the tradition of the "country house," like Ragdale. And there was the Arts and Crafts Movement that led to many of the proposals of early modernism. At the German Bauhaus, for example, the study of fine art was joined to the study of craft, and both were taught as they contributed to the art of architecture, which had as its ultimate goal the reform of the society. But here the results were arts that were spare of ornament and could be reproduced efficiently by the methods of mass production.

The Style of Ragdale

Shaw would have, or take, opportunities to address the public good in his architecture. Notably in the design of Market Square (1912-16), a project that he conceived as the means of adding grace and civility to the growing community of Lake Forest. And in 1915, the design of Marktown, a community of more than four hundred houses for steel workers, commissioned by the manufacturer Clayton Mark, though only part of that development was ever built. Still, Shaw's most perfect realization of Arts and Crafts motives, in theory and in practice, was Ragdale.

The style of Ragdale is an English country style, in particular the English Cotswold architecture that Shaw admired. The Cotswold cottage style is based on a simple house type built since the Middle Ages in the Cotswold region of southwestern England. A Cotswold cottage is characterized by a roof of high pitch, often with double gables as at Ragdale, where two steep gables are posed prominently at the front of the house. The casement windows have mullions with small panes of glass. Cotswold cottage building materials are brick, stone, or stucco as at Ragdale. The roof is usually slate shingles, as it is here. And there are elements of asymmetry. At Ragdale, the porch is centered, but the front door is not centered in this porch; and the weight and shape of the wing at the left are different than at the right.

There are Shaw hallmarks in the stocky Doric columns, the proportion that a Classical column often took in early medieval churches. And Shaw was fond of the inset porch, as it appears here at the front. True to Arts and Crafts sensibilities, there are several porches, all by way of integrating this house into its lovely landscape, inviting life to spill from the interior to the exterior and back again. Here and there are the marks of the craftsman, the mason's marks Shaw carved into the stones of the front porch; the delight in ornament, such as the heart motifs that appear in the shutters of the house and on benches inside and outside of the house.

Characteristic of an Arts and Crafts house, the exterior design gives the impression that the house has been designed from the inside out, rather than the Beaux Arts ideal of a beautifully symmetrical facade which presents a formal face to the world and reveals nothing of the life inside. The Arts and Crafts house, with its protruding gables and irregular windows and multiple porches, proclaims that this house is lived in and enjoyed.

On the inside of an Arts and Crafts house, like Ragdale, formality again gives way to informality. In general, "parlors" or receiving rooms were abandoned for simple entry halls and "living rooms." The interior of Ragdale features a "living room," a room in which the family gathered, focused on the comfort of a large fireplace. Here at the side and open to the living room was the "study" with Shaw's desk, where he worked in the evening and where he could see and hear his wife and daughters nearby. Like all good Arts and Crafts dwellings, it is an interior of comfortable proportions, conveying intimacy, with the surprise of charming details–walls of oak panels in the entry hall; originally, William Morris wallpaper in the living room and dining room; leaded glass windows between the entry hall and the dining room.

The ground floor is formed of the entry hall, a living room, a dining room, a dining porch, and a kitchen. Upstairs, there are five bedrooms, four bathrooms, a study, and three sleeping porches. At top, there is an attic, which in its time was a place to play on rainy days.

Shaw was a very busy architect who was known for the high level of attention to detail he gave to all of the projects that came his way. His recreation was, in the truest sense of Arts and Crafts, the pleasant labor of building Ragdale. According to his granddaughter: "It was 1897 and the young architect had begun building his house and its landscape in Lake Forest. Although he worked in the city of Chicago and lived there in the winter, his weekends were spent casting fence posts and building bridges. He built an outdoor theatre and beside it a little cottage where his wife could write plays and poetry. Ragdale was saturated with the Arts and Crafts Movement . . . Into the native limestone flagstones of the front porch, Shaw even carved mason's marks like those in the stones of medieval cathedrals. He designed every detail of the house and garden himself." (Hayes 2004, 1) In this place Shaw was carpenter, mason, painter, and gardener.

Shaw initially purchased about eighteen acres for Ragdale, but he soon added property to total fifty acres. The region of Lake Forest was known for its beautiful landscape of long vistas. An important Arts and Crafts principle was respect for the land and the subordination of the architecture to its site and its gardens. Of this land, Hayes says: "To him, Ragdale meant meadows and woods and hollow apple trees and country vistas. The raggedy look of the shrubbery, the low hanging branches of trees, and the invasion of the lawn by the violets were all deliberate effects. He was aiming for informal country surroundings for his house, not a well-groomed estate." (Hayes and Moon 1990, 59) It was a lesson well learned by his daughters. Hayes says: "The Shaw sisters had inherited from their father a passionate concern for the aesthetics of Ragdale. Branches of trees were never pruned without endless consideration of what effect the pruning would have on the view, and yet perfection was carefully avoided, so that the landscape kept its old-fashioned, rough-edged, romantic beauty." (Hayes and Moon 1990, 86)

The Ragdale Foundation

Ragdale was always the place Sylvia Shaw Judson wanted to be. When her mother, Frances, died in 1937, lots were drawn to determine how the property would be divided. The eldest daughter, Evelyn Shaw McCutcheon, inherited the part of the property that included the outdoor theatre, the Ragdale Ring, where she built a house "with a view across the prairie to the sunsets she loved." The youngest daughter, Theodora Shaw King, inherited the old farmhouse and the barn, which her architect husband remodeled to make "a rambling house, where they lived with their three children." (Hayes and Moon 1990, 80) Providentially, Sylvia, the middle child, inherited the house built by her father, and she and her husband, Clay, soon moved from the city to live here full-time.

Of this life, her daughter says: "When Sylvia inherited her part of Ragdale, she built the studio overlooking what we did not then know was a genuine piece of original prairie. My parents moved out to the country in the early forties during the war. As long as the war lasted, my lawyer father and sculptor mother raised chickens and sheep as a contribution to the war effort. In lambing season, my mother sometimes slept in the sheep shed, and, when a lamb heart appeared on the table nicely cooked in gravy, my mother burst into tears and went upstairs.

"Even after the war when they had stopped being farmers, she used to get up early on winter mornings and go down through the snow to turn the heat on in her studio in the meadow. When she got back to the house, my commuter father was watching the cardinals on the birdfeeder while he finished his breakfast, and she'd eat hers while the studio heated up to at least fifty before she began work. Sometimes she wore an old fur coat to work in and underneath her work clothes in winter, she always had on her long red flannel underwear." (Hayes 2004, 6)

In 1976 Alice Judson Hayes was given the house by her mother. She moved immediately to preserve the house and its site, and to do that in a way that would honor all of the creative life that had been nurtured in this place. In that year she began the process of incorporation that has allowed Ragdale to have a new life as a residence for artists—artists of many disciplines: painters, sculptors, writers of all stripes, composers, choreographers, and performance artists. Now Ragdale continues to do what it was designed to do, to give pleasure, comfort, and inspiration to all who have the good fortune to work there.

Becoming an Artist

An artist's education is made of many parts. The work that a creative artist does is so very particular, even peculiar, that it is difficult to say how one is "educated" to do it. Some would suggest that it can't be done, that a "school of art" is an empty enterprise. According to this theory, creative work is the result of certain innate gifts and pure inspiration. You cannot make an artist of someone who is not gifted, and further you may inhibit the creative impulse if you subject an artist to "schooling."

As usual the truth rests somewhere to the leeward side of opinions and proclamations. Clearly visual artists are persons with unique sensibility. They have the ability to "speak" a language of shapes, lines, shades, and colors that will communicate to the rest of us some concept or narrative that cannot easily be put into words. And training can be helpful in this, to learn methods of study and execution, and technical matters, such as how to manipulate materials. But probably the best way to understand what truly forms the "education" of an artist is to understand that an artist brings everything he or she has experienced, in life as well as in a classroom, to the making of a work of art.

By this standard, Sylvia Shaw Judson's education included a life filled with rich experiences. By her own testimony, these were her teachers:

Her Father, Howard Van Doren Shaw (1869-1926)

On many occasions, Judson said that the most important influence on her life as a sculptor was her father. He had drawn her to the profession by the example of his own dedication to and love of his art, architecture. He had prompted her to take up sculpture, hoping that in time she would be his collaborator in designs for architectural ornament and garden sculpture. And he had been tireless in offering her words of encouragement and practical advice in her student years and later when she established her own studio.

Her Mother, Frances Wells Shaw (1872-1937)

A life enriched by many arts had been the offering of her mother, a poet and playwright. Judson's 1954 book, *The Quiet Eye: A Way of Looking at Pictures*, was dedicated to her mother.

Her Paternal Grandmother, Sarah Van Doren Shaw (1845-1918)

An accomplished painter, in an age when women were unlikely to be taken seriously as artists, Sarah Van Doren Shaw had pursued her art with keen determination and had traveled abroad to find teachers and inspiration for her work. She provided to her granddaughter a powerful example of a woman committed to the serious occupation of expression in the visual arts.

Ragdale (1897)

Of the influence of this place on her art, Judson said: "I have lived in the place I have most loved for nearly all of my life. It is permeated for me with a sense of gentle continuity. The quiet studio looks out over prairie land, and when I make something there, it probably bears the imprint of this environment." (Judson 1967a, n.p.)

This summer home of her childhood, that would become her permanent home in 1942, was not only inspiration and solace to Judson, but it held important lessons about how to live one's life. Of course there were the memories of family here. But also, in this extraordinary house and setting, there were the lessons of the Arts and Crafts Movement: that handwork and craft were valued over the impersonal products of machines; that life in the country was much to be preferred over life in crowded and dirty cities; and that the garden was understood to be where you went to nourish your spirit.

Anna Hyatt (1876-1973)

In the summer of 1915, when Judson was seventeen years old, she took an "internship" with Anna Hyatt at the artist's studio in Annisquam, Massachusetts. Hyatt was then thirty-nine years old and well-established as a premier sculptor of animal subjects in this country and abroad. Hyatt's father had been a paleontologist at the Massachusetts Institute of Technol-

ogy. Influenced by his studies of the evidence of life forms in the remote past, and by her own youthful fascination with horses, she gave much of her work over to the naturalistic representation of animal forms, in small and large scale.

Judson's experience at Annisquam would have been much like what Hyatt valued in her own training. Largely self-taught through the careful observation of domestic animals (at family farms) and wild animals (at zoos in Boston and New York), Hyatt presented herself as "mentor" rather than "teacher." Having moved from Boston to New York in 1902, then to Paris in 1907, and back to New York in 1910, Hyatt spent the war years (1914-20) at her family's summer home in the pleasant setting of the village of Annisquam at Cape Ann. During Judson's time with her, Hyatt was occupied with the completion of an equestrian statue of Joan of Arc, commissioned to commemorate the five hundredth anniversary of the saint's birth. Cast in bronze, the work was set in place on Riverside Drive in New York in December of 1915, to great critical acclaim. Judson would have witnessed the accomplishment of this monumental work by a woman at a time when few woman achieved professional recognition as artists and very few were sculptors.

Their paths would cross again some years later. In 1923 Anna Hyatt married Archer Milton Huntington, the heir to a vast railroad fortune. Early in his life Huntington had gained interests in art, history, and literature, and, in particular, Spanish culture; and he directed his very considerable philanthropy to the establishment of museums that embodied his passions. Among these was Brookgreen Gardens, the first and largest sculpture garden in the United States, founded in 1931 by Archer and Anna Hyatt Huntington as one of several elements of a nature preserve of over nine thousand acres in the coastal regions of South Carolina. To establish the sculpture garden, the Huntingtons collected most actively in the 1930s, in the first decade of the garden. An important work by Judson was added to the collection in 1936. "Girl with Squirrel" is there now, in the Brown Sculpture Court.

Albin Polasek (1897-1965)

In the fall of 1915, Sylvia Shaw began her formal studies in art at the Art Institute of Chicago. It was then, and is now, one of the premier art schools in the country. The curriculum in the early twentieth century provided a good solid academic training, with rigorous studies of the human form as the foundation for all artistic invention. Sylvia was there at the beginning of the tenure of Albin Polasek, who came to Chicago as the head of the department of sculpture in 1916 and remained in that position until he retired in 1943.

Polasek would prove to be a teacher Sylvia was glad to have. Years later she said: "I entered the School of the Art Institute of Chicago, where for three years, we modeled Head in the morning and Figure in the after-

noon, under the sound academic leadership of Albin Polasek. In all that time nothing done by the students was considered worth keeping. It was a stiff training which I have never regretted." (Judson 1967a, n.p.) It was a training that afforded her mastery of form, experience with technique, and above all the rigor of discipline.

A gifted and prolific sculptor, Polasek was born in Moravia, now the Czech Republic. He began work as a wood carver, then emigrated to the United States in 1901 at the age of twenty-two, following the paths of two brothers who had come here. In 1906 he began studies at the Pennsylvania Academy of Fine Arts, learning traditional methods of sculpture. In the next few years, he won several prizes and notices for his work and established a reputation that resulted in his appointment at the Art Institute. During his time in Chicago, Polasek received several commissions for public monuments in Chicago, some of these in collaboration with Howard Van Doren Shaw.

In 1950, after his retirement, Polasek moved to Winter Park, Florida, to a home he designed on three acres overlooking Lake Osceola. In the following year, he wrote to Judson, a letter that bears witness to their mutual affection: "It was so nice to hear that you like my house and that it is a possibility that you may come to Winter Park. . . . I am sure you would travel by auto and I have a wild idea. It would give me pleasure if you would bring a piece of any kind of stone and leave it as remembrance of you to place at our entrance. I am most lonesome for stones, as here I do not see any. All sand and again sand. . . . I am not finished with my landscaping so my garden is neglected." (Polasek 1951) In the years that followed, the garden flourished. In 1961 Polasek set in motion plans to open his estate to the public. Now entered on the National Register of Historic Places, the Albin Polasek Museum and Sculpture Gardens features a large collection of his work and sponsors a number of cultural and educational programs committed to advancing the legacy of this gifted artist and teacher.

Chinese Art

In 1917 Sylvia Shaw's studies at the Art Institute were interrupted when her father took her on an extended tour of China and Japan. Her daughter, Alice Judson Hayes, remembers: "Sylvia's father took her to the Orient as part of her education to be an artist. They traveled in an Edwardian manner with some lavish friends." (Hayes 2004, 2) Throughout her life Judson referred to this trip as an experience that had a lasting imprint on her art. In 1967 she said: "An early trip to China has been a continuing influence, especially the sculptured animals that I saw there." And she added, by way of explanation, this observation by the English art historian Roger Fry: "The Chinese animal sculptor respects the essential character. There is no attempt to read human feeling into it. It keeps its own vague mysterious animal life." (Judson 1967a, n.p.)

In Chinese art, there is a long tradition of animal subjects in sculpture. Often these images were intended to convey spiritual symbolism. Accordingly the style was broad and simple, rather than specific and detailed; abstracted rather than realistic. These are the types of forms that Judson would come to prefer, and two good examples of this method are shown here, "Twin Lambs" (Illustration 7) and "Vixen" (Illustration 21).

Antoine Bourdelle
(1861-1929)

Following her studies at the Art Institute, Judson "tried her wings" by renting a studio in New York for the winter. Next she made a decision that hundreds of American artists had made, as a matter of course, in the late nineteenth and early twentieth centuries. She went to Paris. She explained the decision in this way: "Feeling the need for more study I then went to Paris and worked under Bourdelle at the Grande Chaumière. There I learned more from the other students than from the master, who, when he came, sat on a high stool in the corner, and talked metaphysics in a difficult dialect. I shed baffled tears. Paris is, however, a tender memory." (Judson 1967a, n.p.)

Judson's response to this experience was not at all unusual. By the middle of the nineteenth century, in part because of the enormous prestige of the French Academy and in part because of the pre-eminence of French artists in that era, any American artist serious about pursuing the profession of art contemplated study in Paris, at the Academy or in the studio of an acknowledged master. Some stubborn Americans would make the decision to stay home or go elsewhere. Of those who went to Paris, most believed, fervently, that there were important lessons to be learned as students of great French masters, and that was frequently a lie. Paris was the real teacher.

Masters like Bourdelle held a kind of odd court, largely for the benefit of dozens and dozens of foreign students. Bourdelle was a fine sculptor, an acknowledged master, and a teacher of considerable reputation. He had been born in the provinces in France, at Montauban, the son of a cabinet-maker. He began training in art at Toulouse in 1876, then gained entry to the Academy in Paris in 1884. By 1893 he was an assistant in the studio of the greatest French sculptor of the age, Auguste Rodin. By this association and by the success of his own work, he gained a reputation as a popular teacher, and students came from many different countries to attend his "classes" at Académie de la Grande Chaumière. There, as in other studios of the sort, students worked independently. They waited for the appearance of the master, sometimes no more than once a week, who would give lofty lectures and quick critiques of the work the students had accomplished. The experience for many of these students was often unsettling, and Judson offered particularly keen insights about these events in these remembrances:

In 1923, just two years after her study in Paris, she recalled the experience in this way: "The 'Maître,' as they called him [Bourdelle], came once a week, commented on those that interested him and ignored the others. Then he seated himself on a high stool and expounded theories on every known subject while the students sat about at his feet drinking it in with large round eyes. Most of them had to drink it in with their eyes as he spoke a very pronounced patois, the theories were very obscure, and at least half of the class didn't even understand French. . . .

"I remember one day, the last day of the pose we had been working on, when an incident occurred typical of many which always succeeded in filling me with wonder and jogging all my previously conceived artistic theories established during four years training in our more conservative schools. A Swede, a very finished student of the academic school, whose technique was well nigh perfect, was working beside a very beautiful Russian woman whose work was crude beyond belief. I remember that when we had a fat model, she made her thin and when we had a thin model, she made her fat. Bourdelle arrived. The class always followed him about to hear his criticism. To the Swede he said, 'C'est bien' [That's all right]; to the Russian, 'Ce n'est pas bien mais c'est mieux que bien' [That's not all right, it's better than all right]."

And, just two years away from this experience, her conclusion was: "The modern spirit is to allow free play to each artist's personality." (Judson 1924, 17)

Almost fifty years later, in 1972, Judson was prepared to confess the truth of this experience: "I was an art student in Paris at the age of twenty-two. Bourdelle was the master at the Grande Chaumière. He came seldom and when he did he made a beeline to a handsome young Russian woman student, passing the rest of us by. When the model was fat, she made it thin, and when thin, she made it fat. Coming from an academic training at the Art Institute, I found this confusing and used to go home to the Hôtel des St. Pères . . . and weep.

"A few years ago there was a posthumous show of Bourdelle's sculpture in Chicago and I recognized immediately two small bronze figures as unmistakably that Russian student. One was in smock with calipers [a tool used to measure sculpture for the purpose of making an enlargement], the other in the nude. After all these years I was comforted." (Judson 1972, 3)

Aristide Maillol (1861-1944)

For Judson and hundreds of other art students, there were other "teachers" in Paris. One was the city itself, the beauty of the place. Then there were the great museums and dozens and dozens of commercial galleries. And there was the opportunity to meet those rare artists whose character and work would prove to be inspirational. For Judson, an important contact in Paris was the French sculptor, Aristide Maillol.

Maillol is remembered now as one of the important artists showing the way to modern sculpture. He began his studies at the Academy in 1884, but he was soon attracted by the simplifying symbolist style of a group of painters called the Nabis, which included Paul Gauguin. For sources for his work, he turned to the flat decorative patterns of Gothic tapestries, and then to a spare and simple classicism. It was this classical style of simple volumes that drew Judson's interest.

She said: "While I was a student in Paris, I visited the studio of Maillol, and came to know and admire him and his work. At that time it was a rediscovered idea that a work of sculpture should be a work of architecture in itself. Maillol's sculpture has a quality, in addition to a right relation of masses, which keeps it from being static. . . . There is a passionate striving for unity and simplicity, a paring down; but together with a fullness of form, a growing outward from within." (Judson 1967a, n.p.)

Gerhard Marcks (1889-1981)

Through the years, there would come to be artists whose works she admired, whose art affirmed something she was trying to achieve. Of one of these, she said: "Gerhard Marcks, the last of that great group of German Expressionist sculptors, is also one for whom I feel an affinity. I like the fact that he celebrates the created world, and often in its lighter aspects. Sculpture need not always be deadly serious." (Judson 1967a, n.p.)

On the face of it, it would seem to be a surprising choice for Judson. Marcks had not always known life "in its lighter aspects." He had taught ceramics at the Bauhaus, the famous school of art and design founded in 1919 by Walter Gropius in Weimar, Germany. But he left that school when the direction turned to a greater emphasis on technology. During the Nazi era, he was considered a "degenerate artist" because of the simple abstraction of his art and because of his support for Jewish colleagues. He, as others of the "degenerates," was forbidden to work and a body of his art was destroyed. But before and after these troubles, Marcks had often taken animals as subjects, in prints as well as in sculptures. And these are, rather like the animal subjects Judson portrayed, simple, full, almost geometric volumes, influenced by the primitive clarity of Archaic Greek sculpture.

The Lessons of Modern Art

Judson had begun her professional career at the moment when American artists were "choosing up sides." They would continue to pursue the naturalistic images and humanistic themes that had animated American art in its short but lively history. Or they would turn to the examples of European modernism, styles such as Fauvism, Cubism, Expressionism, and Abstraction, in which living subjects were often grotesquely distorted or eliminated altogether. "Modern art," as it was then conventionally known, had

been introduced to American artists and the American public in 1913 at a famous exposition in New York City, at the 69th Regiment Armory building. This was not the first time works of the "moderns," such as Matisse and Picasso, had been seen in this country, but it was the largest and most publicized event of its kind to that date.

The "International Exhibition of Modern Art," more commonly known as the Armory Show, opened in New York City on February 15, 1913, and closed on March 15. The plan was to move this important show on to other cities, and the second location on the tour was Chicago, where it opened on March 24 and closed on April 16. The reception in New York City had been spirited, with a good bit of banter between those who supported the experimental styles and those who were repulsed by them. Still, in New York, there was the sense that many artists and collectors had benefited from the experience of seeing these new works. By contrast, the general tone of the event in Chicago was sour and mean. There was little support for the exhibition, and Chicago came to be painted by the show's organizers as "a Rube Town," a place overrun by philistines. (Milton Brown 1963, 170, quoting Walt Kuhn) Nonetheless, just twenty years later, there would be a landmark exhibition of modern art in the galleries of the Art Institute of Chicago. The "Century of Progress" exhibition in 1933-34 showed that the city had come to embrace traditions of modern art. (Brettell and Prince 1990, 224-25)

Sylvia Shaw was just sixteen years old when the Armory Show came to Chicago, but she came of age as an artist in the next two decades. "Modern art" did not escape her notice, and she struggled with the import of these styles. In 1924 she gave a talk to the Three Arts Club of Chicago on "Modern Sculpture." She was twenty-seven years old. She had married in 1921, and in the following year she had given birth to her daughter, Alice, and established a studio to begin her work as a professional artist. This was ten years after the fury that the Armory Show had caused in Chicago, and ten years before the affirmation of modernism given by the "Century of Progress" exhibition. And these were her thoughts on modern sculpture:

First, she was struck by the similar methods of expression used by the old masters of medieval sculpture and by many of the moderns: "Three years ago [1920-21] in Europe, everywhere I went, in every museum and church, whenever something would seem almost to jump up and hold out its arms to me, I could be certain that on looking it up it would prove to have been done in the twelfth or thirteenth century. And on arriving in Paris and learning something of modern sculpture, it was a blow to find that those two centuries had had the most profound influence on many of the modern sculptors."

And, she refused to discredit the motives of the moderns: "I am far from being a champion of everything modern, but one thing really rouses my ire–and that is when anyone says comprehensively that none of the extreme moderns are sincere–that they are only concerned with notoriety and

making fools of the public, and that they have adopted this form of art because they would not be competent to grapple with one which required profound academic training. . . . People don't starve for things they don't believe in . . .

"The feeling of most modern sculpture is subjective. Form for form's sake . . . In emphasis of the mass and subordination of non-essentials, realism is sacrificed. Naturally this becomes reminiscent of the primitive, a reversion to the ideals of the Greek, Romanesque, and Oriental. The results may be exotic, but they are too powerful to be overlooked." (Judson 1924, 16-17)

This matter of modernism continued to occupy her through her life as a working artist. Twenty-five years later, in 1959, she offered the following thoughts about modern art, in part echoing the tolerance for these forms that she had expressed as a young woman, and in part coming to terms with the character of her own work:

"Many of us, especially the older ones, find ourselves sometimes baffled by contemporary art forms . . . [But] before condemning an artist you should learn what it is that he is trying to say and judge him by how successfully he has said it –not by whether you would like it in your bedroom. Perhaps he is trying to protest that to him the world seems a cruel and meaningless chaos. . . . There have always been the protestors and the satirists. They fulfill a valuable function. . . .

"Even those among us who believe that the function of the artist is the more affirmative one of trying to create cosmos from chaos can appreciate that the world really has changed during our lifetimes. Man's present conception of the universe is different than it used to be. . . . Flying has made man more aware of the dimensions of depth, of looking through things, and of seeing them in plan. . . . The emphasis on the subconscious is also a major influence." (Judson 1959, 8-10)

A Summary

By all accounts, Sylvia Shaw Judson had an excellent art education. She began her formal training in an internship with a leading sculptor of the day, Anna Hyatt; she took a degree at the Art Institute of Chicago, at a time when that school was named as one of the largest and most influential art schools in the country; and she did what many American artists thought they were obliged to do in the late nineteenth and early twentieth centuries, she went to Paris to study with a French master.

But she wasn't entirely comfortable with this "education." She had had a year of "finish" at the Westover School in Middlebury, Connecticut, before she began her internship with Hyatt. Forty years later she returned to Westover, to be honored, and she made these observations:

"I am a living example of what current educators consider the wrong education for a woman. . . . From the moment I graduated from here at seventeen, I specialized, horrid word. . . .

"Some of what most women get at college I have only gotten during the last eleven years by attending a Great Books class with my husband. He had majored in economics at Harvard and was almost as ignorant of the Classics as I. They have come to us with great freshness and force, and the sharing has been fun. He reads aloud while I do the family mending. I certainly don't hold that this is the right order of education, but it is one way." (Judson 1955, 2-3)

She had come to believe that a true education was the learning one gained from the reading of classical texts as they would be represented in the liberal arts curriculum of a college. For a remedy to the college experience she thought she had missed, she could not have been in a better place, at a better time: in Chicago, in the early 1940s.

According to her account, she and her husband had been in a "Great Books class" since 1944. The Great Books program, in which an understanding of the "great ideas" of Western culture is gained through the reading of classical texts (Aeschylus to Freud by way of Chaucer), is associated with Chicago. In a common telling of the history of the Great Books program, the method began at the University of Chicago in 1931 when Robert Maynard Hutchins, then president of the university, invited Mortimer Adler, a newly arrived professor, to join him in teaching an honors course based on close reading of classical texts. In truth, the program had its origins at Harvard University and Columbia University earlier in the twentieth century, with efforts to compile a list of seminal texts to use as the basis for teaching the fundamental assumptions of Western culture. In 1921 Columbia professor John Erskine taught such a seminar, and one of his students was Adler.

The vitality with which Hutchins and Adler used the method in their course brought attention to the program of Great Books and thereby drew the association with Chicago. The university honors class was popular with students, but the faculty could not be persuaded to adopt the program as a central element of the undergraduate curriculum. By 1943 Hutchins and Adler had a new plan. Adler, in particular, had become convinced that this very rich education in ideas and values was wasted on undergraduates, that a more worthy audience was the general population of adults. In 1943 Hutchins and Adler posed an experiment. They began what would be called "The Fat Man's Great Books Course" by inviting a number of prominent business leaders in Chicago to monthly seminars at the university, prompting them to read selected texts for discussions. These seminars were a great success, and the program soon spread throughout Chicago and then throughout the United States. (Satterfield 2002)

Clay Judson, Sylvia's husband, had taken his law degree in 1917 at the University of Chicago, and, throughout his life, he served on various university boards. By 1944 he was prominent in the Chicago business community, and he and his wife were participants in the first "Businessmen's Great Books Course" taught by Hutchins and Adler. The Great Books Foun-

dation, from which the movement spread across the country, was not established until 1947.

Clearly the experience with Great Books was important to Judson. She liked the notion of capturing a liberal arts education that she believed she had missed in her training as "a specialist." But, in truth, Judson had grown up in a home filled with books. Throughout her life, she kept lists of the books she had read. She traveled. She was interested in the world of art she inhabited, and she was concerned, always, about what was happening in the larger world. Her "education" was made of many parts, and it continued throughout her life.

Her daughter remembers: "At Westover, Sylvia learned hundreds of lines of nineteenth century poetry, because, when you were 'bad,' the punishment was to go to your room and learn a certain number of lines of Tennyson or Keats. She was bad a lot and forever grateful for this store of poetry which she never forgot." (Hayes 2005) These verses came to be a solace to Judson: "As an old lady, when she couldn't sleep she could still comfort herself with the reams of poetry she knew by heart." (Hayes 2004, 1)

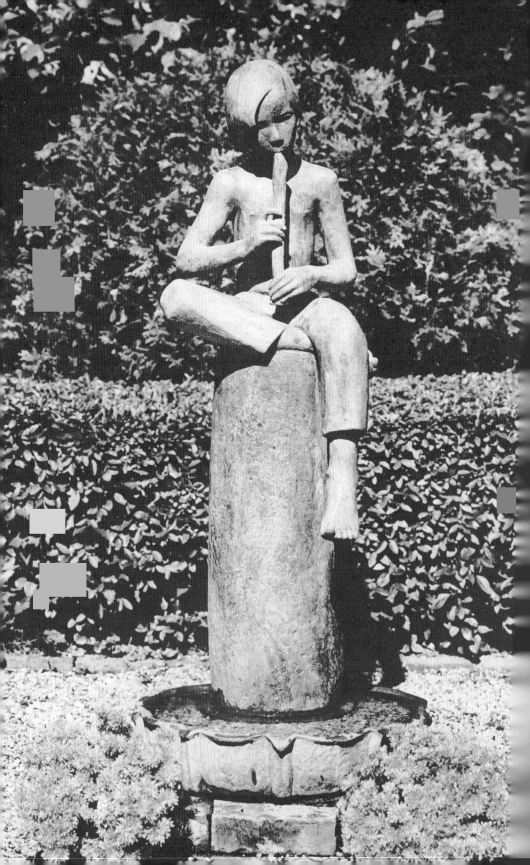

For Gardens and Other Places: The Art of Garden Sculpture

In the early 1960s, Sylvia Shaw Judson was approached by Henry Regnery to assemble a book of photographs and comment that would document the work she had done for four decades. Regnery was a well-regarded Chicago publisher who owned works by Judson and who had followed her career with interest. In 1954 he had published Judson's meditations on art, *The Quiet Eye: A Way of Looking at Pictures.* His wife was a devout Quaker, and he was not immune to the convictions of that faith, so he was sympathetic to the Quaker themes of *The Quiet Eye.* Now a decade later, he was proposing that Judson prepare a monograph on her work, a survey by which a larger audience might come to know the work she had made since she began her professional career in the early 1920s.

For Gardens and Other Places: The Sculpture of Sylvia Shaw Judson was published by Regnery in 1967. It is the only book to survey Judson's sculpture, and it is invaluable in understanding the character of her work. With a brief introductory essay by the artist, the book is composed of photographs of her sculpture. Most of these works are garden statues. The images are representational rather than abstract. By equal measure, the subjects are humans, usually children, and animals; and these forms are portrayed life-size.

By the late 1960s, she had achieved her youthful ambition to make sculpture for gardens. Her success at accomplishing this goal had resulted in the unbidden consequence that she was not "famous," in the way some artists become "famous." Gardens are private places, and Judson's sculpture was so pleasing to her patrons that the work, almost without exception, came into a family and stayed there. "Fame" requires some aspect of publicity, or at least some element of notoriety. Judson's lovely sculptures for private places were testaments to her very considerable success, but they offered none of the prospects for fame that would reach beyond the patrons who commissioned her work, and the professionals, such as landscape architects, who admired her work.

Illustration 4. "Recorder Player" by Sylvia Shaw Judson (1956, bronze) in the garden of Mr. and Mrs. Albert D. Farwell, Lake Forest, Illinois, photographed in 1957 by Hedrich-Blessing, Chicago. *Courtesy of the Chicago Historical Society.*

On Making Sculpture
for Gardens (1939)

Because the focus of Judson's work was garden sculpture, she was often called upon to speak about that art. In a lecture at the Dayton Art Institute in 1939, she gave as good a description of the character of her work as one is likely to find. Her comments are given here with headings to signal the particular qualities of garden sculpture that drew her attention. She said:

"Before saying how garden sculpture should differ from other sculpture, I should like to say first how I think it should not differ.

"First, it should be good sculpture . . .

Subject and Composition. "The subject should be suitable for sculpture. It should give you a feeling of equilibrium. The masses should be balanced, the profiles interesting, and it should be serene in spirit.

"There is something about the permanence of sculpture that makes action poses of a transitory nature tiresome to look at for long. If you are unconsciously thinking about what it is going to do next, you get restless. It has been done, but very rarely, to achieve such perfect balance that the figure seems static. . . . But in most cases I think that it is safe to say, 'Beware of dancing figures and so called "cute" poses.'

"Decorative subjects seem more justified outside than in, and simply decorated objects like urns . . . and sometimes quite casual and humorous things like grotesque animals strike a happy note. . . .

"The detail should be stronger to carry out of doors where the light comes from all sides. . . . "

Scale. "There are some special problems that sculptors must face in executing a commission for a garden or anywhere else out of doors that are different from making an exhibition piece.

"First the scale must be right for the size of the garden and the distance from which it is to be seen."

Material. "Another thing that all sculpture should have in common is a feeling for the material used. The right subject matter and treatment is not the same for stone, metal, and terra cotta. . . .

"The material must be practical for climatic conditions. Highly polished metals, such as polished brass or aluminum suitable for some modern subjects, don't seem to me to agree with growing things. Mellow surfaces like lead and weathered stone and rich bronze patinas seem particularly becoming to nature.

"If the subject is a fountain, the play of water should be considered as part of the composition. . . . "

Spirit or Significance. "The last and most important thing to achieve to my mind is a rightness of mood. The garden may be a sophisticated city garden or penthouse terrace, or it may be a wild garden, or a large formal garden, or a dozen other kinds. The spirit of the work should suit the site as

much as possible, but I feel very strongly that the spirit of any garden should be one of tranquility and contemplation." (Judson 1939a, 1-3)

On Selecting a Site for
Garden Sculpture (1959)

In 1959 Judson was asked to speak to garden clubs in the Chicago region. Undaunted by the opulent setting of the Grand Ballroom of the Palmer House Hotel in Chicago, she offered her observations about garden sculpture, elaborating on the principles she had announced two decades earlier. She began with her thoughts on the significance of the site:

"What we look for in a garden is refreshment and peace and a sense of relationship to nature. If the sculpture in your garden contributes to this mood, you have selected wisely. Every sculptor's dream is of making the perfect piece of sculpture and of having it in the perfect site.

"There are two ways of choosing a piece of sculpture for a garden. One way is to buy the sculpture and then make the site for it. . . . But many of us can't afford this way of choosing. Besides, we already have our gardens and a certain spot cries out for a punctuation mark. So, the second manner of selection is to find just the right sculpture for a particular site—and it can be a fascinating search.

"Which are these spots that need sculpture? Not always the center of a pool or a flower bed, although these remain good places. A piece of sculpture can seem as inevitable when placed informally on the corner of a terrace or the end of a step or a wall, or, of course, gate posts. It can be tucked away in an unexpected nook where coming upon it gives a shock of surprise and pleasure, or it can accent the distance by silhouetting against space . . . At the end of a path, it can become the objective for a stroll, or perhaps it just sits cozily beside your front door.

"The edge of a pool, where it will be reflected, always provides a congenial setting. But the play of water in a fountain need not necessarily come out of the sculpture. . . .

"The height at which the piece is placed is important. Some sculpture can stand quite simply with no base, on a pavement, a lawn, or a gravel path, but usually it is better raised on a block of stone or a step of brick. . . .

"Many settings require no special planting, but if plants are used around the base, or as a background, it is better to use plain green foliage, the leaves of which are in scale with the sculpture. . . . Too much bloom can be confusing." (Judson 1959, 1-4)

Next Judson offered this checklist of things to consider in selecting garden sculpture:

"Many sculptors welcome the challenge of creating something for a special location. It is a discipline—the way the sonnet form is for a poet.

"An architect father trained me to think of a piece of sculpture as a specific problem to be solved. It should suit its site, in form, in spirit, in scale, and in material. It should be honestly fashioned and sculpturally conceived." (Judson 1959, 4)

"If you have a special place in your garden, no matter how simple, for which you would like to buy a piece of sculpture, here are some ways to test its suitability for the site. They are what a sculptor thinks about when he designs something for a specific place."

Scale. "Is it the right size? It should be neither so large that it dominates, nor so small as to appear insignificant, and it should be a reasonable size for its subject. Personally I don't respond to either a half-scale human being or a gigantic frog out of doors. . . ."

Material. "Is it the right material? A natural looking material harmonizes better with plants; stone or granite, terra cotta, or a soft colored bronze or lead. A highly polished surface requires a very special place. The material and the color should be in harmony with any related architecture.

"Will it stand the climate? . . . Granite and bronze will last forever; lead and a good quality of limestone should last for one's lifetime or longer, and iron if it is painted. Terra cotta and cast stone are a slight gamble in a severe climate, but if you can take them indoors in winter they should be safe indefinitely. Marble and wood cannot stand freezing and thawing weather. Plaster can be hardened to make it last for a couple of years only, as they do at expositions. Here is a trick of the trade: If you want stone to hurry up and look old, wash it with milk to encourage the growth of moss, or you can even pack it with manure for awhile. . . ."

Form. "Is the sculpture a sound, honest piece of workmanship? . . . Is it a satisfying form? A good piece of sculpture, and one of which you never tire, must be an interesting shape. It takes a strong and simple form to carry out of doors.

"Sculpture is three dimensional, and in a park or garden is frequently seen from all sides. This is something with which a painter does not have to cope. . . ."

Texture. "It should have tactile value. It is often climbed on by children or stroked by adults. I like to imagine myself a giant–lifting each piece, turning it about in my hand, feeling it, and judging whether it is satisfying to hold, as well as to look at. . . ."

Spirit or Significance. "Is it suitable in spirit? This is something which only you can decide. Naturally one piece will not be right in every location or for every person . . . Be brave, take the plunge, select what you like and not what someone else tells you is correct. What if, ten years from now, you do give it away and try again? That is how taste develops and you have had the fun of choosing." (Judson 1959, 6-8)

Conclusions

The examples of Judson's garden sculpture illustrated here confirm her comments about form, composition, scale, material, tactility, and spirit. "Recorder Player" (Illustration 4), "Harbor Seal" (Illustration 5), "Twin Lambs" (Illustration 7), and "Vixen" (Illustration 21) are all very different in subject and in character. But all of them are good, simple volumes that fare well in bright sunlight as well as in the half light of shade. They are all sturdy figures, well made. And they are all the human and animal subjects that Judson preferred.

She had closed her lecture at the Dayton Art Institute in 1939 with this comment about a negative review she had received, the burden all artists must bear: "One newspaper critic said that my work lacked social significance. This did not bother me at all because I feel that a garden is a place where one should be able to forget things like social significance for a little while and find things like peace." (Judson 1939a, 3)

This conviction did not leave her in a lifetime of making sculpture for gardens. To conclude the essay she wrote for the 1967 book, *For Gardens and Other Places,* Judson said:

"Mine has not been a life calculated to produce an art of protest, although only a very insensitive person could fail to participate in the anxieties of our time. In spite of the widening horizons of science and the current preoccupation with space, I am still primarily interested in human beings, and in the creature companions of our pilgrimage. There is a thread which connects one generation and one country with another, and which draws us close in a common humanity. This is the thread of authentic experience, simple, homely, fresh, and vivid as the parables. Art which follows this thread lasts a long time and can be widely shared without having to lose its local flavor. It is an art which can be at the same time universal and particular." (Judson 1967a, n.p.)

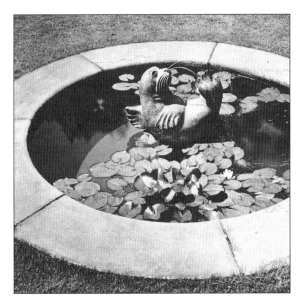

Illustration 5. "Harbor Seal" by Sylvia Shaw Judson (1945, bronze) in a lily pond at the residence of Mr. and Mrs. Clarence C. Prentice, Lake Forest, Illinois, photographed in 1946 by Hedrich-Blessing, Chicago. *Courtesy of the Chicago Historical Society.*

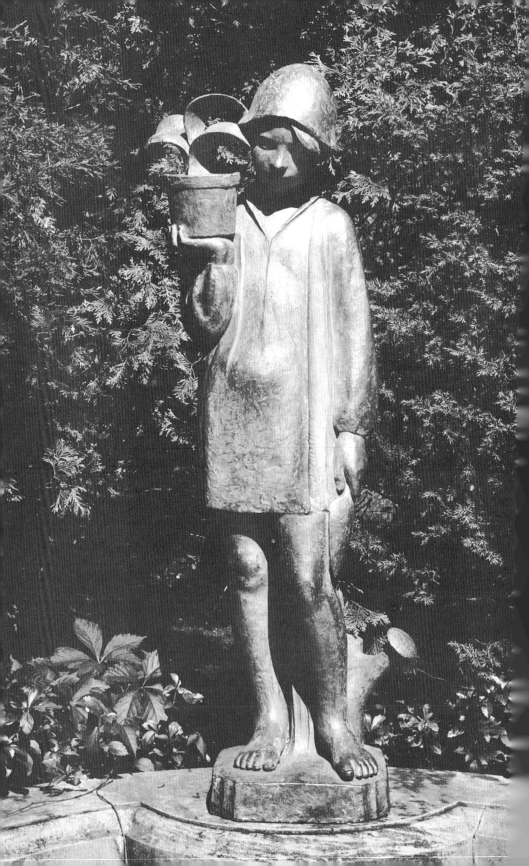

The "Gardener": At the White House and Other Places

Before the phenomenon of the "Bird Girl" swallowed up all else that was known of the life and work of Sylvia Shaw Judson, the garden sculpture for which she was best known was a figure called the "Gardener." Sometimes he (or she) is called the "Little Gardener," but the figure is identified as the "Gardener" in the survey of her work, *For Gardens and Other Places*, published in 1967.

It is an early work, dated to 1929, seven years before the design of the "Bird Girl." It was a work that quite obviously pleased Judson, and others. It was shown often, first in November of 1929 at an exhibition of American sculpture and painting at the Art Institute of Chicago. In this show, the figure was singled out for praise and awarded the Logan Prize of $750. A newspaper reviewer identified the work as the "Little Gardener": " . . . a young boy to be executed in lead for a garden decoration. He stands dreaming with a potted plant poised above one shoulder and a watering pot at his feet. Dressed in a short smock and a little felt hat, he is as romantic as a Renaissance cherub sprouting wings." (Kelley 1929)

The invention of the "Gardener" is remembered somewhat less romantically by Judson's daughter, Alice Judson Hayes:

"My brother was born in 1926, and as my father began to earn more money practicing law, we moved into a bigger apartment overlooking Lincoln Park and near enough to the zoo so that from my bed at night, I could hear wolves howling, peacocks screaming, seals barking, and the occasional scary roar of a lion.

"There the studio was a spare bedroom with good light where I remember posing. I stood for what seemed like hours holding a flowerpot on my shoulder. I was fed Life Savers while my grandmother read aloud to me and I was paid a dime each time I posed. But just the same, tears of misery trickled down my seven-year-old face. It was pure torture to stand still.

"Finally she found another child to pose for this statue and never used me as a model again; but he and I, who still know each other now in our

Illustration 6. "Gardener" by Sylvia Shaw Judson (1935, bronze) at the Dunham residence, Lake Forest, Illinois, photographed in 1938 by Hedrich-Blessing, Chicago. *Courtesy of the Chicago Historical Society.*

eighties, argue about whether the pot belly of the 'Little Gardener' is his or mine. Both of us claim to be the model for the other parts of this figure, which, much later, was bought for a garden designed for Jackie Kennedy at the White House. It stood near a side door to the White House, and we imagined that sometimes on a warm day, when the president greeted some important visitor at this door, the TV cameras would move fleetingly past the child holding a flowerpot." (Hayes 2004, 3)

The "Gardener" was commissioned in 1929 by a Chicago architect, Alfred Granger, and first cast in lead. Three additional copies were sold through the Erkins Gallery in New York City in the late 1950s. Then in September of 1964, Perry H. Wheeler, a landscape architect in Washington, D.C., sent this request to Judson:

"Would you be good enough to place an order for two figures of the girl holding the flowerpot? I can't be very definite in describing this, but I believe she has the flowerpot on her shoulder and is wearing a little hat." The further instruction was that both copies should be sent to Mrs. Paul Mellon of Upperville, Virginia, and Washington, D.C. (Wheeler 1964c) These two copies were cast in bronze at the Roman Bronze Works foundry in New York City, one to be delivered to Mrs. Mellon at her Virginia residence and one to be delivered to the White House. The cost of each figure was $1,500.

Rachel "Bunny" Lloyd Mellon was the second wife of Paul Mellon, son of Andrew W. Mellon, a banker who had served terms as secretary of the treasury and as ambassador to Britain. Early in life Paul Mellon found that he had no appetite for a career in business, so he turned his gifts and his fortune to the occupations of horse breeding, conservation, philanthropy, and art collecting. He is probably best remembered for his support of the National Gallery of Art in Washington, D.C., in large gifts of art as well as funding for the construction of the museum's East Building. It was a fitting family gift. In 1928 his father, as secretary of the treasury, began to conceive of a national gallery of art. In subsequent years, he would engage an architect and provide funds for the first building (the West Building). Andrew Mellon died in 1937, four years before the opening of the National Gallery of Art in 1941. At the dedication ceremony, his son made a gift to the nation of his father's art collection, works that would form the core of the museum's collection.

Rachel Mellon shared her husband's interest in art, and she joined First Lady Jacqueline Kennedy's campaign to refurbish the White House and its grounds by sponsoring the design of the gardens. A great formal Rose Garden was modeled on the gardens of Versailles, and a more intimate garden, the Jacqueline Kennedy Garden, was placed near the office of the president. It was for this smaller garden that the figure of the "Gardener" was ordered.

By June of 1965, the figure had been placed, much to the delight and surprise of the sculptor. In a letter to her, the landscape architect wrote: "I received your letter, and I too am very pleased that your girl with the water-

ing can is in the Jacqueline Kennedy garden. It must have been a surprise to you to find out from a friend that it was there." (Wheeler 1965)

In the following year, Judson was surprised again. A request came to her from J. Carter Brown, then assistant director of the National Gallery of Art, acting on behalf of the First Lady of the United States, Mrs. Lyndon B. Johnson. The Johnsons planned a trip to the Philippines, and they wished to present President and Mrs. Ferdinand Marcos with a casting of the "Gardener." By that time at least six casts of the "Gardener" had been made. Sensitive always to the need to limit editions of her work, Judson proposed an alternative to Brown; but he prevailed, writing to her: "It just happens . . . that Mrs. Johnson is particularly interested in commemorating the interest that she shares with Mrs. Marcos in gardening, so that your Little Gardener is ideal for that purpose. . . . I think it is splendid that a Sylvia Shaw Judson piece will be representing our country in the Philippines, and all of us here are very grateful to you for allowing another cast of this charming piece to be made." (J. Carter Brown 1966a and 1966b)

By now seven casts of the figure had been made, but there was one more to come. In 1968 Judson was a member "Elect" of the venerable old National Academy of Design in New York City. By presentation of an example of her work to be held in the permanent collection of the Academy, she would be admitted to membership as "Academician in the Sculptor Class." The sculpture she chose to submit for this honor was the "Gardener," this time cast in hydrocal (a composite of gypsum, popular for casting sculpture because of its strength, and its ability to show detail and to accept various finishes). Correspondence from the Academy acknowledged this transaction:

"We anticipate the arrival of your sculpture work, 'Gardener' . . . and were delighted to learn that it was given an important award in Chicago (years ago) and recently, had been selected for the White House garden." Upon receipt of the figure, Judson heard from the director of the Academy: "I am happy to tell you that the Council of the Academy were delighted with your sculpture 'The Gardener' which you submitted in qualification as an Academician in the Sculptor Class. They have asked me to express their deep appreciation to you for they believe you are now well represented in our Permanent Collection." (Kent 1968 and Melrose 1968)

"Who Loves the Rain"

By Frances Wells Shaw

Who loves the rain,
And loves his home,
And looks on life with quiet eyes,
Him will I follow through the storm;
And at his hearth-fire keep me warm;
Nor hell nor heaven shall that soul surprise,
Who loves the rain,
And loves his home,
And looks on life with quiet eyes.

For publication in 1953, Sylvia Shaw Judson crafted a book of illustrations of works of art from many different times and styles. Each image was accompanied by words, short phrases drawn from equally wide-ranging sources. Her aim was to communicate, by these images and these words, "a sense of affirmation, of wonder, of trust" as a way of recovering spiritual values needed in a difficult and insecure age. She drew the title of this book, *The Quiet Eye: A Way of Looking at Pictures,* from this poem by her mother, Frances Wells Shaw (1872-1937). She dedicated this book in this way: "In grateful memory of my mother Frances Shaw."

The poetry of Frances Wells Shaw appeared in the *Ragdale Book of Verse* (privately printed, Lake Forest, Illinois, 1911), in various editions of *Poetry* magazine edited by Harriet Monroe, and in a number of anthologies. "Who Loves the Rain" is printed here by permission of Alice Judson Hayes.

Illustration 7. "Twin Lambs" by Sylvia Shaw
Judson (1949, grey granite) at Ragdale,
Lake Forest, Illinois, photographed in 1952
by Hedrich-Blessing, Chicago. *Courtesy of
the Chicago Historical Society.*

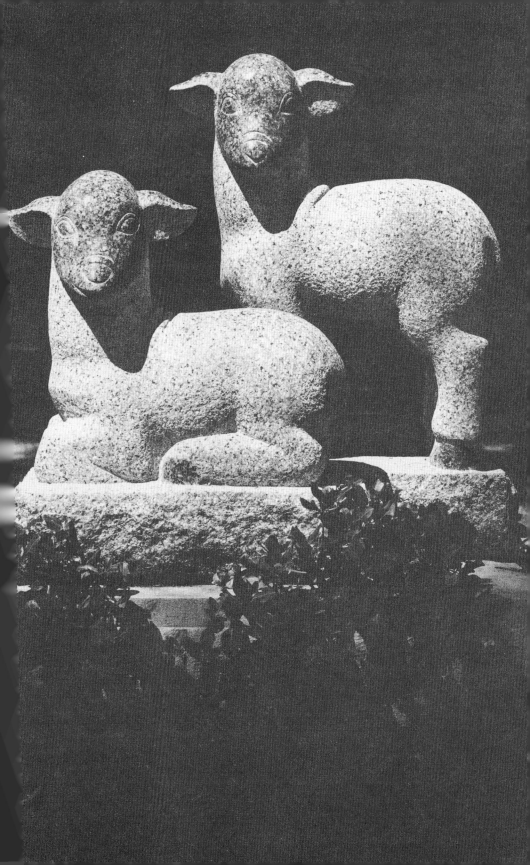

The Quiet Eye:
On Being a Quaker Artist

In 1954 the respected Chicago publisher Henry Regnery issued a book by Sylvia Shaw Judson. Its title was *The Quiet Eye: A Way of Looking at Pictures*. Judson drew the title from a poem by her mother, and she dedicated the book to her.

It is a curious and charming volume. There is very little text. Other than a brief introduction, the book is formed of thirty-four illustrations of works of art, each one accompanied by a short verse or saying. In the "Introduction," Judson says: "This book is not meant to teach. It is intended as an experience." (Judson 1954, 1) But the experience was meant to be instructive. Her plan was to show that art has the capacity to nourish the spirit as certainly as food nourishes the body. And the lesson was directed most particularly at her Quaker colleagues.

Judson had applied for and been admitted to membership in the Society of Friends in 1949, though she had contemplated joining the Society for at least a decade. From the beginning, she was apprehensive about what it would mean to be a Quaker and an artist. Traditionally the Quakers had rejected the visual arts as distracting, even unhealthy, in the practice of the faith. Judson had strong commitments to a spiritual life and to her vocation as a sculptor. She saw these as not at all in conflict, but rather as complements. So she set about to persuade the Quakers that a path to becoming "whole human beings" was to accept what the visual arts could contribute in the matter of human understanding. She said, "Anything that can add so immeasurably to our awareness and brings us deeper intuitions is surely worthy of our serious attention." (Judson 1954, 2)

To be sure, in selecting the images for this book, she had in mind certain art experiences that would affirm Quaker values: "I have wanted particularly to find examples with a sense of 'divine ordinariness,' a delicate balance between the outward and the inward, with freshness and a serene wholeness and respect for all simple first-rate things, which are for all times and all people." (Judson 1954, 1-2) She found these examples in the art of many different times and places, and many different styles.

Most of the works are representational, but a few are abstract. The representational styles vary from academic realism to folk or naive art. There are forms depicted with great detail, and others are shown only by simple

volumes. The art traditions include, among many others, Archaic Greek sculpture, Italian Early Renaissance painting, Chinese screen painting, and German Expressionist drawing. Among the artists represented are Vincent van Gogh, Albrecht Dürer, Paul Klee, Vermeer, and Constantin Brancusi. The collection would seem to be marked by differences; but all of these images convey a human desire for simplicity, honesty, dignity, grace, and caring for others. These were the convictions of her faith and of her occupation as a sculptor.

Judson is now remembered as "a Quaker artist," along with Benjamin West, a distinguished American academic painter of the late eighteenth and early nineteenth centuries, and Edward Hicks, a well-loved American folk painter of the first half of the nineteenth century. The list of "Quaker artists" in history is very short, because of the antipathy with which the arts were long regarded by the faith. But Judson contributed to a shift in Quaker thinking about this matter, so now there are vital organizations such as the Fellowship of Quakers in the Arts, begun in the early 1990s.

As early as the 1930s, the decade in which she designed the work later known as the "Bird Girl" and had her first one-person show at the Art Institute of Chicago, Judson worried about how an artist could be a responsible citizen of the world. In December of 1939, she wrote to Rufus Jones, a well-known Quaker historian and reformer:

"For years I have admired the work of the Quakers. Last year my husband and I heard you speak at the University of Chicago and afterwards I bought your book on 'The Faith and Practice of the Quakers.' I am in deep sympathy with their entire viewpoint.

"I am a sculptor. In order to be the best sculptor I can, and wife and mother as well, I have little time for being a good citizen in the larger sense. This has worried me and made me feel that practicing an art . . . was a sort of luxury in these days when democracy needs everyone who believes in it. However, it seems to me foolish to desert the field in which I am trained and which makes me happy in order to engage in some activity for which I am untrained and perhaps unsuited.

"When I was first married we needed the money I earned but now we are in easier circumstances . . . so I have decided to give my earnings to the Quakers to administer with their usual wisdom [directing funds to] the place where they consider that there is the greatest need. Since making this decision I have worked harder and I believe better and with greater peace of mind so the gift is equally to myself.

"To be sure sculptors don't earn fortunes, especially nowadays, but I am enclosing a check for seven hundred dollars which I have cleared in the past year and I hope that other years it may be larger." (Judson 1939b)

In 1949, when she presented an application for membership in the Society of Friends, she spoke of this potential impediment to her request: "I am trained as a sculptor and feel that I can serve best in that capacity. I am fifty-two years old. Sculpture is an arduous profession and I have all the

time more opportunities to practice it. I know that from now on I shall have to withdraw from other activities rather than take on more. Any contribution that I am able to make should be if possible thru the dedication of my art and its proceeds." (Judson 1949b) But she was admitted to membership, and she did not confine her contribution to "the dedication of her art and its proceeds." Just three years later, in 1952, she led the effort to form a Lake Forest Friends Meeting, in a region where none had existed. The meeting house in Lake Forest, Illinois, stands today, a good simple building with a room of the sort that she preferred: "My favorite arrangement is where there are benches on three sides of a square with a fireplace on the fourth side." (Judson 1949a, 2)

In 1963 she was honored by the Illinois Yearly Meeting of Friends by being asked to give the Jonathan W. Plummer Lecture. She entitled her lecture "Universal or Particular," and she spoke of many aspects of life that, in her view, should be relished in both the universal and in the particular. Not surprisingly, she brought the topic around to her own profession. She said: "I am perhaps best qualified to speak on art. I believe that the contemporary abstract movement at its best is trying to speak a universal language and sometimes it amazingly succeeds. Relationships of line, space and color can convey emotions, tragedy, ecstasy, tension, equilibrium. . . . I have to confess that I am still interested in those old human beings and in the non human companions of our voyage. Living subjects hold an especial warmth and immediacy for me, and I believe for most people. I seem to find a humble thread which connects one generation and one country with another and which draws us close in a common humanity. It is the thread of human experience . . . This is an art which we can all share." (Judson 1963, 10-11)

By the time Judson had addressed this 1963 conference in Illinois, there was one certain and very public affirmation of her faith and her art. Of all of her sculptures, this is surely the one seen by most people: the statue of Mary Dyer, the Quaker martyr, commissioned in 1957 and dedicated in 1959, posed on the south lawn of the Massachusetts State House in Boston.

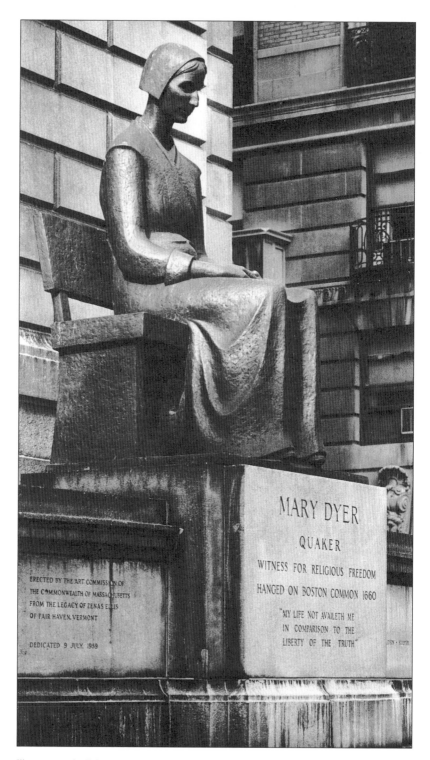

Illustration 8. "Monument to Mary Dyer" by Sylvia Shaw Judson
(1958-59, bronze), State House, Boston, photographed in 1966.

The Monument to the Quaker Martyr Mary Dyer

In 1957 Sylvia Shaw Judson received a commission for a monumental statue of the Quaker martyr, Mary Dyer, to be placed on the grounds of the Massachusetts State House in Boston. It was, by her own testimony, her "biggest job." And she confessed that the way she came to the commission was "rather a curious story." She shared this story in a talk she gave to a group of friends in 1959, and no one can tell this tale better than she did, in these words:

"One day a stranger lady, named Mrs. E. Sobier Welch, appeared at my studio. She lives . . . in Boston. She had read a book that I had published a few years ago called *The Quiet Eye* and seen on the jacket that I was both a sculptor and a Quaker. . . .

"She also was a Quaker and she told me about the competition for a monument to the Quaker, Mary Dyer, who was hanged by the Puritans on Boston Common in 1660. They seemed to have ceased to believe in religious freedom. The Friends maintained that each person can have a direct relationship to God without intermediaries. This was a threat to the authority of the Puritan minister. I guess the Quakers were a little difficult–they still are–but they didn't deserve to be thrown into prison and dragged behind carts and flogged and to have their ears cut off and their tongues bored. Mary Dyer was condemned to death together with two men, Marmaduke Stevenson and William Robinson. (I like to mention their names because I think the men should get some credit.) They had all refused either to recant their heresies or to leave Boston. The men were hanged but when Mary Dyer was already on the scaffold, she was reprieved and banished. She went to Providence with her husband and six children. But two years later, many of her friends still being in prison in Boston, she returned to visit them and this time she was hanged. There was such a revulsion from her death that a few years later the restrictive laws were repealed.

"Mrs. Welsh told me that ten years ago a descendant of Mary Dyer, named Zenas Ellis, had left a sum of money to the Commonwealth of Massachusetts with which to erect a monument to her on the Massachusetts State House grounds. The money was accepted and a competition announced, but nothing to the satisfaction of the Massachusetts Art Commission had yet appeared. They now planned to close the competition and

return the money to the family unless something turned up within the next two weeks. Mrs. Welch urged me to submit something. I quickly made a little model and shipped it to Boston. It was accepted! Mary Dyer took me two years to make. I made a third-scale model and a half-scale model. I had to have masculine help with the physical labor of enlarging it to full size.

"Last spring [1958] I spent five blissful weeks in Florence, checking on the bronze casting and supervising the patination (coloring, done with acids). Casting in Italy is good and so much cheaper that I was able to ship the plaster model over in two sections and back in bronze and go myself and still save a great deal on the cost of the cast.

"Mary Dyer was unveiled and dedicated last July [1959]. The Governor of the Commonwealth made a nice speech and his wife pulled the cord (no champagne). She sits at the top of Beacon Hill in front of the gold-domed State House facing toward the Common–a really frighteningly fancy site. . . .

"Duncan Phillips [founder of the Phillips Gallery in Washington, D.C.] says that artists create from their inner need. My Clay was terribly ill when I was making Mary Dyer, and the qualities that I was trying to express in her were just those that we both so badly needed ourselves. So, in a sense, this was his work as much as mine." (Judson 1960, n.p.)

In 1960 Clay Judson, Sr., her beloved husband of thirty-nine years, died. He was sixty-eight years old and had been in poor health in recent years. Now, at the age of sixty-three, Sylvia Shaw Judson was a widow. The "Mary Dyer" marked a turning point in her life. She would fill her remaining years with work, and travel, and teaching, and a second marriage, to Sidney Haskins, an old friend and an English Quaker.

The statue of Mary Dyer, dedicated on July 9, 1959, is a representation of a stalwart woman in Quaker dress, seated on a bench, her hands clasped and resting in her lap. She sits quite still, her frame as square as the meeting house bench she sits on, but with her head slightly bowed. The volumes of the figure are simple, and the heavy fabric of her dress falls against the figure in broad folds. These plain surfaces are animated by the marks of the artist's hand, the path of Judson's fingers as she worked the clay for the model that would become this bronze. There is nothing fussy about the composition of the work, or about the demeanor of the figure. This Mary Dyer sits where we can see her, but she looks within herself in the Quaker manner of finding solace in one's personal experience with God.

On the south lawn of the State House in Boston, that splendid old building designed by Charles Bulfinch and completed in 1798, sits "Mary Dyer" made by Sylvia Shaw Judson. The bronze statue rests on a stone base. The front of this base is engraved with these words: "Mary Dyer, Quaker, Witness for Religious Freedom, Hanged on Boston Common 1660, 'My Life Not Availeth Me in Comparison to the Liberty of the Truth'." On the right side of the base is inscribed "Sylvia Shaw Judson, Sculptor"; and on the left side of the base, "Erected by the Art Commission of the Commonwealth of

Massachusetts, From the Legacy of Zenas Ellis of Fair Haven, Vermont, Dedicated 9 July 1959."

A second casting of this figure was made in 1960. It, too, has an auspicious address. In 1975, it was placed at the Friends Center and Meeting House on Cherry Street in Philadelphia, Pennsylvania.

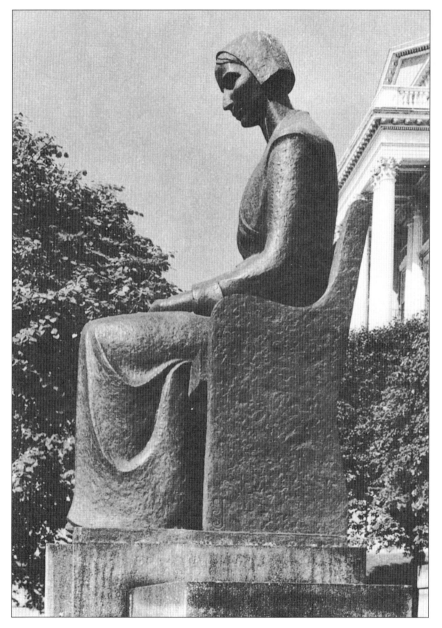

Illustration 9. "Monument to Mary Dyer" by Sylvia Shaw Judson (1958-59, bronze), State House, Boston, photographed in 1966.

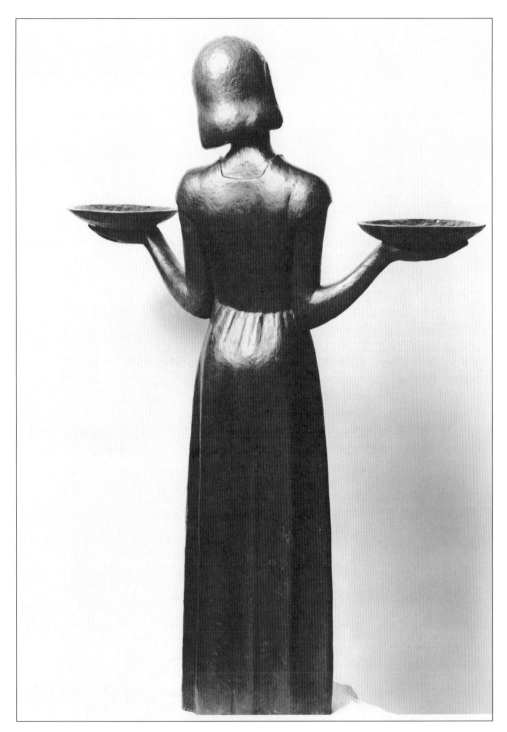

Illustration 10. "Bird Girl" by Sylvia Shaw Judson (1936, bronze), back view. Loaned by the Descendants of Lucy Boyd Trosdal to the Telfair Museum of Art, Savannah, Georgia.

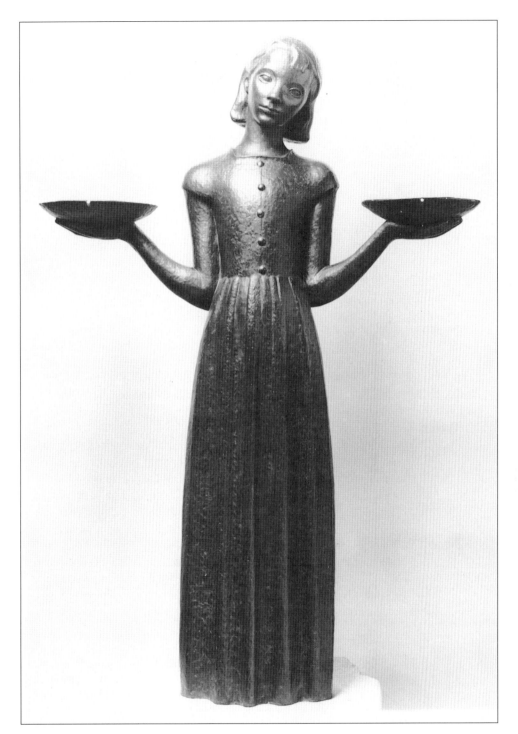

Illustration 11. "Bird Girl" by Sylvia Shaw Judson (1936, bronze), front view. Loaned by the Descendants of Lucy Boyd Trosdal to the Telfair Museum of Art, Savannah, Georgia.

Adventures of the "Bird Girl"

1936

Sylvia Shaw Judson is commissioned by Mr. and Mrs. Edward L. Ryerson, Jr., of Chicago, Illinois, to make a statue for a seaside garden at their summer home in Marion, Massachusetts. Judson designs the sculpture in her studio in Chicago. The model is nine-year-old Lorraine Greenman.

August 1937

The first statue is cast, in lead, at the Roman Bronze Works foundry in New York City, where all six castings (one in lead, five in bronze) will be made. The figure is identified as "Standing Figure." The cost to the artist is $400; Judson will offer the lead casting for sale for $950.

March 1938

The first two castings in bronze are made. The work is now called "Girl with Bowls." The cost to the artist of each bronze statue is $400, but she is offered the rate of $375 each if more than one is made at the same time. Each bronze sculpture sells for $1,000. The first bronze is delivered to the Ryersons in Marion, Massachusetts.

June 1938

Minutes of the University of Chicago Board of Trustees report that a fountain will be erected at the Country Home for Convalescent Crippled Children in memory of Mrs. Charles H. Schweppe. The fountain will be surmounted by a sculptured figure to be executed by Sylvia Judson.

July-October 1938

The statue, now identified as "Fountain Figure," is featured in Judson's first one-person show, an exhibition at the Art Institute of Chicago. There are nineteen pieces in this show. The show gets excellent reviews, and "Fountain Figure" is described as an example of the "delicate grace" that characterizes Judson's sculpture. The statue is posed in the middle of the room, with the remaining works arranged against the side walls.

September 1938

A news release from the Art Institute of Chicago gives notice that the show will be closing in October, and lists among Judson's commissions "The Laura Shedd Schweppe Memorial Fountain, Country Home for Convalescent Children, Princes Crossing, Illinois." Judson associates the "Fountain Figure" with this commission, and a drawing survives that shows the figure on an elaborate pedestal, with water flowing from the bowls in her hands down into two tiers of water at the base.

September 1938

"The Great New England Hurricane of 1938" strikes the New England coast. The fierce winds and powerful storm tides devastate the Ryerson property in Marion, Massachusetts. The "Fountain Figure" is toppled from its base and damaged, but the damage is repaired. By 1940 this "Fountain Figure" is moved to the family farm in Deerfield, Illinois, now Ryerson Woods, a nature conservation district.

October 1938

At the close of the show at the Art Institute, the exhibition of Judson's works begins a "Circuit Exhibition," first to the Milwaukee Art Institute (October-November 1938); then to The John Herron Art Institute, Indianapolis, Indiana (December 1938-January 1939); The Flint Institute of Arts, Flint, Michigan (January-February 1939); Dayton Art Institute, Dayton, Ohio (March-April 1939); and finally to the Art Institute in Zanesville, Ohio (April-May 1939). To begin the circuit, most of the works are shipped from Chicago, but "Fountain Figure" is shipped from New York, suggesting that the first three copies (one lead and two bronze) have already been placed (one bronze with the Ryersons, perhaps one bronze or lead at "The Laura Shedd Schweppe Memorial Fountain," and one now unknown).

December 1938

A fourth cast (the third bronze) is made at the Roman Bronze Works, New York City. Presumably this is the statue sent from New York to begin the "Circuit Exhibition" in Milwaukee.

February 1939

A fifth sculpture (the fourth in bronze) is cast. This may be the casting that goes to Mrs. Frederick A. Preston of Lake Forest, Illinois, a neighbor at Ragdale. Subsequently, this sculpture is inherited by a son who takes it to his home in Providence, Rhode Island.

February-December 1939

"Fountain Figure" is loaned to "The Golden Gate International Exposition," to be shown in the Fine Arts Building, San Francisco, California.

April 1939

From the exhibition at the Dayton Art Institute, a sale of the "Fountain Figure" is made to Mrs. Davidson, of Washington, D.C. She requests that the statue be shipped to her at the close of this exhibition, so the "Fountain Figure" is not included in the exhibition at the Art Institute, Zanesville, Ohio, the fifth and last show on the "circuit." Subsequently, this sculpture is inherited by a daughter and taken to her home in Reading, Pennsylvania.

April 1940

A sixth sculpture (the fifth in bronze) is cast, to be delivered to Arden Gallery, New York City, for a one-person show of Judson's work. Mildred Steil is the curator of Judson's show, and she refers to the work as "Peasant Girl." In May of 1940, the Arden Gallery reports that it has two casts of "Peasant Girl" for sale.

April 1940

"Fountain Figure" is shown at the Whitney Museum, New York City, in the "Sculpture Festival," an exhibition sponsored by the National Sculpture Society. In the group of around two hundred sculptures, "Fountain Figure" is identified in a review in *The Art Digest* as one of the "outstanding" works in the show.

March 1941

"Peasant Girl" is loaned by the Arden Gallery for use by a Pennsylvania garden club at the Philadelphia Flower Show in a competition calling for the display "of a section of a small garden featuring sculpture." The loan is acknowledged by Mrs. H. Chace Tatnall of Whitemarsh, Pennsylvania, who writes to Judson: "I loved 'The Peasant Girl' from the first moment I saw her–she is so like my thirteen year old daughter Sheila." The exhibit won the $100 award given by the Pennsylvania Academy of Fine Arts for the garden making the best use of sculpture and the second prize awarded by the Pennsylvania Horticultural Society. (Tatnall 1941)

April 1941

"Peasant Girl" wins a $200 prize given by the Philadelphia Flower Show, Inc., for the best piece of garden sculpture in the show.

January 1942

The plaster model of "Peasant Girl" is shipped to the artist from the Roman Bronze Works foundry in New York City, indicating that the edition of the sculpture is complete and no more castings will be made.

September 1949

The plaster model of "Peasant Girl" is shown in a group show at the Mandel Brothers Galleries in Chicago. The piece is listed "N.F.S." (Not For Sale). By this time, Judson identifies the edition of this work as "Sold" and "no longer available."

After 1950

The plaster model is donated by Judson to the Crow Island School, a public elementary school in Winnetka, Illinois.

April 1957

Judson has a one-person show at the Sculpture Center, New York City. In the group of sixteen works, the "Fountain Figure" (A.K.A. "Standing Figure," "Girl with Bowls," and "Peasant Girl") is not included.

1967

For Gardens and Other Places: The Sculpture of Sylvia Shaw Judson is published by Henry Regnery, Co. The figure now identified as the "Bird Girl" is featured on the dust jacket of this book, in a beautiful photograph taken by Hedrich-Blessing, a premier architectural photography firm in Chicago. In the listing of works, Judson identifies the Ryerson "Bird Girl" as the first casting of the edition and the second as the statue owned by Mrs. Preston. She lists only these two casts, confessing in an editorial note that her records are incomplete so it has not been possible to cite all of the castings of all of the works.

1977

In the year before her death in 1978, Judson draws a list for the Roman Bronze Works foundry, to assess what plaster models still exist at the foundry (for editions that have not been sold out) and what models have been destroyed. Among those she names as destroyed (but with a question mark) is "Girl with Two Bowls." (Judson [1977])

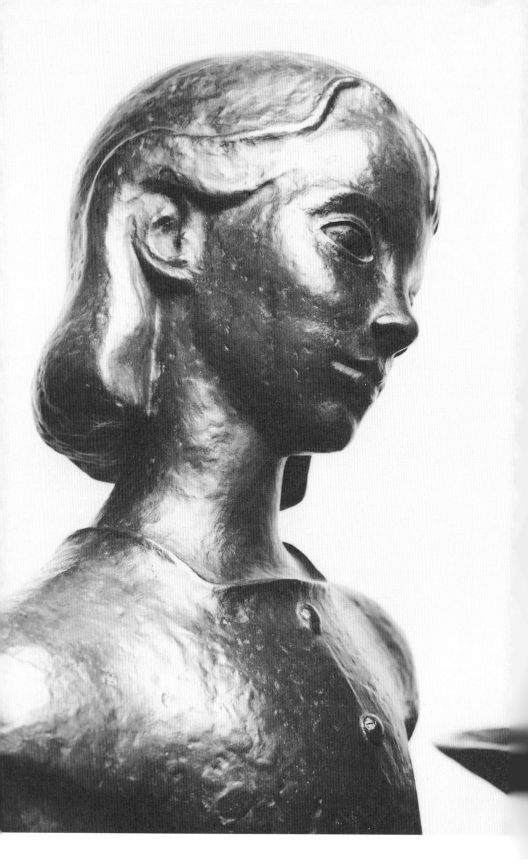

Lorraine Greenman

Some artists require models; some don't. Sylvia Shaw Judson was trained in the academic method by masters of the art of sculpture, and this method relies on the study of the human form as the basis for artistic invention. For the sculpture that would come to be known as the "Bird Girl," she needed a model. A particular model, one who would inspire her, who would help her realize the goal for her work. As she contemplated this sculpture of a girl holding two shallow bowls aloft, she had in mind a certain physical type.

Alice Judson Hayes remembers that her mother often used members of the family as models for her art. One of her own earliest memories is of posing, or rather being posed by her mother, for a sculpture called "Merchild" (now at the Chicago Botanic Garden in Glencoe, Illinois). At the time, her mother's "studio" was in a great empty hall on the top floor of the Newberry Library near the Judson home in Chicago. Hayes says: "I remember myself at three, there among the marble columns, sitting naked on a high stool with my legs wrapped tightly in a towel, posing for a figure of a merchild. Years later my psychoanalyst understandably refused to believe that this was not a dream, until I triumphantly produced a snapshot which still smelled of the oil-based clay my mother used." (Hayes 2004, 3)

In 1936, when Judson was commissioned to make a statue for a home in Marion, Massachusetts, the matter of a model was now complicated. Her daughter says, "At this time, her children and nieces and nephews who had previously been convenient models were either too old or too young or too busy or too fat to model for the figure she imagined for this little seaside garden." (Hayes 2004, 4) But just the perfect image turned out to be the slender form of a nine-year-old child named Lorraine Greenman.

Lorraine Greenman is now Mrs. Victor Ganz, wife of a retired dentist and a proud mother and grandmother. Of her four children, her daughter trained as a medical technician and two of her three sons are physicians. She remembers the experience of posing for Judson well, and warmly.

Illustration 12. "Bird Girl" by Sylvia Shaw Judson (1936, bronze), detail. Loaned by the Descendants of Lucy Boyd Trosdal to the Telfair Museum of Art, Savannah, Georgia.

She is the daughter of immigrant Jewish parents, her father from Russia and her mother from Lithuania. Her parents, she remembers, were committed to becoming Americans, eager to realize all of the promise that could come of a life in this new place. The family was poor in means—her father worked as a tailor, but her parents were rich in spirit and ambition. Still, life was filled with challenges. They lived in a neighborhood in Chicago occupied primarily by Italian immigrants, where there were few Jews and where Jews were taunted.

Social reformers in Chicago took early note of what it meant to make a civil society of a brew of poor immigrant peoples. In the late nineteenth century, several charitable organizations were formed, among them the so-called settlement houses, the best known of which was Hull House founded in 1889 by Jane Addams and Ellen Gates Starr. The settlement houses offered a great variety of programs to assist this immigrant population, including childcare, educational programs for adults, social and recreational opportunities for children and adults, and, always, training in the arts: the visual arts and crafts, music, theater, and dance.

The aim of the settlement house was to provide resources to nourish the body, mind, and spirit. And from the earliest moment of these institutions, the arts played a significant role. The notion that the arts were essential to a happy and healthy culture was advanced in the second half of the nineteenth century in the writings and teachings of the English critic John Ruskin. Ruskin's views formed the basis for the Arts and Crafts Movement, which had as one of its goals to reform society. Ruskin's very numerous books and articles in magazines and newspapers were read eagerly in England and America. In both countries, Arts and Crafts theories flourished, taking hold in Chicago as in few other places.

Lorraine Greenman's mother looked for experiences that would take her three children, a son and two daughters, off of the mean streets of their neighborhood. For the daughters, she looked to programs at the nearby settlement house, the Eli Bates House, first established as a charity for young girls in 1876 by Bates, a prosperous Chicago lumber merchant. Among the programs here there was a social club called the Camp Fire Girls, founded in 1910 by Luther and Charlotte Gulick. This was the first nonsectarian, inter-racial organization for girls in the United States. (The Girl Scouts, founded by Juliette "Daisy" Low of Savannah, was established in 1912.) Jane Addams of Hull House had been an early supporter and contributor to the development of the Camp Fire Girls. The programs included a variety of educational and enrichment opportunities, and activities in the arts were a prominent feature of these programs.

Lorraine Greenman was in a dance class at the Eli Bates House when Judson came to look for a model for her sculpture. And here her eye was caught by nine-year-old Lorraine.

Ganz describes herself as a child as very thin, with blond hair and blue eyes. She carried herself well, and her mother always saw that she was well

dressed and well groomed, by contrast to many of the children in her neighborhood. She remembers that, even in these circumstances, and in the middle of The Great Depression, because of the spirit and the actions of her parents, she did not feel poor or deprived.

When Judson called on Lorraine's mother, to seek her permission for Lorraine to model, she said that she was interested in the child because she was "very well proportioned." Ganz recalls that Judson was a woman of great kindness and sensitivity, elements of good character that persuaded her mother to allow the child to be given over to the care of the artist for the several sessions of modeling needed to complete this figure.

The work of an artist's model is not easy as it may seem. It is difficult to pose and to remain quite still for long periods of time. It can be boring, even uncomfortable. Ganz remembers that Judson was always very considerate of her feelings as she posed. She says, "There were frequent breaks, and Mrs. Judson was always very concerned if I got tired or hungry." Ganz also remembers sensing that Judson was a woman of great privilege: "She was very kind, very gracious, but it was clear to me, even as a child, that she didn't know how some of us lived." It is an observation that reveals what many have seen in the face of the "Bird Girl": a knowledge of the world beyond the ordinary capacity of a young child.

Very often in the history of art, the name and the experience of the model are lost. Yet the model may be an important collaborator in the making of an artwork. In the peculiar case of the "Bird Girl," the latter-day fame of the sculpture erupted from a photograph on a book cover and a cameo role in a movie. At first, the artist was unknown, and the identification of the model was a complete mystery. But in one of the many events of surprise and coincidence in the story of the "Bird Girl," the model would come to be known.

Alice Judson Hayes tells this story:

"The final extraordinary chance event came about when I made the acquaintance of a young man writing a biography of the architect, David Adler. Stephen Salny was an admirer of the 'Bird Girl' and we talked about the sad fact that there was no way of knowing who the model for the statue had been. She was a child whom my mother had found as a model in a dancing class at the Eli Bates House, a long gone settlement house in Chicago. She had posed a number of times in 1936, and it seemed quite hopeless to locate her in 1994.

"Mr. Salny was on his way to a celebration of his parents' fiftieth wedding anniversary in Florida. So we said a cordial good bye.

"A week later the telephone rang and the excited voice of my friend came over the line. He told me the following story: He was at a party for his parents who had retired to Florida. Some of their recently acquired friends were there, and Stephen pricked up his ears when he heard two elderly women talking about *Midnight in the Garden of Good and Evil,* then a best seller. 'You know the picture on the cover?' said one. 'My sister's best friend posed for that statue when she was a little girl!'

"So we found her, Lorraine Greenman Ganz, a charming woman who well remembered posing for that statue in my mother's studio in Chicago." (Hayes 2004, 13)

Ganz recalls first seeing the cover of "The Book" in a story in *The New York Times*, and, excited by this recognition, she attempted to make contact with the publisher of the book. She was, by her account, dismissed. There was no interest in the sculpture or in the story of the child who had helped bring this work of art to life. The publisher's response is interesting and bears on the central question of what role Judson's statue played in the phenomenal response to "The Book." Might a photograph of any other statue of a child in Bonaventure Cemetery have brought the same success? Easy question. The answer: No.

The story of Lorraine Greenman is another good reminder of the contribution a model can make to the character of an artwork. Why is this image so compelling? In some measure it is because we see here an uncommon child. Invested in the "Bird Girl" is the spirit of a young and very self-assured Jewish girl from an immigrant neighborhood of Chicago in those difficult years of The Great Depression.

What's in a Name?

She's known now as the "Bird Girl." But that name came to her rather late in life, and by means that are now unclear.

She began life as "Standing Figure." This is the title given to the statue on the work order for the first casting of the figure in 1937, at the Roman Bronze Works foundry in New York City where all six casts were made. In recent years, the archives of this foundry have been preserved and made available to scholars at the Amon Carter Museum in Fort Worth, Texas. In the process of organizing these materials, museum archivists discovered that a "working title" of an artwork was frequently assigned at the foundry based on the appearance of the form. An artist might (and usually did) designate an official title that would be known to agents and patrons; but, in dealing with the foundry, the "working title" prevailed.

So when Judson sent her plaster model to the Roman Bronze Works in July of 1937, the sculpture was anointed "Standing Figure" for a casting in lead. However, when she placed an order for the first two bronzes just a few months later, to be delivered early in 1938, the "working title" became "Girl with Bowls," a more descriptive title. Over the years, on various lists that Judson kept to attempt a running inventory of her art, she most often referred to the work as "Girl with Bowls."

In July of 1938, Judson's first one-person show opened at the Art Institute in Chicago, and this statue was featured in that display. She stood alone, on a pedestal in the middle of the room, while the other eighteen works were posed along the perimeter of the walls. And in this exhibition, she was called "Fountain Figure," a name which followed her when, two years later, in 1940, she was exhibited at the Whitney Museum in New York City, in a show sponsored by the National Sculpture Society. (Jewett 1938b and *Art Digest* 1940)

Judson had designed other figures for installation with water displays, in ponds or as elements of fountains. While there is no known installation of the "Bird Girl" as a part of a fountain, this early title, "Fountain Figure," suggests that such a plan had been conceived. Indeed, in the Sylvia Shaw Judson Papers at the Archives of American Art, in Washington, D.C., there is an undated drawing, with no notation, of the "Bird Girl" posed at the top of an elaborate semi-circular base of three tiers, with water flowing from her bowls

into two levels of water below. This may be the plan for an installation which is named in several of Judson's lists, "The Laura Shedd Schweppe Memorial Fountain, Country Home for Convalescent Children, Princes Crossing, Illinois," a mystery "Bird Girl" about which more will be said later.

At the same time that this sculpture was making the rounds as "Fountain Figure," she appeared with the title of "Peasant Girl." This name seems to have arrived at the bidding of Mildred Steil McCauley (Mrs. John C. McCauley, Jr.), who, with Mrs. Theodore Roosevelt, Jr., ran the Arden Gallery on Park Avenue in New York City. Judson placed some of her works for sale at this gallery from the mid-1930s through the early 1960s. In the spring of 1940, the gallery presented her work in a one-person show, and here for the first time the figure was named "Peasant Girl." (Arden Gallery 1940b) When she was loaned by this gallery to other exhibitions, as she was to the Philadelphia Flower Show in the spring of 1941, she was called "Peasant Girl." However, when she traveled during 1938-40 from the Art Institute in Chicago to other exhibitions in the midwest and the west (she appeared at The Golden Gate International Exposition in San Francisco in 1939), she was called "Fountain Figure."

"Peasant Girl" is an interesting title for this figure, as it captures the element of good, plain simplicity that marks the image. Nothing about the figure is fussy. The hairstyle is a simple page boy, with bangs. (The model for the statue, Lorraine Greenman Ganz, recalls that she wore her hair with bangs, but the smooth style of the page boy was Judson's invention, since the child's hair was quite curly.) The dress is plain, a squared neck, cap sleeves, and a buttoned bodice, with a long skirt that falls in deep and regular folds as if the cloth were heavy, even coarse. (Ganz remembers that Judson provided the costume, which she wore at each session of modeling. Judson then offered it to Lorraine's mother, but her mother found no use for it so the offer was refused.) Both peasants and children were popular subjects in the Arts and Crafts style, as both symbolized an honesty and goodness uncorrupted by pretension and false sophistication. The directors of the Arden Gallery, Mrs. McCauley and Mrs. Roosevelt, must have subscribed to an Arts and Crafts aesthetic, because they represented in this gallery a great variety of arts of the "useful" sort, including garden sculpture and furniture, and the needlepoint and embroidery for which Mrs. Roosevelt was well known.

This sculpture does not debut as the "Bird Girl" until the publication of *For Gardens and Other Places* in 1967. Here she is named "Bird Girl," and she is featured on the dust jacket of that book, in the beautiful photograph shown here by Hedrich-Blessing (Illustration 1).

And where does this name come from? No one is certain. It is a very apt name, quick and precise. A seemingly obvious name, but really quite a clever turn of phrase. This dainty bird-like child holds offerings for the birds. It is difficult, now that she has charmed us all as the "Bird Girl," to think of her having the more pedestrian titles of "Standing Figure," or "Girl with

Bowls," or "Fountain Figure," or "Peasant Girl." Perhaps it was the inspiration of an editor involved in the production of the 1967 book, who recognized the special character of this figure and reached for a title with more punch. Or, as Alice Judson Hayes proposes, "My mother and all of her friends, they all liked birds." Simple as that.

How the
"Bird Girl" Was Made

Sylvia Shaw Judson was a sculptor, an artist working in three-dimensions. The method of conceiving of an object in the round or in relief (that is, shapes projecting from a background) is very different from the methods used by painters and printmakers, artists who work on a flat surface. It takes a particular kind of creative vision to comprehend how an art object will look from many different points of view; and in this, she was surely influenced by her father, an architect. Very good architecture (and he was a very good architect) is the ultimate art of realizing the potential of occupying space. In the early twentieth century, it was unusual for a woman to take up work as an artist, and even more unusual for a woman to take up the labor-intensive work of sculpture. But Judson surely inherited from her father an understanding of realizing form in three-dimensions, not to mention the encouragement he gave her to pursue sculpture so that she might collaborate with him in inventing figures and ornament for architectural embellishment.

As a sculptor, Judson was primarily a modeler, not a carver. These are very different processes. The carver begins with a block of stone (or a piece of wood) and carves away material to reveal the figure, a method called "subtractive." Usually the carving results in one unique object. Judson used the "additive" method, modeling or making a figure by adding bits of a soft material (usually clay) until the figure she desired had achieved the shape she wanted. The surface of the work could show her "marks," the touch of her hand as she worked with the soft material; or, the surface could be rendered smooth, hiding the maker's "marks." In many of Judson's works, including the "Bird Girl," her "marks" are evident.

From the clay model, a mold is made so that a copy of the work can be "cast" in a durable material (such as a variety of metals or composite materials like "cast stone"). From this mold, many copies can be made.

Judson's daughter, Alice Judson Hayes, tells the story of the beginning of her mother's professional life–the establishment of her studios, her materials, and her working methods– in this account:

"After she graduated from the Art Institute and after a winter in a studio of her own in New York, and another winter studying with Bourdelle in Paris, she married Clay Judson, a young lawyer, and settled down to be a

sculptor in Chicago. In those days practicing law didn't mean instant riches. I was born as soon as was decent–nine months and a week after the wedding–not by plan but by accident. . . .

"My mother's first studio [in 1921-22] was an affordable small basement room across the courtyard from our apartment [in Chicago] where she continued doggedly to work while I was taken care of by a seventeen-year-old mother's helper who also cooked and cleaned. Sylvia's father stopped by her studio every day on his way home from his architecture office to see what she'd done that day and to offer criticism and advice. . . . She and her father were sympathetic friends and instead of feeling pushed, she was deeply appreciative of his interest and encouragement. By the time he died a few years later, he had transmitted to her the passion he had for his work, and at a time when young married women with babies almost automatically became dilettantes, she continued to have a studio and doggedly to go to it. . . .

"As Sylvia began to sell more of her work, she was able to rent a genuine studio away from our apartment. But my father had always wanted to have a house and finally in 1933 he bought one and built a beautiful little studio for my mother in the back and it is in this studio that the story of the 'Bird Girl' begins." (Hayes 2004, 2-4)

And these were Judson's materials and methods:

"When Sylvia graduated from art school in 1918, her father gave her a big chest filled with plasticine, the oil-based clay which stays pliable forever. Almost every piece of sculpture my mother ever made was first made out of the clay from this chest. I suppose there are people who associate their mothers with the smell of cookies or freshly ironed sheets, but my mother couldn't cook and didn't know how to iron. The pleasantly oily smell of plasticine was the mother-smell of my childhood. Sometimes I watched her make a lead pipe armature with wood and wire butterflies attached. This rather spooky skeletal creature would stand in her studio for a day or two while she bent it and twisted it, and covered it with her marvelous indestructible clay.

"After the statue was finished, Mr. Orlandi, the plaster-caster, came and slurped what looked like marshmallow sauce all over the clay. When the plaster had dried and was split open my mother carefully scooped every vestige of clay off of the mold and the armature to be used again. She used it all of her life. I still have quite a lot left and almost eighty years after Howard Shaw gave it to his daughter, it's as good as new." (Hayes 2004, 5)

When the plaster hardened on the surface of the clay, and was broken open, the "positive" image of the sculpture was embedded inside that plaster shell. This plaster would be used to make a hard (plaster) model which was then sent to a foundry. At the foundry, a mold would be prepared to receive the bronze, lead, or cast stone that were the materials Judson preferred.

Judson explained her method in a talk, illustrated with slides, that she gave in 1960 titled "Life with Clay" (a happy pun as it referred to her life modeling clay and her life with Clay Judson). She described the work of Mr. Orlandi, and later his nephew's son (another Mr. Orlandi), as fixing little dividing lines of tin on the clay model that allowed the plaster coating to be removed in sections. Then the wet plaster was "splashed" onto the clay. When the plaster dried, the sections were pulled off, and, in the process, the original clay model was destroyed. The clay was picked away from the plaster and thrown back into the clay chest, "where it waits for the next job." The Orlandis then took these sections of plaster, "the hollow pieces," off to their shop in Chicago where they made a positive model, a duplicate in plaster of the original modeled in clay. Judson then went to their shop, to retouch the plaster model before it was shipped to the foundry in New York City, where it would be cast in the finish material. She remembered the Orlandis' shop with great affection:

"This shop, in an old house near Milwaukee and Grand Avenues, is one of my favorite spots. I have to go there to retouch the plaster models before they are shipped to the bronze foundry. I sit on a box by the stove. . . . The radio is playing Italian popular songs and spaghetti advertisements. Eddie and Ezio join in. Italian neighbors come in to gossip and get warm. I bring my lunch. Ezio's pretty Italian wife and bambini live upstairs where I go for the hospitality of the house. The walls of the bathroom are lined with home-canned peaches." (Judson 1960, n.p.)

For casting her works in durable materials, Judson used the Roman Bronze Works foundry in Brooklyn, New York, established by Riccardo Bertelli in 1897. According to Lucy D. Rosenfeld, "At the height of its operations, from the early 1900s to World War II, Roman Bronze was the foundry of choice of most of the major sculptors in the United States." (Rosenfeld 2002, 11) Judson may have been introduced to the foundry by her teacher at the Chicago Art Institute. Albin Polasek first used Roman Bronze Works in 1914, and he continued to use the foundry into the 1950s. (Rosenfeld 2002, 222)

Much of the work of this foundry was done by the old method called "lost wax," in which the pattern is created out of wax, and then the wax is "lost" or replaced when hot molten material is poured into the form. Many of Judson's works were cast by the method of sand casting, in which a mold is made by mixing sand with a binding agent (such as a wet clay); and, while the sand is still damp, the pattern (the plaster model) is pressed into the sand to make an impression. When that impression hardens, a mold results into which bronze, lead, or other materials can be poured.

Judson had her art works cast in a variety of materials. Sometimes the edition of a single work would be cast in two or three different materials. She made the judgments based on the shape and the character of the sculpture, where the sculpture would be placed, and cost.

She was fond of lead, although she didn't use it often. Lead had become popular for garden ornaments in the Arts and Crafts Movement because it was easily worked, relatively inexpensive, durable, and had some associations with medieval architectural ornament and sculpture. Lead could give a pleasing appearance to a garden sculpture, and Judson chose this material for the first casting of the edition of six "Bird Girls." She often used cast stone, a composite masonry product that could simulate a wide variety of natural stones, such as limestone and granite, in a great variety of colors. It was relatively inexpensive, and very durable. And sometimes a professional stone carver was engaged to copy a plaster model by using calipers for measurements, to make an accurate copy.

Five of the six castings of the "Bird Girl" were bronze. Bronze, an alloy of copper and other materials (such as tin, zinc, or lead), was the most desirable material for art objects, and the most expensive. It had been used for sculpture since ancient times, and it can be counted on to last for centuries. The surface of bronze can be treated to achieve a variety of effects by the method called patination, which is the application of chemicals that results in the colors of reds and browns, or greens and blues, or black, with qualities that are more or less transparent or more or less opaque.

For the last casting of the "Bird Girl," then identified as "Girl with the Bowls," Judson wrote to Mr. Bertelli at Roman Bronze Works, asking him to evaluate the color of this cast because her agent at the Arden Gallery in New York, where this sculpture would be shown, was concerned: "Mildred Steil is sending the plaster model back to you. Will you talk with her about the color [for the final casting of the figure]. She felt that the light grey green (I believe it was almost lead color) was more becoming to the figure than the heavier color that I had used." (Judson [1940]) Just a few days later, Mr. Bertelli replied: "Dear Mrs. Judson, We are in receipt of your letter of February 27, and following your instructions, we are proceeding with the casting in bronze of the last copy of your girl with bowls. We shall be glad to deliver the same to the Arden Gallery, on or about April 7. We shall communicate with Miss Steil, in reference to the patina and I am sure that everything will be satisfactory." (Bertelli 1940)

And indeed, everything was, as Mr. Bertelli had promised, quite satisfactory. Judson continued her association with the Roman Bronze Works foundry through her working career, with the exception of the casting of the monumental figure of "Mary Dyer," produced in 1958-59. That sculpture was cast in Italy because of greatly reduced costs of materials and labor for such a large-scale work.

How Many "Bird Girls" Are There?

The "Bird Girl," as most of Judson's sculptures, was modeled in soft clay, then prepared as a hard plaster model, from which a mold was made. From that mold, many copies could be cast in a variety of materials. But how many copies?

The issues of how to define an "original" and how to sustain the value of a work of art are concerns of long-standing in the history of art. If a sculpture is carved by the direct method, there is no question but that this is the "original," the one unique copy of this work. Consequently, if the desire for this object is strong, the market responds by setting a high value on this work, and the person who can pay the most for it will have the pleasure of owning it. Similarly, a painting is a unique product, only one of a kind. (Although, because the history of art is an interesting and sometimes lively history, there are plenty of examples of carvers and painters who made something lovely; and, because the work was admired and desired, it sometimes got carved or painted, in exact or near copies, again and again.)

There are special problems for the arts that have the capacity to be reproduced, to be made in multiples, such as sculptures cast in molds or prints on paper (such as engravings, etchings, wood block prints, lithographs, serigraphs, or photographs). The artist may make the decision to pose no limit on an edition of a work, so that dozens, or hundreds, or thousands are made. In that case, there is no aspect of "rarity," and anyone can have a copy. The certain results of this decision are that the monetary value of the work is limited and the aesthetic quality of the work becomes compromised (that is, the artist is likely to have lost control over the manufacture of the copies so that the quality of the work is degraded as more copies are made).

Judson favored a method of sculpture that would allow her to make more than one copy of each "invention." She said: "It is fortunate that sculpture can be made in editions. Sculptors welcome this because the costs are so high that if they asked a price commensurate with the cost in time and money, few people would be able to buy." (Judson 1967a, n.p.) But, she knew that this process was both a blessing and a curse. If editions were not limited, and carefully controlled, there was the prospect that the work would be devalued, both in monetary value and in the life of the object as a creative work, an invention, a surprise.

Judson made the decision to limit the number of works made in each "edition," after which the mold would be destroyed. So long as the hard plaster model existed, there was the prospect of creating a new mold, so she kept careful track of the plasters as well. When an edition was complete, or sold out in the number she had set, Judson could destroy the plaster model. But very often she donated her plasters to the public schools of the North Shore, the regions north of Chicago, where they might be enjoyed by the students and teachers. Throughout her life, she took an interest in primary school education and in promoting the importance of the arts in the curriculum of these schools. Clearly, in her mind these plaster models donated to the schools were "sculptures." And they were out of reach of the foundry and never intended to be used again to make a mold.

In *For Gardens and Other Places,* the 1967 book surveying her work, Judson confessed: "Owing to incomplete records and lack of space, it has regrettably been impossible to include all work or to note the various owners of each version of the pieces listed. Some exist in the maximum number of castings allotted to the edition–usually four." (Judson 1967a, n.p.) Several copies of her own "inventories" of her work, really just handwritten lists and often undated, now survive in her papers at the Archives of American Art. But keeping good records was complicated by the fact that some works were represented by galleries, which didn't always report to the artist when a work was sold and to whom.

In an attempt to correct her own records for the upcoming monograph on her work, Judson wrote to an agent of one of these galleries in 1964, and received this sad reply: "With reference to the matter of the names of purchasers of your sculpture, I have spoken to Mr. Couch (the man who has taken over part of my work at Erkins) and he says that he has no records in the files. After I retired, early in 1963, there was a complete turnover of personnel. Mrs. Cole, who had taken care of the files for nine years, and who could usually track down old information, was retired later that year, and Miss Marron resigned in May of this year, so there is no one there who has had enough experience with old records to do the necessary 'digging,' and it is possible that much old information may have been destroyed when the files were transferred at the end of 1963." (Groskoph 1964)

In the popular accounts of the early history of the "Bird Girl," which emerged very shortly after her debut on the cover of "The Book," newspapers, magazines, and a fantastic array of Internet sources announced, always with some conviction, that there were two "Bird Girls," or three, or four. Not only was there confusion about the number, but, there was generally a misapprehension about where these two or three or four "Bird Girls" might be located. It was clear that there was one in Savannah, but others seemed just to pop up, here and there.

It is now possible to state, with some authority, that there are six "Bird Girls," based on the clear and definitive records of the work orders at the Roman Bronze Works foundry, now maintained and available to scholars

at the Amon Carter Museum in Fort Worth, Texas. Judson's own records are unclear. On her "lists" in the 1950s and 1960s, she refers to this statue (now known variously as "Girl with Bowls," "Fountain Girl," or "Peasant Girl") with the notation: "5? or 6?" She names, with certainty, only two of these: the Ryerson bronze, the original commission for the figure, the second one cast but the first one cast in bronze; and the Preston bronze, the statue that would come to live at her neighbor's home, adjacent to Ragdale. Another name that appears on some of these lists is Davidson, a bronze that was purchased for a garden in Washington, D.C. Another entry for this figure, again appearing on only some lists, is a mysterious one: "The Laura Shedd Schweppe Memorial Fountain, Country Home for Convalescent Children, Princes Crossing, Illinois." Occasionally there is an undecipherable name beginning with "Van." There is never a reference to a statue purchased by Lucy Boyd Trosdal, or to a work destined for Savannah, Georgia.

Six castings of this statue were made, the first in lead and the remaining five in bronze. All of these were cast at the Roman Bronze Works foundry in New York City, in the years 1937-1940, after which time the edition was determined to be "complete." That much is certain. The work orders survive in the ledgers of the foundry, with order numbers and dates for the orders, and completion and delivery dates. Because three of these were made for or sold to close friends or, in the case of Mrs. Davidson, a distant relative, and because all of these have remained in the hands of descendants of the original owners, the artist's daughter, Alice Judson Hayes, can confirm the location of these three. As for the Savannah "Bird Girl," while it is not clear how she got to Savannah, there is no dispute about the fact that she did. The locations of two of these six casts, the first in lead and one in bronze, are now unknown.

In a talk to a gathering of garden clubs in 1959, Judson offered this observation about the size of editions of sculpture: "Edition numbers vary. Seven seems to be a favorite number. I believe that Rodins and Degas are made in this number. That's why you see the same pieces in different museums. I usually do larger things in editions of four and smaller ones in editions of six. . . . It is legitimate for the buyer of a costly piece to ask that no other be sold in the same town. But it is impossible to prevent one sold somewhere else from being brought in. . . .

"Naturally, the frankly commercial pieces that are sold by the hundreds are cheaper, or should be. Some of the carvings of this type, in soft stone being imported now from Italy, are very pleasant. Personally I don't care whether my dress is exclusive or not if I like it, but many people do. It does disturb me, however, to see limitless copies of things as contemporary as John Flannagan's monkey sold in cast stone after his death, when you consider that he almost starved in his lifetime." (Judson 1959, 5-6. Her reference is to the American sculptor John Flannagan, born in 1895, who committed suicide in 1942, whose popular figure of a monkey was pirated in commercial copies.)

Judson's own concern about protecting the integrity of the editions of her works is clear in this correspondence with the director of the Roman Bronze Works foundry early in 1975, three years before her death. In January, she writes to Mr. Schiavo, directing him to identify all of the plaster models still at the foundry. She tells him that she has received from his assistant a list of her models which still exist there, and she adds to this list four more models that she has identified from records in her own files. One of these is this entry: "Also I didn't see . . . on an earlier list (no date) girl with two bowls (about 4 ft.) . . . See if you can find [this] and put [it] with the others. I know that the one called 'Akimbo' and the 'Gardener' were destroyed." (Judson 1975)

She writes Mr. Schiavo again at some later time, probably in 1977, after she has moved back to Ragdale from the Quaker retirement community in Pennsylvania where she and her second husband, Sidney Haskins, have lived for some years. She says: "In January 1975 we checked the models of mine that were in your basement. Following is the list as I have it." And she names seventeen models. She adds five models that she identifies as "not listed?" and four that are "destroyed?" (and one of these is "Girl with Two Bowls"). At the close of the letter, she instructs Mr. Schiavo: "Please check on those not listed and those destroyed, as I will want them all destroyed when I die." (Judson [1977]) The fate of all of these plaster models is told by her daughter, Alice Judson Hayes: "After her death, at her request, I spent a horrible afternoon at the bronze foundry in New York watching men break up children and animals with sledge hammers. She was afraid of pirated copies although occasionally she brought home a cast to give to a public school in the Chicago area." (Hayes 2004, 5) And that was just what had happened to the plaster model of the "Bird Girl," although at the time of these notes to Mr. Shiavo, the memory of her gift to the Crow Island School was lost to her.

Six "Bird Girls," although we can now account for the location of only four. Judson's own testimony is unclear. In February of 1940, she writes to Mr. Bertelli at the foundry: "I think I will take a chance on having you cast the last of my edition of six of the 'Girl with the Bowls' before my show (which will open at the Arden Gallery on April 15th)." (Judson 1940) That would seem to be reliable evidence from the artist, because the date of the letter corresponds with the date of the last of six casts produced by this foundry. However, in 1956, Judson writes to Mr. Schiavo, then director of the foundry, with questions about the preparation of works for her one-person show at the Sculpture Center in New York City. She adds this note: "P.S. You remember the figure of a girl holding a bowl in each hand that you cast four of for me. One of them is owned by a neighbor and I note that rust is beginning to show at the seams. What should we do?" (Judson 1956)

Still, the ledgers of Roman Bronze Works give work order numbers, dates of the orders, dates for completion, and delivery dates. And, there are six "Bird Girls." But why six when she has said that the larger figures are usually limited to four? There are at least these explanations:

Of all of her garden sculptures, the two most successful were the "Ga dener" and the "Bird Girl." Both of these are "large" figures in the conte of her work; both of them stand fifty inches high. The edition of the "Ga dener" exceeded four because the demand was sometimes irresistible. (Wh can deny presidents of the United States?) And, as she pointed out in h 1959 talk to garden clubs, central to the issue of controlling the number castings of a figure is the issue of geographic distribution: "It is legitimate f the buyer of a costly piece to ask that no other be sold in the same town Popular works, such as the "Gardener" and the "Bird Girl," could be mac in the larger number provided that the works would be held by owners different parts of the country. So long as she knew, to use her analogy, th two owners wouldn't be wearing the same dress in the same town, she wa comfortable with the plan to move the edition over four. (Judson 1959, 6)

There is abundant evidence that the "Bird Girl" (A.K.A. "Fountain Fi ure" or "Peasant Girl") was very successful. The sculpture, designed in 193 and first cast in 1937, is sold out in an edition of six sometime before th year 1949. (Mandel Brothers Galleries 1949) In the years 1937-40, th figure was seen in several exhibitions, in Chicago, New York City, Philade phia, San Francisco, and at a number of museums in the midwest.

In so far as Judson could control the distribution of these sculpture one had gone to Massachusetts (that it came back to the North Shore wa something she could not anticipate), one had gone to Washington, D.C and one to a neighbor in Lake Forest, Illinois. She planned for one to t part of a monument in the region now known as West Chicago. Sadly, th surviving records don't tell us if she knew that one would go to Savannah Georgia. And, of the sixth, there is no certain knowledge at all.

That she realized the immediate success of the "Bird Girl" is clear. Hov ever, she could not have imagined what would come of this little statu after *Midnight* hit Savannah.

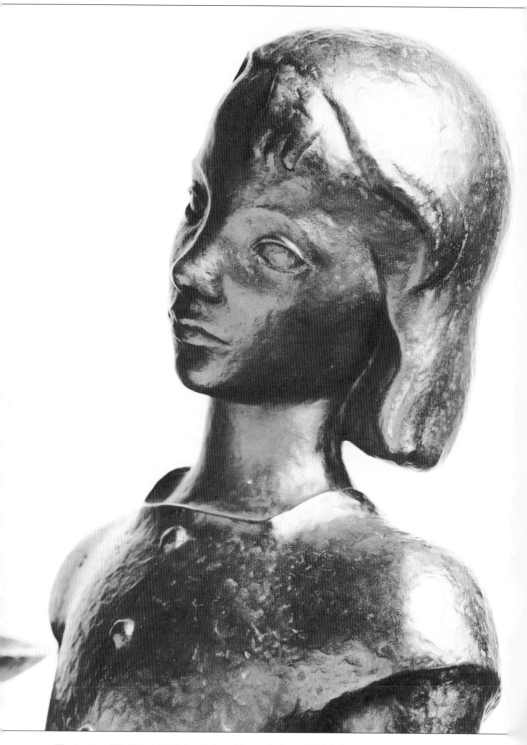

Illustration 13. "Bird Girl" by Sylvia Shaw Judson (1936, bronze), detail. Loaned by the Descendants of Lucy Boyd Trosdal to the Telfair Museum of Art, Savannah, Georgia.

The Original "Bird Girls"

Of the six castings of the "Bird Girl," which is the "original"? Sometimes the Ryerson "Bird Girl" is referred to as the "original," because it was the commission for which the statue was designed, and it has been generally believed that this was the first one cast. We now know that the first casting was in lead, and that statue is now lost. Of the two first castings in bronze, it is likely that one of those was sent to Marion, Massachusetts, to fulfill the commission. However, all of the six castings of this figure made in the life-time of the artist, and at her direction, are considered to be "originals."

Sometimes in the case of multiples, such as prints and photographs, an edition will be comprised of "originals" that are signed and numbered. For example, for a limited edition of thirty prints, each one will be signed by the artist and numbered, "1/30" or "5/30," to show the size of the edition and the place in the sequence when that particular print was made. For editions of sculpture, such as the "Bird Girl," the practices of signing and numbering the works in the edition are rare. Sylvia Shaw Judson did neither.

What do we know of these six "originals"? For two of them, quite a lot. For two of them, not very much. For one of them, nothing at all. And for one of them, a tale of much mystery and considerable speculation. These stories are worth knowing because art objects are often changed by the events of their history. For example, we know some paintings better than others because of who owned them or where they were displayed or be-cause they were victims of some calamity. Here is what is known of the lives of the six "Bird Girls."

The Lead "Bird Girl"

The first of the edition cast, this is the "Bird Girl" with no history at all. It was made, and that seems to be the end of its story. Judson was fond of lead, its color and texture; and she appreciated its association with Arts and Crafts ornament. She seemed prepared for this figure to be cast in either lead or bronze, because, when the statue was first shown, in her one-person show at the Art Institute of Chicago, in July-October of 1938, she listed on the inven-tory form the "sales price" for both lead (at $950) and bronze (at $1,000). But, the lead is missing, and the figure was never again cast in this material.

The Ryerson "Bird Girl"

Judson was commissioned by Mr. and Mrs. Edward L. Ryerson, Jr., to make a statue for a garden at their summer home in Marion, Massachusetts. It was for this commission that the "Bird Girl" was designed, and one of the first two bronze castings of the figure, completed in March of 1938, was delivered to the Ryerson's home in Marion.

Edward L. Ryerson, Jr. was the grandson of Joseph T. Ryerson, the founder of Ryerson Steel Company. In 1929, he succeeded his father, Edward L. Ryerson, Sr., as president of the company and continued a family tradition of civic responsibility and philanthropy. His particular interests were education and the arts, including terms as chairman of the University of Chicago's board of trustees and president of the Chicago Symphony Orchestra.

Ryerson and his wife, Nora, were residents of Chicago, well familiar with the work of Howard Van Doren Shaw. In 1912, Shaw had designed an extraordinary country home for Ryerson's father. Havenwood was the largest of the Lake Forest estates designed by Shaw. Modeled after a Florentine palace, the estate featured an Italian-style formal garden with sculpture that Shaw had selected in Italy for the estate. (Greene 1998, 69)

By 1936, the time of the commission of the "Bird Girl," Sylvia Shaw Judson had been working professionally as sculptor for fifteen years. One work in particular, the "Gardener" of 1929, had received special notice in that same year as the recipient of the Logan Prize in an exhibition at the Art Institute of Chicago. That a commission would come to her from the Ryersons for a garden piece is not surprising at all. She could not have known that it would come to be one of her most successful and most loved creations.

Marion, Massachusetts, is fifty-five miles south of Boston, located on Sippican Harbor of Buzzards Bay. A charming New England town with a history reaching back to 1679, Marion boasts all of the pleasures of seacoast living, with the certain exception of a day in September of 1938, less than seven months after the "Bird Girl" had come here to live in the Ryerson's garden by the side of the sea. This is how Alice Judson Hayes remembers this story:

"There hadn't been a hurricane in New England for many years when, in September of 1938, powerful winds and tremendous tides swept along the coast. There was very little warning. The weather service had not begun the high tech hurricane watches, and nobody knew that this formidable storm was coming until it was already there.

"In Marion, suddenly the boats were dragging. At the Ryerson home, two men struggled out to the yawl anchored in the cove in front of the house to put out extra anchors. The two women in the house took to the second floor because the first floor was rapidly filling with water. Suddenly a huge wave swept the big yawl through the garden and into the woods, carrying the two men who were trying to save it. From a second floor bal-

cony, the women threw over a mattress with ropes tied to it, and the two men swam to it and were pulled in and saved. But the boat was completely wrecked and most of the trees around the house were toppled. When the water went down, the 'Bird Girl' was lying prone in the muddy garden." (Hayes 2005, 4)

The Ryerson "Bird Girl" was a casualty of The Great New England Hurricane of 1938, an event so terrible that it is still remembered in the region. Born in the far eastern Atlantic, the storm gathered fury for twelve days before it crashed ashore on September 21. There were sustained winds of over one hundred miles per hour and storm tides up to twenty-five feet. Damage was extensive. Reported deaths numbered 564, and 1,700 persons were injured; almost 9,000 homes were destroyed, and 15,000 were damaged. Thousands of boats were lost or damaged. But, the Ryerson "Bird Girl" survived. Beaten about by the storm, she had been damaged, but she was repaired and again took up her duties in the seaside garden.

A few years later, the Ryerson "Bird Girl" would make her way back to Illinois, to a country home built by the Ryersons in the Lake County District north of Chicago. In 1928, the Ryersons purchased land along the Des Plaines River, a region of primal woodlands and prairie. First they occupied the land in modest cabins, then they commissioned a friend and architect, Ambrose Cramer, to design a Classical Revival house on the property. True to historic precedents in design, and using salvaged old bricks, floor boards, and fixtures, Brushwood was finished in 1942, looking as it had been there for a hundred years. Ultimately barns were added, and the Ryersons raised dairy cattle, pigs, and Arabian horses. It was an idyllic retreat in which to enjoy and respect the land.

In the 1960s the Ryersons encouraged their neighbors to join them in donating these historic lands to a forest preserve. As a result, there are now 552 protected acres, the Ryerson Conservation Area, a wildlife sanctuary in Deerfield, Illinois, owned by the Lake County Forest Preserves. Trails are open for hiking, and public and school programs are held throughout the year. Brushwood serves now as the Visitors Center. And not far from the entry to the house is the Ryerson "Bird Girl."

Hayes tells this second chapter in the life of the Ryerson "Bird Girl" in this way: "Some years later when the house in Marion was sold, the repaired statue was brought to the family's farm in Illinois to stand in a garden far from the waves of the sea. She stands there under an oak tree whose roots, pushing against her base, have made her slightly tipsy. Acorns fall into her bowls, and she has become more of a squirrel perch than a bird feeder. Now the farm and its adjacent woods belong to the Illinois Forest Preserve District and 'Bird Girl' watches the people who come to hike and birdwatch and see the pigs and cows from behind the old house at Ryerson Woods." (Hayes 2005, 4-5)

The Davidson "Bird Girl"

Of the two bronze castings made in 1938, one went to Marion, Massachusetts, and one was featured in Judson's first one-person show, an exhibition at the Art Institute of Chicago. The show was mounted in July, and, when it closed in October, this group of works began a "Circuit Exhibition," moving to five museums in the midwest (in Milwaukee, Wisconsin; Indianapolis, Indiana; Flint, Michigan; Dayton, Ohio; and Zanesville, Ohio). According to the records for the "Circuit Exhibition," most of the works were shipped from Chicago, but "Fountain Figure" (as the statue was then known) was shipped from New York, suggesting that the first three castings of the figure (one lead and two bronze) had already been placed. (Rich 1938)

In April of 1939, while the "Circuit Exhibition" was at the Dayton Art Institute, the director received a letter from a Mrs. Davidson of Washington, D.C., informing him of her plans to purchase the figure and requesting that it be sent to her from Dayton at the close of that exhibition. (Weng 1939) Sales were important, and welcome, so Judson and the director obliged Mrs. Davidson. But it meant that "Fountain Figure" was not included in the fifth and last show on the "circuit," at Zanesville, Ohio.

Because Mrs. Davidson was a distant relative, Alice Judson Hayes had some reports of the statue over the years. She knew that this "Bird Girl" had gone first to a home and a garden being constructed in the Washington, D.C., area. And she knew that, when that property was sold, a daughter inherited the statue and took it to her home in Reading, Pennsylvania. There it remains in the hands of the original family, well cared for and loved.

The Preston "Bird Girl"

One of the bronze castings of 1938-39 was purchased by Mrs. Frederick A. Preston. Mr. Preston was a lawyer in Chicago, and, in 1948 for their residence, he and his wife secured the property at Ragdale that had been inherited by Theodora Shaw King and renovated by her architect husband. The dwelling was what is now known as the Ragdale Barnhouse, a structure which includes a Greek Revival farmhouse dated to the mid-nineteenth century, joined to later renovations. This structure is historically significant, in a beautiful landscape including the remnants of a formal garden designed by Howard Van Doren Shaw. In all, the home the Prestons enjoyed was quite different from property as Shaw had found it.

Alice Judson Hayes gives this account of the Barnhouse: "When Shaw bought the property, it was a working farm. The brick farmhouse had been built in the late 1830s and is the oldest house still standing in Lake County. In 'Annals of Ragdale,' Shaw described it as 'the most dilapidated thing you ever saw.' He made repairs on the farmhouse and built a new barn, cowshed, wagon shed, and shop to form a courtyard adjoining the farmhouse itself.

He built a limestone dry wall with a wide wooden gate to form the fourth side of the courtyard. For the cupola above the slate roof, he designed a weathervane with an R for Ragdale." (Hayes and Moon 1990, 76)

Into this courtyard came a bronze "Bird Girl," particularly welcome there because she was near "home." By that time, Judson and her husband, Clay, were living year-round at Ragdale. The "Bird Girl" portrayed on the cover of Judson's book published in 1967, *For Gardens and Other Places*, is the Preston "Bird Girl," photographed in this courtyard by Hedrich-Blessing in 1958. Hayes remembers this "Bird Girl" as the most beautiful of the lot, because Mrs. Preston waxed the figure every year to protect it, turning the patina a deep green, almost black. And it was the memory of this statue that would lead her to approve a late casting, years later.

In 1976 Judson gave Ragdale to her daughter, and Hayes began the process of incorporation establishing the Ragdale Foundation as a residence for artists. In 1980 the Barnhouse was purchased for use by the Foundation, and the Prestons and the Preston "Bird Girl" moved away. The statue stayed for a time at a residence nearby, but subsequently it was inherited by a son who took it to his home in Providence, Rhode Island. How a "Bird Girl" returned to Ragdale is told by Hayes in this account:

"I had long wanted a cast of 'Bird Girl' to put back in the courtyard of the Barnhouse at Ragdale. . . . [But, so far as she knew, the edition was complete, and the plaster model and the mold were destroyed. When the plaster model emerged at Crow Island School in the winter of 1994, it was possible to cast the figure in a limited posthumous edition, starting with a bronze for Ragdale.]

"Now I could turn my attention to getting a bronze copy of 'Bird Girl' to put back in the courtyard of the Ragdale Barnhouse. In 1980 the barn was reunited with the rest of Ragdale and became a part of the Foundation. Writers and artists live and work in the two houses and I was eager to have the soothing presence of 'Bird Girl' back where she had stood for so long. . . .

"The foundry on Long Island [Roman Bronze Works] had made a mold and many promises about the time when my copy of the statue would be ready. . . . The day before Labor Day [1996] the telephone rang. Mr. Schiavo [the director of the foundry] was bringing the cast himself. He had hired a truck and a driver and they would be there the day after Labor Day. I was stunned. They arrived late in the evening, unloaded a bronze of 'Bird Girl' in the dark and invited us to have breakfast with them the next morning at the motel where they were staying. After ham and eggs, I went back to Ragdale to savor the 'Bird Girl' who had at last come home." (Hayes 2004, 9, 12)

The Laura Shedd
Schweppe Memorial Fountain

Of all of the known "Bird Girl" lives, this is perhaps the most curious, and certainly the most mysterious. The reference to "The Laura Shedd Schweppe Memorial Fountain, Country Home for Convalescent Children, Princes Crossing, Illinois" appears at the debut of the "Bird Girl" in Judson's one-person show at the Art Institute of Chicago in July of 1938. In the press release for this show, this commission is listed among several others. (Art Institute of Chicago 1938) In various lists kept by Judson over the years, to attempt to track the whereabouts of all of the castings of her works, she associates "Fountain Girl" or "Peasant Girl" with this memorial fountain. In particular, this entry appears in the lists categorized by title, owner, and location compiled in preparation for the 1967 book, *For Gardens and Other Places*, and now in her papers at the Archives of American Art.

In addition to Judson's persistent testimony, there is very good evidence that such a commission was made. The official minutes of the June 9, 1938, meeting of the University of Chicago Board of Trustees reported: "From friends of The Country Home for Convalescent Crippled Children, through Mrs. C. Phillip Miller, $200 to pay for the erection and landscaping of a fountain in memory of Mrs. Charles H. Schweppe. The fountain will be surmounted by a sculptured figure to be executed by Sylvia Judson, which will be paid for by friends of the Home." (Document identified by Daniel Meyer, University Archivist, University of Chicago Library, in e-mail correspondence with the author, January 26, 2005.) In Judson's papers, a drawing survives that shows the "Bird Girl" on an elaborate pedestal, with water flowing from the bowls in her hands down into two tiers of water at the base. No other known installation of this statue was planned as a fountain, although the sculpture was presented in 1938 at the Art Institute of Chicago as "Fountain Figure." But, regrettably, though several have searched, this memorial fountain and its "Bird Girl" are nowhere to be found.

Still, as in most "Bird Girl" matters, the story is intriguing.

Laura Shedd Schweppe was one of two beloved daughters of John Graves Shedd, who began his career as a salesman at Marshall Field Department Store in Chicago. By 1893, he was a partner in the retail operation, and in 1906 he succeeded Marshall Field as president. He is credited with important retail innovations, such as focus on customer service, making purchases by tracing what customers actually bought, and controlling the quality of goods by owning and managing the sources of production. As many of the successful business leaders of Chicago, Shedd was involved in civic service and philanthropy, his particular gift to the city being the Shedd Aquarium.

When Laura Shedd married Charles Schweppe, a banker, in 1913, her father's gift to the young couple was a splendid Lake Forest mansion in the

English Tudor style. A grand home, with generous formal rooms, twenty bedrooms, eighteen bathrooms, and beautiful gardens, allowing for the extravagant entertainment of guests. When Laura Shedd Schweppe died of heart disease in 1937, at the age of fifty-eight, among her many philanthropies was listed the Home for Crippled Children, of which she was "a director." (*Chicago Daily Tribune* 1937a) And when her estate (first valued at $3,250,000, and later valued at more than $5,000,000) was settled, it was reported that one of her substantial charitable bequests was $25,000 to the Country Home for Convalescent Children at Princes Crossing, Illinois. (*Chicago Daily Tribune* 1937b)

The Country Home for Convalescent Children had been established in 1911. It was located in what was then described as a woodland setting, thirty-five miles west of the city, on land given by Richard W. Sears, founder of Sears-Roebuck Company. The home had been designed as a model treatment center for a crisis of the age: children afflicted by tuberculosis, so-called "tubercular boned children." The plan of the Country Home was to provide these children with orthopedic surgeries, programs of physical therapy, then rest, ample sunshine, interesting occupations of handicraft, and excellent food grown in nearby gardens. By 1927, the home was presented by its founders to the University of Chicago, and the "scope of its administration and financing was enlarged and its permanency for all time was assured." (Bennett 1931)

Well, not perhaps for "all time." According to Daniel Meyer, Archivist of the University of Chicago, treatment for tubercular children changed so that it was no longer necessary or advisable to keep them in residential facilities. They could live at home and be cared for with brief hospital stays or as outpatients. So in 1945 the University of Chicago sold the Country Home property, including twenty-five acres, several buildings, and their furnishings, to Wheaton College. (Report to the author by e-mail, January 26, 2005.) According to David B. Malone, Archivist of Wheaton College, that site became the campus of Wheaton Academy, a preparatory school allied with the college since the mid-nineteenth century. And all that seems to remain of a memorial fountain, if it ever in fact existed, is "a reflecting pool." (Report to the author by e-mail, January 24, 2005.)

The region is now in the jurisdiction of West Chicago, and Sally DeFauw, Curator of the West Chicago City Museum, searches still in photographs of the 1930s and 1940s for this lost "Bird Girl." Though she has not been found, it is pleasant to think that once she was there, sharing her sweet spirit with the convalescent children of the Country Home at Princes Crossing.

The Savannah "Bird Girl"

Very little is known about how the Savannah "Bird Girl" got to Savannah. When *Midnight* roared through the city in the spring of 1994, one of the several "interested parties" who contributed bits toward solving "Bird

Girl" mysteries was an elderly gentleman who called with the news that his father, a landscape architect, had helped a widow in Savannah place that statue in the center of a family burial plot in Bonaventure Cemetery. The plan, he said, was for the plot to look like a garden rather than like a cemetery plot. (Telfair Museum Archives [1997a])

"A garden" being the goal, it is not so surprising that a statue by Sylvia Shaw Judson should be contemplated to fill this assignment. By the late 1940s, her works were well known, and most particularly they were well known by landscape architects looking for garden sculptures. Galleries and agents who represented her work were likely to contact these design professionals by sending them photographs of available sculptures. By 1940 there were at least two castings of the "Bird Girl" available for sale, two of them in the inventory of the Arden Gallery on Park Avenue in New York City. (McCauley 1940b)

The involvement of landscape architects in placing her works was valued by Judson and by her agents. From her architect father, who had collaborated with landscape architects and who was considerably experienced himself in the design of gardens, she had learned the value of professional expertise in this matter. This issue is reflected in correspondence she pursued in the fall of 1964, preparing for the coming monograph on her work to be published as *For Gardens and Other Places* in 1967. To Mildred McCauley, a former director of Arden Gallery, Judson wrote: "Perhaps you know of some of my pieces which you sold which had particularly good settings or went to people who would have placed them tastefully." (Judson 1964)

This reply to Judson's inquiry came from a former agent at Erkins Gallery in New York: "Where the figures have been planned by landscape architects you would undoubtedly find them well placed, but that is not always true where an untrained buyer has done the planning. We have had some pretty sad looking examples [of photographs of works in their new homes] sent to us over a period of years, and one of those was one which we had requested for Harriet Frishmuth. After she saw the photograph, she was sorry she had seen it, because it did not do justice to her beautiful figure." (Groskoph 1964. The writer refers to Harriet Whitney Frishmuth, 1880-1980, an accomplished and prolific American sculptor, trained in the classical academic style.)

But a hazard for Judson in selling to landscape architects was that she might not know the destination of the sculpture. Indeed, in Judson's surviving records, there is no report of the sale of a bronze cast of the "Bird Girl" destined for a cemetery plot in Savannah, Georgia.

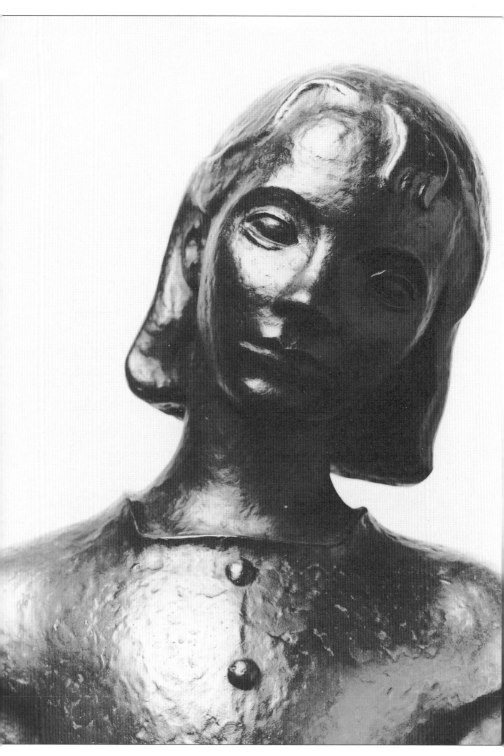

Illustration 14. "Bird Girl" by Sylvia Shaw Judson (1936, bronze), detail. Loaned by the Descendants of Lucy Boyd Trosdal to the Telfair Museum of Art, Savannah, Georgia.

Further Adventures of the Savannah "Bird Girl"

July 1932

Einar Storm Trosdal, Sr., dies and is interred in the family plot in Bonaventure Cemetery, Savannah, Georgia. Born in Oslo, Norway, in 1877, he comes to the port city of Savannah in 1898 where he is employed in the shipping industry. Ultimately, he is president of the South Atlantic Steamship Line and of the Dixie Line. He is credited with bringing national prominence to the shipping businesses of the southeast region of the United States. He is a member of several important Savannah clubs and organizations. In 1904, he marries Lucy Boyd, a native of Georgia, and they have three children, a son and two daughters.

Circa 1938-40

A landscape architect is retained by Mrs. Lucy Boyd Trosdal of Savannah to design the family plot at Bonaventure Cemetery, and a bronze casting of "Fountain Figure" (A.K.A. "Standing Figure," "Girl with Bowls," and "Peasant Girl") is selected as the centerpiece of this plot. The statue may have been seen in New York City at the Arden Gallery or viewed in photographs distributed by Erkins Studios or Grand Central Galleries, both known to have represented Judson's work.

September 1971

Mrs. Lucy Boyd Trosdal dies at age 90. She is remembered in the *Savannah Morning News* as "a cultural leader" in the city. She is active in support of several organizations, including the Savannah Symphony, Historic Savannah Foundation, Armstrong College, libraries, children's homes, and the Telfair Academy of Arts and Sciences (now the Telfair Museum of Art where the "Bird Girl" presently resides on loan from the descendants of Lucy Boyd Trosdal).

1982

John Berendt begins to visit Savannah. Enchanted by the place and the people, he conceives of a book.

1985-1990

Berendt moves to Savannah to write *Midnight in the Garden of Good and Evil,* taping interviews with the Savannah "characters" who will populate his book and conducting research on Old Savannah at the Georgia Historical Society.

July 1993

Jack Leigh, a prominent Savannah photographer, is commissioned by Random House to submit a photograph for the cover of Berendt's book. Berendt suggests Bonaventure as the setting. Leigh spends two nights alone in Bonaventure looking for just the right view. At dusk on the second night, he takes "The Photograph." He submits only this one photograph to Random House, and it is accepted. Random House buys the rights for the photograph from Leigh for the first U.S. edition of *Midnight in the Garden of Good and Evil.*

January 1994

The book *Midnight in the Garden of Good and Evil* is released. The cover photograph plays a significant role in the phenomenal success of the book, although the origin and name of the statue are unknown. In just a few weeks, crowds come to Bonaventure Cemetery looking for the statue of the girl on the cover of "The Book."

March 1994

Tour buses overrun Bonaventure Cemetery, and the statue is now a "photo opportunity" for tourists who are eager to pose with her. Fearing damage to the statue and neighboring grave sites, and concerned for the sanctity of the place, members of the Trosdal family have the statue removed and taken to a family residence a safe several miles away where it is held in seclusion. However, the interest in the statue does not subside.

Spring 1994

Jack Leigh begins a search for the origin of the sculpture.

A visitor to Savannah from Maine reports to one of Leigh's friends that the sculptor is Sylvia Shaw Judson, but this woman escapes without leaving her own name so that she can be contacted. She is later identified as Lee Hagadon, a photographer.

Leigh gets a call from an elderly gentleman who reports that his father was a landscape architect who had helped a widow select and place this sculpture in a family plot in Bonaventure Cemetery.

Gene Davis, reporter for the *Savannah Morning News,* receives a packet of information about Judson from Judy Gummere, a resident of Lake Forest, Illinois, and a librarian at the Lake Forest Library. Gummere

had been visiting Savannah when she recognized the "Bird Girl" from the cover of Judson's 1967 book, *For Gardens and Other Places.*

The sculpture is now identified by artist and date, and by the title of "Bird Girl." Leigh makes contact with Alice Judson Hayes, the daughter of the artist. Hayes is living at Ragdale, now an artists' colony, and Leigh accepts her invitation to visit Ragdale in May.

Spring 1994

With the growing fame of the "Bird Girl," souvenir images begin to proliferate. Wishing to protect the integrity of her mother's invention, Alice Judson Hayes seeks to stop the production of all copies of the image. Ultimately, in 1998, as the holder of the copyright for the image, she consents to the manufacture of three-dimensional reproductions of the statue with the profits to benefit the Ragdale Foundation. These are made in resin in various sizes, but all are smaller than the original sculpture, which is fifty inches tall.

In 2003 Hayes conveys the exercise of copyright for Judson's work to her daughter, Francie Shaw. Shaw, an artist, authorizes a new model for the reproductions made by a laser process that will result in copies which are closer to the original in proportion and surface texture, to be produced in fiberglass.

Other souvenir products abound. Most of these are unregulated by the estate of the artist, because the effort that would be required to control these is too daunting.

December 1994

Sam Joseph, legendary director of window displays at Macy's in Herald Square, and a native Georgian, conceives of a display for Macy's spring garden and flower show, which will feature a "Bird Girl." His attempts to borrow the known bronze statues–in Deerfield and Lake Forest, Illinois, and Savannah–are unsuccessful, so he calls Alice Judson Hayes to see if a new casting can be made. She tells him that the mold no longer exists.

Shortly after Joseph's inquiry, Hayes is called by Betty Carbol, the art teacher at the Crow Island School, a public elementary school in Winnetka, Illinois, a Chicago suburb. Carbol has the news that the school has the original plaster model of the statue. The plaster is loaned to Hayes, who sends it to the foundry in New York City to make a new mold, and she authorizes a limited edition of posthumous casts. First, two plaster casts are made. One is delivered to Sam Joseph at Macy's and painted to resemble weathered bronze for presentation in the window display. One plaster cast is returned to the Crow Island School to replace the original plaster model.

Spring 1995

The plaster cast of the "Bird Girl" painted to simulate bronze is displayed in the window at Macy's, with beds of flowers. It is a great success, drawing huge crowds. Following this display, this plaster is returned to Alice Judson Hayes.

November 1995

Jack Leigh negotiates with Hayes to buy the Macy's "Bird Girl." He commissions a diorama in which the statue is featured, recreating the famous photograph. It is Leigh's desire to fill the void for the waves of tourists who continue to seek the "Bird Girl" but are disappointed because she has been removed from Bonaventure Cemetery. The diorama is unveiled as a display at the Savannah History Museum at the Visitors Center.

September 1996

The foundry delivers to Ragdale a bronze casting of the "Bird Girl" commissioned by Alice Judson Hayes.

May-July 1997

Clint Eastwood shoots his film version of *Midnight in the Garden of Good and Evil*. For the film, permission to make another copy of the "Bird Girl" is gained from Alice Judson Hayes, on condition that it be returned to her. This fiberglass copy appears in the opening and closing scenes of the film, sited in Bonaventure Cemetery, and in publicity materials.

July 1997

The descendants of Lucy Boyd Trosdal offer the Savannah "Bird Girl" as a loan to the Telfair Museum of Art. A conservator is retained to evaluate the sculpture. Although the statue has been out of doors in Bonaventure Cemetery for almost sixty years, she judges the work to be in generally good condition, with some areas of corrosion. She cleans the work, removes the corrosion, and waxes it to prepare it for museum display.

August 1997

The Savannah "Bird Girl" debuts at the Telfair, and her grateful fans come by the dozens and the dozens of dozens to see her there.

August 1997

Eastwood's movie version of *Midnight in the Garden of Good and Evil* is released. Francie Shaw, the artist's granddaughter, is visiting London at the time of the release of the film. Posters for this film are every-

where, particularly in the subway system (known in London as the Tube or the Underground). She knows that the fiberglass copy has been shipped to Warner Brothers in Los Angeles in good condition; but she notices that, in the posters for the film, the arms of the figure are clearly reversed. Apparently the arms have broken in transport or use, and they have been reattached in reverse with the thumbs in front, quite contrary to human anatomy.

2000

The film copy of the "Bird Girl" is returned to Alice Judson Hayes, who presents it to the Cliff Dwellers Club in Chicago. The Cliff Dwellers is a private club of members who have a serious interest in the arts. Howard Van Doren Shaw was a charter member of the club and the designer of the Arts and Crafts room on top of Orchestra Hall where the club met for most of its history.

Today

The Savannah "Bird Girl" remains at the Telfair Museum of Art, on loan from the descendants of Lucy Boyd Trosdal. Named by the City of Savannah Convention and Visitors Bureau as one of Savannah's "Unique Icons," she is visited daily by legions of her admirers.

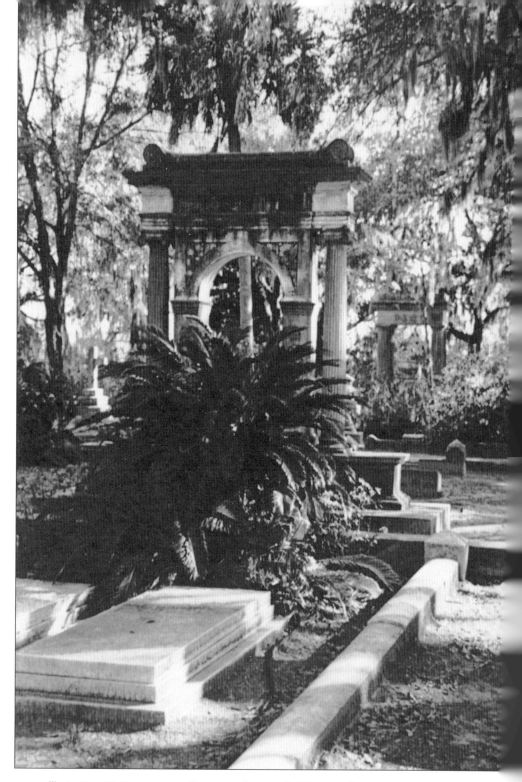

Illustration 15. Bonaventure Cemetery, Savannah, Georgia. General view.

"Little Pagan Rain Song"

By Frances Wells Shaw

In the dark and peace of my final bed,
The wet grass waving above my head,
At rest from love, at rest from pain,
I lie and listen to the rain.

Falling, softly falling,
Song of my soul that is free;
Song of my soul that has not forgot
The sleeping body of me.

When quiet and calm and straight I lie,
High in the air my soul rides by:
Shall I await thee, soul, in vain?
Hark to the answer in the rain.

Falling, softly falling,
Song of my soul that is free;
Song of my soul that will not forget
The sleeping body of me.

For over fifty years, the Savannah "Bird Girl" tended those who slept in Bonaventure Cemetery. This poem by Frances Wells Shaw (1872-1937), the mother of Sylvia Shaw Judson, evokes the grace of that bronze statue as she carried out her duties. Here, in the spirit of Arts and Crafts, Shaw uses the word "pagan" in its original meaning as "someone from a small rural village."

The poetry of Frances Wells Shaw appeared in the *Ragdale Book of Verse* (privately printed, Lake Forest, Illinois, 1911), in various editions of *Poetry* magazine edited by Harriet Monroe, and in a number of anthologies. "Little Pagan Rain Song" is printed here by permission of Alice Judson Hayes.

Illustration 16. Bonaventure Cemetery, Savannah, Georgia.
White marble monument, detail of angel.

"Little Wendy"

He had never seen her there before. That was the report of Jack Leigh, who took the famous photograph of the "Bird Girl" in Bonaventure Cemetery. He had been commissioned by Random House, the publisher of John Berendt's book, to provide a photograph for the cover. The title, *Midnight in the Garden of Good and Evil: A Savannah Story*, suggested Bonaventure Cemetery, a location that played an important role in Berendt's book. So it seemed a right course of action to go there. But Leigh would say later that he wandered around Bonaventure for days, looking for just the right image. And he knew Bonaventure. He was a native of Savannah, and friends and family members were buried there. It is an irresistibly picturesque place, and he had photographed there many times before.

But it was late in the day, at dusk, on the last day and at the last hour. There she was. "I knew I had something," he would later say.

And why hadn't he seen her before? In this story, that is a question worth pursuing, and it involves the matters of why, when, and how this statue found its way to Bonaventure Cemetery.

There are no surviving records that tell us how this casting of the statue later known as the "Bird Girl" came to Savannah. Of the six castings of this sculpture, provenance (or ownership) is known in three cases (the Ryerson, the Preston, and the Davidson "Bird Girls") and may be speculated in one case (the Laura Shedd Schweppe Memorial Fountain). From the dates of the design of the sculpture and the six castings, we may surmise that the copy destined for Savannah was one of the two bronzes in the inventory of the Arden Gallery in New York City in 1940, so it is likely that the earliest date by which this sculpture came to Savannah was 1940.

The next clue comes from a note that survives in the archives of the Telfair Museum of Art, which may be dated to the autumn of 1997, when the descendants of Lucy Boyd Trosdal offered the statue on loan to the museum. The quickly scrawled note records the contact that Jack Leigh had in the spring of 1994 from an elderly gentleman. The gentleman said that his father, a landscape architect, had helped a widow in Savannah select and place this statue in Bonaventure Cemetery. He said that the statue was posed in the center of the plot, as the memorial centerpiece of

the space, and that the intention was for the area to look like a garden. A name is given: Mr. Bingantt. (Telfair Museum of Art Archives [1997a])

That explanation of how this "Bird Girl" got to Savannah makes perfectly good sense. Sylvia Shaw Judson's works were well known to landscape architects. Her specialty was, after all, statues for garden ornament. Garden sculpture was a popular specialty in the 1920s and 1930s, and notices of this genre of artwork were often featured in magazines and newspapers of the time. If the intention of the Savannah project was to give the aspect of a garden, a landscape architect would know where to find sculptures of an appropriate type.

What is next known is that Mrs. Lucy Boyd Trosdal, widow of Einar Storm Trosdal, Sr., chose a bronze casting of this figure, probably advertised by the title "Peasant Girl," to grace the family plot at Bonaventure Cemetery where her husband had been interred in 1932. And what follows here is entirely conjecture. For good and right reasons, the descendants of Mrs. Trosdal prefer not to speak of the events of early 1994 and what has emanated from them. Other than to affirm that Mrs. Trosdal selected this little statue as the memorial figure for a family burial plot to honor her husband. And that she came to call the figure "Little Wendy," in a reference to Wendy Darling of J. M. Barrie's famous stories of Peter Pan.

Most of us have had or will have the sad responsibility to select funeral monuments. Styles of monuments change over time, but within any given era, the choices are usually fairly predictable. Bonaventure Cemetery is essentially a Victorian cemetery, characterized by dense planting and heaving monuments of marble and granite. The extraordinary character of Mrs. Trosdal's selection of this statue by Judson can best be understood after a visit to Bonaventure Cemetery.

Bonaventure is just three miles east of the downtown district of Savannah. The cemetery is located on a bluff overlooking the Wilmington River, a beautiful site settled in 1760 by John Mulryne, an English colonel. He built a grand plantation house here and named the site Bonaventure, or "good fortune." By 1846 the house had burned, and six hundred acres of the old family estate were sold to a Savannah businessman who planned to turn seventy of those acres into a public cemetery. In 1868 the Evergreen Cemetery Company was formed, and the sale of burial lots commenced. In 1907 the Evergreen Cemetery of Bonaventure, as it had come to be known, was purchased by the City of Savannah, which continues to administer this facility.

Very often immodestly referred to as one of the most beautiful cemeteries in this country, Bonaventure is perhaps the most perfect setting for a Victorian graveyard. In those years of the second half of the nineteenth century, during the reign of Queen Victoria, Bonaventure began its life as a public cemetery. Victorian cemeteries are characterized by beautiful park-like settings, filled with elaborate monuments where the families of the deceased came often to stroll in this "park" and to visit the graves where loved ones "slept."

Bonaventure is sometimes described as a natural "cathedral," and the description is apt. Along the allées, or pathways, the live oak trees, in their unique way, stretch their arms over the paths to form arches. Draped from the arms of these trees are veils of Spanish moss, like the tapestries of old churches. The light is broken by the dense foliage of the trees and is caught in the landscape as bits of light, scattered and shifting, in the manner of old stained glass. And for a time in the spring, the place is painted by the bloom of twenty-seven miles of azaleas. Bonaventure is as beautiful a room as nature has ever made.

Characteristic of the Victorian cemetery is the profusion and individuality of funeral monuments. There are vaults and slabs and markers of all sorts, some with elaborate ornament; columns and obelisks; and figurative sculpture, very often angels who weep or angels who don't weep, and sweet children. Almost without exception, these are marble and granite monuments, polished white or colored surfaces that catch the light as it slips through the dense canopy of the live oak trees.

Into this setting, probably sometime around 1940, came a bronze statue of a child. It was, by its size, modest in proportion to other monuments. And the bronze, in the sultry climate of Savannah, would weather and darken. There was nothing in the character of this figure, in her appearance or her demeanor, to make her stand out in the neighborhoods of Bonaventure. She was, as good garden sculpture is, intensely private. And very likely that is a reason why she was chosen for this place.

Mrs. Trosdal christened the statue "Little Wendy." Of her personal reasons for doing this, we cannot know. But even if the family had not confirmed that the reference was to Wendy Darling of the Peter Pan stories, it would be easy to guess. In the early 1940s, "Wendy" was an unusual name, and it was generally credited to the figure invented by J. M. Barrie, a Scottish writer of novels and plays. The legend of Peter Pan first appeared in 1904, in a performance of a play by that name in a London theater. In the immensely popular novels that followed, we would come to know Wendy Darling, the child who is persuaded by Peter to accompany him and her brothers to Neverland, where she will become a "mother" before her time to the Lost Boys. Wendy comes to symbolize a child of extraordinary sweetness and caring, whose duty it was to watch over others.

Popular legend has it that her name came from a child friend of Barrie's, little Miss Margaret Henley. Margaret called Barrie her "friendy," but in her baby-speak and absent good r's, the word became "fwendy." She died at the age of six in the late 1890s, to be memorized in Barrie's tales as Little Wendy. From the first appearance of the stories, Wendy became a popular name, clearly associated with the magical tales of Peter Pan.

The family memories of this sculpture as the centerpiece for this burial plot are private. For the most of the rest of us, the presence of this sculpture in Bonaventure Cemetery is evoked only in "The Photograph" taken by Jack Leigh. Quickly following the phenomenon of "The Book," mobs of

tourists descended on this gravesite. Tourists taken individually are usually fine people; but, when gathered in untoward numbers, they become mobs. Huge crowds swarmed this place, disturbing the quiet and threatening the well being of the gravesite and its neighbors.

"Little Wendy" was spirited away by the family. Carried to safety and sequestered at a family residence several miles away, the statue remained there for three years. But interest in the figure did not diminish; and speculation continued, in the press and on the Internet, about where the "Bird Girl" had flown. When the location at a family home seemed no longer safe, the sculpture was given over, on loan, to the custody of the Telfair Museum of Art in Savannah, where she could be cared for, protected, and allowed to meet her scores of admirers.

What accounts for the fame of the Savannah "Bird Girl," as she would become known in the press? Art is made of surprises. We are surprised (and titillated) by the stories John Berendt had to tell about Savannah. And we are surprised by the little statue Jack Leigh found in Bonaventure Cemetery. This figure startles us, because it would seem that she really didn't belong there. She was, after all, a garden statue, relatively small in stature compared to the ordinary occupants of Bonaventure, the looming live oak trees draped in Spanish moss and the rows and rows of stone mausoleums and monuments. And she was a dark green, the bronze patinated by the years and weather, by contrast to the glittering white of the marble and the rich tones of granite of the other funeral monuments. And she was, by her nature, shy and sweet in disposition, not given to grief and wailing. She was, by her size and her color and her spirit, utterly apart from all around her.

So when Jack Leigh came upon her, he did make a discovery. It was the revelation of an extraordinary decision that had been made many years before by Mrs. Lucy Boyd Trosdal to honor her husband who had died some years before and was buried there, in Bonaventure Cemetery.

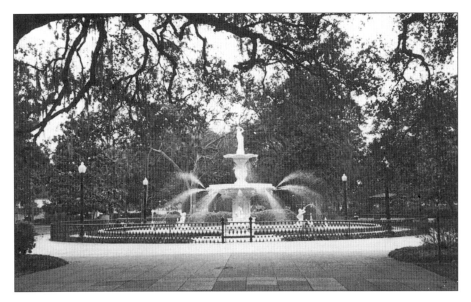

Illustration 17. Forsyth Park Fountain (1858, cast iron), Savannah, Georgia. Manufactured by Janes, Beebe and Company of New York, this fountain is now one of the best-loved monuments in Savannah and an emblem of the city.

The Second Siege of Savannah: "The Book" and "The Photograph"

In December of 1778, the British captured Savannah, to draw the territory back into the Loyalist camp. Over the next several months, American and French forces gathered to retake the strategic area. In October of 1779, the Siege of Savannah began. It was a bloody battle, with hundreds of allied casualties, against fewer than twenty English troops dead. The allies were forced to retreat, a terrible setback in the cause of the Revolution. But, in time–in two years, to be precise–Savannah and the nation would prevail.

In January of 1994, Savannah was assaulted by "The Book." The blow was tremendous. "The Book" has been described as "a love letter to Savannah," but it was a most peculiar way of making love. Savannah had been described in 1946 by the sharp-tongued Lady Astor as "a beautiful lady with a dirty face," but the city had rallied, reclaimed her priceless architectural heritage then in danger of being lost. She was now, again, beautiful. But now someone (a Yankee, of course) had come to town and peeped up her skirts.

In polite neighborhoods, it is still right to confess that you have never read "The Book," or that you read it so long ago that you have forgotten it altogether. And the good people of Savannah, of whom there are very many, will tell you that the unsavory tales told in "The Book" say very little about the good people of Savannah.

In fast summary, John Berendt, a journalist from New York City, sometime associate editor at *Esquire* and sometime editor of *New York* magazine, began to visit Savannah in 1982. He was charmed by the beauty of the city and fascinated by the people he met and the stories he heard. In 1982 he met, among others, Jim Williams, a prominent dealer in antiques and restorer of many of the structures in Savannah's historic district. In the prior year, Williams had been charged with the murder of a young man who worked for him as a handyman and who was also, as it happened, his sexual partner. Over the next several years, there would be four murder trials, two convictions overturned on appeal, a hung jury, and finally an acquittal in 1989. That murder and the astonishing array of curious folk whom Berendt met, in the delightful environment of Savannah's lush landscape and incomparable architectural heritage, led him to conceive of a book. It would be a nonfiction report of this delicious setting and these engaging characters against the drama of the murder trials.

"The Book," as it is now known in Savannah, hit the streets in January of 1994. Almost immediately it made its way onto *The New York Times* bestseller list, where it sat for a record number of 216 weeks.

The specific content of "The Book" bears no relationship to the "Bird Girl." She was not known to Berendt, and she played no role in his narrative. He met her first when he was offered the opportunity to review the proposal for the cover of his book. He told that story to Brian Lamb at a "Booknotes" interview on C-SPAN in August of 1997. In the direct and unvarnished way of shaping an interview for which Lamb is much admired, he posed as one of his first questions to Berendt: "What is this on the cover?"

And Berendt replied:

"That's a statue in Bonaventure Cemetery in Savannah, and it's in a family plot. . . . When Random House was designing a cover, I said, 'You ought to take a look at Bonaventure Cemetery, one of the most beautiful places in the world.' So they sent a local Savannah photographer out there. I thought that was very good karma. Here I was, a New Yorker. I'd come down to Savannah, written a book about Savannah and gone back to New York. And for Random House to select photographer from Savannah I thought was great because it allowed Savannah to have some creative input into the book.

"Anyway, he went out to Bonaventure Cemetery for two days looking for something that captured his interests and he found this girl on the second day. He had a very, very tight schedule. . . . And he saw her and he took her picture, and he did funny things in the darkroom to make her stand out, and it's a magically, seductively beautiful photograph. It's myste-

rious. It just captures exactly what I would've hoped for in a cover. . . . I was worried that I would see a cover that was OK, that I couldn't reject but that wouldn't help the book. This cover is sensational, beautiful, wonderful cover. I couldn't have hoped for anything better. . . .

"There's certain things that make you buy a book. . . . You go to a bookstore and you hold the book . . . The cover might tip the balance." (Lamb 1997)

Interviewed in January of 2003 by a reporter from Australian radio, Jack Leigh told his story, in the following way:

"I had to make a decision because I knew too many people in the book and I felt an allegiance to a lot of the people that John [Berendt] had written so truthfully about. I didn't think the things John had written were untrue, I just thought they weren't very flattering about a lot of people that I knew and I thought the book was going to cause some degree of difficulty in Savannah.

"And I'm a Savannahian and I've got great loyalties here and my support system is here, and if I do this image for this book, and of course none of us had any idea what the book was going to do, I mean it was still an unknown, and if I do this image and the book is labeled a horrible thing for Savannah in the future then I would have participated in something that's maybe not so good. But then I thought what I will do is that I will create something born of my soul and my feelings for Savannah." (Sales 2003)

Within a few weeks, the tourists were coming in droves. And, as droves are likely to do, they swept through Savannah with a mighty roar, determined to see the *Midnight* sites: have breakfast at Clary's Café, gawk at Mercer House, saunter along River Street, and, always, journey to meet the little bronze child on the cover of "The Book." Quite unlike the British forces in 1779, the good people of Savannah had not secured the ramparts before the Siege began. Some natives thought, in the way that Savannah natives are likely to think, that one should not reward bad behavior with any attention at all; but rather, one should ignore it. But, as a general plan, ignoring did not work, particularly in the case of the little bronze statue. At Bonaventure Cemetery, lines of pedestrian pilgrims turned into caravans of cars and then into hordes of heaving buses. It was more than the statue and her family could bear, so she was spirited away, to safety.

Slowly, and filled with trepidation, Savannah natives came to realize that when you are handed lemons, you should just add them to the Chatham Artillery Punch for which Savannah is justly famous. A *Midnight* tourist industry was growing, to the very substantial economic benefit of the city. But now there were at least a couple of impediments to a very satisfying Savannah tourist experience. The city was just as beautiful as Savannah had ever been, which is to say, very beautiful, indeed. But on the *Midnight* side of things, there were these problems: The little statue was gone, nowhere to be seen; and no one knew who had made her. What we had here was a missing orphan, a situation of yawning sadness and regret.

Alice Judson Hayes remembers what happened next:

"Jack Leigh had been searching for the name of the sculptor, and, by a strange chance, the identify of the artist was revealed just a month or so after the book came out. It happened like this.

"After my father died, my mother married an English Quaker [Sidney Haskins], and, when my mother died fifteen years later, my stepfather married a woman whose photographer daughter, Lee Hagadon, lives in Maine. Because her stepfather [Haskins] happened to have been married to my mother, Lee owned a copy of the book, *For Gardens and Other Places: The Sculpture of Sylvia Shaw Judson*, published in 1967 and long out of print. On the paper cover of this book, there is a beautiful photograph of 'Bird Girl' surrounded by pots of geraniums in the courtyard of the Ragdale Barn.

"Lee went to Savannah in the spring of 1994, to visit friends. She went into an antique shop to look around. The woman who owned the shop was a friend of Jack Leigh's, and she had an original signed print of the photograph on the cover of *Midnight in the Garden of Good and Evil* hanging prominently on the wall of her shop. When a surprised Lee saw a photograph of 'Bird Girl' hanging on the wall of an antique shop in Savannah (Lee had not yet heard of *Midnight*), she said, 'Why, that's a picture of a statue by Sylvia Shaw Judson!' It was the first time Savannah had heard her name. But, Lee went back to Maine without saying anything more.

"Then one day a package came from Lake Forest, Illinois. Judy Gummere, who works in the Lake Forest Library, had been in Savannah and had learned about the mystery of the unknown sculptor. When she got home, she collected everything she could find about Sylvia Shaw Judson and sent it off to Savannah. . . . Jack Leigh called me up just as soon as he opened the package." (Hayes 2004, 7-8)

So began a friendship between a Savannah photographer, grateful for the part that a little bronze statue had played in his very successful photograph, and the artist's daughter, grateful for the opportunity to nourish her mother's professional name and reputation. Soon they would meet, in May of 1994. Hayes says:

"I was living in the log cabin at Ragdale which my mother had bought from the '33 World's Fair in Chicago. It was an old Indiana cabin, which had served its purpose as a replica of Lincoln's Indiana home. My mother bought it to use as a studio at Ragdale at a time when she still lived most of the time in the city. She added a bathroom and kitchen when the cabin was moved, and since everything was being sold for a song as the World's Fair was dismantled, she was able to buy the plumbing from Sally Rand's dressing room for the new cabin bathroom. I was just bushing my teeth in Sally Rand's washbowl one hot morning in the early summer of 1994 when Jack Leigh called to find out if there was a bronze 'Bird Girl' in Lake Forest that he could photograph." (Hayes 2004, 8-9. The reference is to Sally Rand, 1904-79, who had come to prominence at the 1933-34 Chicago Century of Progress world's fair with her first performance of the

legendary "fan dance," which involved just Sally and two very large ostrich feather fans.)

Hayes invited Leigh to visit Ragdale in May. He came to stay at that pleasant place for several days, photographing the house and grounds and the two "Bird Girls" who lived nearby. Hayes has fond memories of Jack Leigh and a high regard for his work as an artist. She was sad with all of Savannah when he died in the spring of 2004.

In June of 1994, Leigh wrote to John Berendt:

"I have just returned from a most remarkable journey to Lake Forest, Illinois. I visited the home and studio of Sylvia Shaw Judson and spent a lovely evening with Sylvia's daughter, Alice Ryerson Hayes.

"In a secluded log cabin, set a distance from the main house named Ragdale by Sylvia's architect father Howard Van Doren Shaw, Alice and I had dinner and sat and talked for hours in front of a slow burning wood fire. We covered much territory–her mother's sculpture, the phenomenon of The Book in Savannah, the curious paths that led me to that remote spot in Bonaventure as well as to seek and find the sculptor of the statue.

"The visit to Lake Forest was a culmination of sorts for me. Yes, I did see and photograph the 'other two' statues [the Ryerson and Preston "Bird Girls"], but much more happened there than that. Ragdale is now a retreat for writers and artists. Alice having been its founder and a noted poet herself. I found myself within not only this family's incredible history, but also within the history of all those who have come to Ragdale to consort with their muse. Each of the numerous rooms there had bedside diaries replete with soulful jottings of the struggle to create. It was vastly reassuring." (Leigh 1994)

Jack Leigh is remembered for much more than just "The Photograph," but why and how he did his work bears on the story of his experience with the bronze statue in Bonaventure Cemetery. Leigh was drawn to the people and the landscape of coastal Georgia and South Carolina. But his "eye" was joined to his heart. By his photographs, he intended to show respect to his subjects, and that often meant gaining their trust before he raised his camera. This is the tale told of his first book, *Oystering–A Way of Life,* published in 1983:

"In his spare time, Leigh would travel back roads throughout the South. It was during these early days that he stumbled upon the South Carolina oystering community.

"He spent two years immersing himself in this dying world, setting out at 3 a.m. in long wooden skiffs and living for the better part of a year in a cannery, winning the trust of the oystermen.

"But the women who worked in the shucking house were wary. Another photographer had documented them covered with slime several years before, and they felt the images in the book that resulted were degrading. They wanted an apology from the other photographer before allowing Leigh to capture their images.

"Leigh hunted the photographer down, secured the apology, and the pictures he took later became some of the most joyful." (Bell 2004)

Of "The Photograph," Leigh said: "The essence of the photo was to honor the statue, the location and Savannah. . . . I'm not out to cause anyone harm or injury." (Downs 1994a) That "The Photograph" would result in the flight of this little statue from Bonaventure was a great regret to him. On balance, "The Book" and "The Photograph" had brought welcome attention and economic success to the city. And, for his own part, he said:

"You can't imagine, I mean, a struggling photographer trying to make ends meet. Economically it's not easy . . . in any realm of the arts, it's not easy to manifest your vision and make a living at the same time, and so *Midnight in the Garden of Good and Evil* has made my professional life a lot more viable." (Sales 2003) Still, in his heart, what he had hoped most to do was to bring honor to the community that he loved.

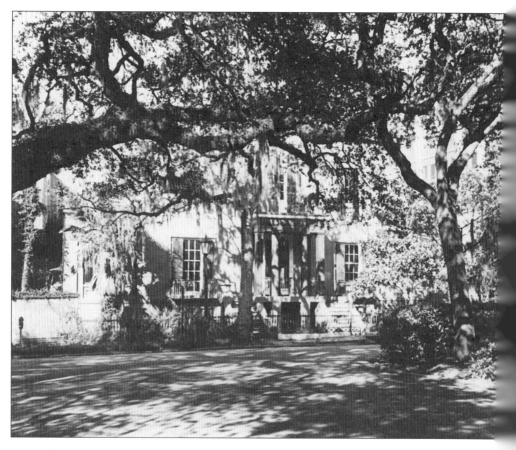

Illustration 18. Sorrel-Weed House (1841) at Madison Square, Savannah, Georgia. One of many beautiful historic houses on one of the twenty-one surviving public squares in the Historic Landmark District of Savannah.

Copyright: Protecting Art

Who owns the right to copy the "Bird Girl"? On some sunny Savannah mornings, it seems that everyone in the entire world does. She has appeared as or on the most astonishing array of goods: bookmarks, bottle openers, lapel pins, doormats, tote bags, Christmas ornaments, coffee mugs, tee shirts, and more, and more. The "favorite" (in the category of "most alarming use of the image") of Sylvia Shaw Judson's daughter, Alice Judson Hayes, is the "Bird Girl" candle. You light the wick on her sweet little head, and, in a few hours, all that is left is a daub of wax.

The answer to why these goods proliferate is easy. When we are so charmed by an image, we are glad to be reminded of it. It is the very meaning of the word "souvenir." But who has the right to use and market this image?

An artist holds the copyright to his or her invention, and may assert that the image cannot be copied or used without permission. In Judson's case, the copyright for the "Bird Girl" is held by the artist's estate, which at her death passed to her daughter, Alice Judson Hayes. In recent years Hayes has transferred that authority to her daughter, Francie Shaw, an artist, who now manages the issue of copyright, including the production of authorized copies and reproductions. By every legal right, Shaw should be consulted to approve or deny use of the image for every doodad that proposes to "quote" the figure.

In the early months of the proliferation of "Bird Girl" stuff, Hayes determined to put a stop to it all, wishing, quite reasonably, to protect the integrity of her mother's invention. She contemplated legal action against all of the manufacturers of "Bird Girl" stuff, and quickly saw that the task was too daunting. "I would have to spend all of my time with lawyers to get this done," she says. So she limited her concern to the manufacture of what can most certainly be judged to be copies of Judson's invention, "Bird Girls" produced as freestanding figures, usually marketed as garden ornaments. As in many things, a good offense is better than an earnest defense. She consented to the production of "authorized reproductions" in several sizes, governing the development of the image so that it was respectful of the original work and supervising the manufacture so that the products were well made. The story of that production is told elsewhere, because it is yet another curious chapter in the adventures of the "Bird Girl."

But what about photographs? Who can photograph and benefit from the photograph of a work of art?

The right of access usually governs who can photograph a work of art. If the art stands on private property, access is granted only to those who have the permission of the property owners to enter. And if a photographer wishes to photograph an artwork in that setting, the owners must grant permission. Once the photograph is taken, the photographer, whose own work is a creative product, owns the rights to the photograph. If the maker of the art object is known, it is conventional for the photographer to acknowledge the person who made the work of art.

If an art work is secured in a museum, as the Savannah "Bird Girl" now is at the Telfair Museum of Art, right of access is granted by the museum. You can come to see the "Bird Girl," provided that you come during the appropriate hours and pay the admission fee and mind your manners. But you cannot photograph her without the permission of the museum; and that permission is usually granted only when the museum estimates that no harm will come to the art object and that the portrayal of the object will be of benefit to the museum, usually by bringing notice to the museum and its collections and programs.

All art museums do (or should) restrict photographs. In part because it is a nuisance for other patrons. In part because, when flash is used, some artworks may be damaged by the powerful light. And in part because a museum holds as its treasure those works in its custody (either owned by the museum or on loan to it). The museum may benefit financially from the use of its own reproductions of these treasures in advertising campaigns or, increasingly, in the manufacture of reproductions for sale, such as prints and note cards.

If the artwork stands on public property, access is not at issue. A photographer may take credit for the photograph, although most would agree that recognition should be given to the artist if he or she is known. In the case of the Savannah "Bird Girl," as she stood in Bonaventure Cemetery, there was free access. The cemetery is owned by the City of Savannah, and access is restricted only by the maintenance of hours of operation. Actually, Jack Leigh took the now famous photograph "after hours," having gained permission from cemetery officials to remain on the property after closing.

As was his right to do, Leigh copyrighted his photograph of the statue as he "discovered" her in Bonaventure Cemetery. He could claim both the "discovery" of a particular view found by his "eye" and the unique characteristics of the print of that photograph as he resolved those matters in his darkroom. Initially he did not identify and credit the sculptor, because the statue was unsigned and the artist was then unknown in Savannah. To Leigh's credit, soon after "The Photograph" appeared on the cover of "The Book," and the interest in the statue began to grow, he set about the task of trying to identify the sculptor.

Leigh sold the right to reproduce his photograph to the publisher, Random House, for use on the cover of the first U. S. edition of "The Book." He negotiated the sale of this right on each subsequent edition and on all other English and foreign language editions that used this cover photograph, as many did.

When Clint Eastwood filmed his version of Midnight in the Garden of Good and Evil, the opening and closing frames of the movie rested on the "Bird Girl." Well, actually not "the" Savannah "Bird Girl," because she was by then in hiding. Eastwood secured permission from Alice Judson Hayes to have a copy fabricated for use in the film, or, as they say in Hollywood, a "stand-in." She was posed in Bonaventure Cemetery (but, graciously, not at the Trosdal family site). And images of the "Bird Girl" in her cemetery setting were used liberally in promotion materials for the movie.

This was an interesting conception for the filmed story, that these powerful and important opening and closing frames of the film should rest on this statue in this setting, because the "Bird Girl" had played no role at all in the narrative of "The Book." Eastwood's decision to use her in this way was clear testimony to the influence of "The Photograph" as a kind of metaphor for the themes of "The Book."

At the "official" Website for the film, an interview with Henry Bumstead, the production designer for the movie, tells about the use of the "Bird Girl" in the film. He says: "Illinois artist Sylvia Shaw Judson sculpted the Bird Girl in 1938. After extensive research, we found out there were only three Bird Girls in existence. . . . The model of the Bird Girl was in Chicago, and after negotiations, it was shipped to Warner Bros., where we made a copy. The model had no base, so we put on a base to match the one that was originally in Bonaventure Cemetery. The statue [the film's copy] probably cost $5,000-$6,000. It was beautiful, it matched exactly, and we were able to shoot it in the cemetery and got a beautiful shot in backlight, like the cover of the book. Worked out great." (Bumstead 1997)

Bumstead's account captures the spirit if not the entire truth of this "Bird Girl" adventure. The "Bird Girl" was designed in 1936, not 1938. And four "Bird Girls" were known in 1996-97, not three. None of the four "Bird Girl" owners were willing to lend their statues to the film company, so permission was gained from Alice Judson Hayes to have a copy made. This fiberglass copy was made in Chicago, under her supervision; and the agreement with her was that the copy would be used only in the movie and returned to her following the filming. (Hayes 2005)

And, while these might be construed as simple errors of the facts of this story, the comment that signaled a potential problem for Warner Brothers was this observation by Bumstead: "It [the film's copy of the statue] was beautiful, it matched exactly, and we were able to shoot it in the cemetery and got a beautiful shot in backlight, like the cover of the book." Like the cover of the book, a photograph owned and copyrighted by Jack Leigh.

In November of 1997, Leigh sued Warner Brothers for copyright infringement, claiming that the film company had stolen his image and used it without credit to him in two sequences in the film and in promotional materials. In part, the suit was based on the generative role of Leigh's photograph in associating the image of the "Bird Girl" in Bonaventure Cemetery, portrayed in a mysterious and evocative light, with the themes of "The Book." Were it not for Leigh's photograph, the "Bird Girl" would not have been associated with John Berendt's story.

Leigh's suit and the resolution of it are important elements of the story of the "Bird Girl," because these issues bear on the whole matter of protecting artistic invention and the question of who should be allowed to benefit from the use of this invention.

In the first rounds of Leigh's contest, he did win a judgment of an undisclosed sum when Warner Brothers admitted that a close view of the "Bird Girl" taken from Leigh's photograph had been used at the Website promoting the film. But the district court ruled that copyright did not extend to ideas, so Leigh's conception of associating the statue in this setting with Berendt's story was not protected. Also Leigh did not own rights to the statue or to its setting. Leigh couldn't claim as protected elements of the image either the background of Bonaventure Cemetery or the pose and expression of the statue by Sylvia Shaw Judson. Nor could he claim copyright protection for the "eerie mood" of the photograph, as that was an element usually associated with statues in cemeteries. Further the court ruled that Warner Brothers had obtained the rights to copy the statue from Judson's heir, Alice Judson Hayes; that the statue had been filmed in a location in the cemetery other than at the Trosdal plot; and elements of viewpoint, lighting, and atmosphere were different from Leigh's photograph. (LaPeter 1999)

Leigh pursued the matter at the Court of Appeals for the Eleventh Circuit. In May of 2000, this court found that, while Leigh had no right to the "idea" of associating this image with the story, and he had no right to the appearance of the statue or the cemetery, he could claim rights to the "expressive elements of craft," and those included the composition of the elements shown in the photograph, the angle of view chosen, and the use of lighting. And it was concluded that some of the still photographs made by Warner Brothers to promote the film were sufficiently similar to Leigh's photograph in this matter of "craft" to recommend a hearing by a jury, to render a judgment in the matter. (A summary of this decision is provided at www.nylawline.com.) With this conclusion, Warner Brothers entered into negotiations with Leigh, and the matter was settled out of court.

The labor of art is often misunderstood and undervalued. Jack Leigh would often tell the story about how "The Photograph" was the result of ten hours in the darkroom, adjusting the light and the dark, over and over, until the result was just what he wanted. The design of the statue is often mistaken as being so simple that it must have been effortless: a young girl,

her head tilted, her arms raised to hold two shallow bowls. But both "The Photograph" and "The Sculpture" are products of exquisite art and craft, and both pose cautionary tales in the rights of artists to claim credit for their inventions.

The Secret of
Crow Island School

Crow Island School in Winnetka, Illinois, is "a special place." And no one knows that better than Betty Williams Carbol, who began her student years there soon after the school opened in 1940, and who returned to Crow Island as an art teacher in 1977, working there until she retired in 1998. Carbol is the author of a booklet about Crow Island School, titled *Still a Special Place*, published in 1991. Both Crow Island School and Betty Carbol would come to play important roles in the history of the "Bird Girl," but the story of this school is quite interesting enough to add to this account.

In 1989 Crow Island School was listed on the National Register of Historic Places. Of the tens of thousands of sites given this designation, fewer than ten are schools; and of these, most schools are named because they are remembered for important events. Crow Island School is the only school listed because it embodies a significant accomplishment in educational reform realized in the shape of its architecture.

It was the vision of Carleton Washburne, who began his long tenure as superintendent of schools in Winnetka, Illinois, around 1919, to abandon the fixed curriculum, to allow each student to progress at his or her own rate of development, to foster each child's own interests and abilities. Further Washburne wanted an architectural plan that would accommodate this educational philosophy. When the project began in 1937, great care was taken in the selection of the architects. The award was given to Perkins, Wheeler, and Will (now Perkins and Will), then a relatively young firm, who gained the contract on the promise that they would partner with more established architects. Their inspired choices were Eliel and Eero Saarinen. Eliel Saarinen, an esteemed Finnish architect and designer, had come to the United States in 1925 to plan and ultimately serve as president of the Cranbrook Academy of Art in Bloomfield Hills, Michigan. Cranbrook was to be a school of art, craft, and architecture modeled on the German Bauhaus. His son, Eero, educated at Yale, joined his father in the architectural firm of Saarinen and Saarinen in 1937, and his many achievements would include the designs for Dulles Airport, near Washington, D.C.; the Gateway Arch in St. Louis, Missouri; and the TWA Terminal at Kennedy Airport in New York City.

The design of Crow Island School took into account the needs of this particular educational plan. Interior spaces were flexible, with moveable furniture and inviting gathering places, such as window seats and work-room nooks. The building finishes (such as door handles, light switches, and blackboards) were scaled to the use by children. The exterior and interior building materials were the warm colors of a common rose brick and wood. Light streamed in from window walls, and it was reflected in these spaces by light-colored floor materials. Special furniture, such as molded plywood chairs shaped to encourage proper posture in children, was designed by Eero Saarinen. And the modernist geometry of the building's exterior was relieved by engaging patterns of brickwork and by a number of ceramic sculptures of fanciful animal figures created by Lily Swann, a New York artist and wife of Eero Saarinen. (Carbol 1991, n.p.)

Into this "special place" had come Sylvia Shaw Judson's original plaster model for the "Bird Girl." The plaster had been returned to Judson from the Roman Bronze Works foundry in 1942, signifying that the edition (of six, as we now know) was completed. The last record of the display of this plaster model comes in September of 1949, at an exhibition in the Mandel Brothers Galleries in Chicago. So the plaster was given by Judson to Crow Island School after 1950. Carbol recalls that the "Bird Girl" was at Crow Island when she began teaching there in 1977.

Judson gave several plaster models to the schools in the regions of Chicago's North Shore. In 1972, she was awarded a commendation by the School District of the City of Lake Forest for having given "statues" (these were all plaster models) to each of the five school buildings in that district. A report of that gift said: "It is Mrs. Haskins' [Judson had married Sidney Haskins in 1963, following the death of her first husband, Clay Judson, in 1960] thought that having fine art accessible to youngsters will in the long run imbue them with a sense of appreciation for art, and also a sense of the necessity to take care of it." (Platt 1973)

And the children did take care of this art. Carbol recalls that the "Bird Girl" lived happily in a corner of the art room at Crow Island School, and that the children were always very respectful of the figure. Occasionally Carbol filled the shallow bowls with trailing philodendron, and now and again a fake crow would perch on or near the figure to honor the name of the school and its site. Crow Island was the high area in a region of marshes where crows gathered and watched for "snacks of snakes and other swamp morsels." (Carbol 1991, n.p.)

Down in Savannah, a very particular "Bird Girl" dilemma had arisen in the fall of 1994. John Berendt's book had moved onto *The New York Times* list of best sellers and seemed destined to stay there for some time. Jack Leigh's image of the bronze girl in Bonaventure Cemetery was everywhere: on the cover of these books now numbering in the thousands, then in the hundreds of thousands; and in newspaper and magazine advertisements promoting "The Book." The crest of the dilemma came when, one day in

the fall of 1994, Alice Judson Hayes got a phone call. She remembers it this way:

"The voice at the other end said he was Sam Joseph, the designer in charge of Macy's windows in New York City. . . . 'I have seen the picture of the statue on the cover of *Midnight in the Garden of Good and Evil* and I want it to put in one of Macy's windows at the time of the spring flower show. It would be the centerpiece of the window displays. If I can borrow a copy, I promise to put the sculptor's name where all of the thousands of people who look at the window will see it.'" (Hayes 2004, 9) Joseph had contacted the owners of known "Bird Girls," and none of them were willing to lend him their statues. Hayes could give him only the sad report that the plaster model and the mold were both long ago destroyed, so there was no way to make a copy. "I regretfully told Sam Joseph that there was nothing I could do. The flower show would have to be 'Bird Girl'-less." (Hayes 2004, 9)

Enter Betty Carbol. Hayes tells this story:

"Three days later [after the conversation with Sam Joseph], I had another 'Bird Girl' call: 'I,' said the voice, 'am Betty Carbol, the art teacher at the Crow Island School in Winnetka. Did you know that we have the original plaster model of the statue by Sylvia Shaw Judson on the cover of that book called *Midnight in the Garden of Good and Evil*?'

"'I didn't know,' I said. 'Is there any chance that, as her daughter, I could borrow the plaster?'

"'Yes,' said Betty Carbol." (Hayes 2004, 9-10)

With the original plaster model of the "Bird Girl" now in hand, Hayes' first thought was that she could fulfill her desire to have a bronze cast of the work for Ragdale, and that bronze could be loaned to Sam Joseph for the tour of duty in Macy's windows in April of 1995. But as it turned out, the foundry was unable to make a bronze on that schedule, so a plaster cast was made. Still, as Hayes says: "Though they can't turn plaster into bronze, window designers can do remarkable transformations. When the flower show opened at Macy's, there amongst the flowers was a faux-bronze 'Bird Girl,' and on the window was the promised attribution of the statue to Sylvia Shaw Judson.'" (Hayes 2004, 11) When the flower show closed at Macy's, this "Bird Girl" was returned to Hayes.

After the event at Macy's, Hayes would receive another "Bird Girl" phone call, this time from Jack Leigh in Savannah:

"He was wondering if he could buy the plaster cast [recently displayed at Macy's]. I had refused to sell another bronze to Savannah. The edition was complete unless some member of Sylvia's family wanted a copy, as I did for Ragdale. But the plaster was another matter. It would have to be kept indoors, out of the weather, and could never be used to make a new mold. Jack wanted her because she had become an important part of his career. He had been generous in sharing the credit for his photograph with my mother as the sculptor of the statue. So, in the summer of 1995, off

went the Macy's plaster-painted-to-look-like-bronze, to Savannah, to be in Jack's gallery.

"It wasn't long until he called again: 'There are crowds of people coming to Savannah to see the city where *Midnight in the Garden of Good and Evil* came into being, and they all want to see the vanished statue of the "Bird Girl." Would it be O.K. with you if I gave my cast to the Savannah History Museum? The tourists hungry to see the little statue on the book cover could see her there.'" (Hayes 2004, 11)

Hayes gave her permission, and later that year she made the journey to Savannah for the dedication of the "Bird Girl" exhibit at the museum portraying Savannah's fascinating history, a museum adjacent to the Visitors Center, now swarming with tourists come to see *Midnight* sites. Hayes remembers: "On November 17, we went to Savannah to see the plaster cast of 'Bird Girl' dedicated. It is set in a diorama skillfully designed by a stage designer to look like the picture on the cover of the book, and, because of Macy's finish, it looks like bronze. The illusion of the cemetery is as close as a museum exhibit can be. There were speeches; credits were generously given, and the mayor presided over a reception of punch and pastries in the museum. The Macy's 'Bird Girl' had found a permanent home." (Hayes 2004, 11-12)

The "Bird Girl" had also come home to Crow Island School. Part of the agreement with Hayes was that the plaster model would be replaced, and it was replaced with a plaster cast made from the new mold. Carbol recalls that the "Bird Girl" who came back to Crow Island School was solid (not hollow as the plaster model was) and was happily missing an unsightly lump on her arm, the result of an old accident and repair.

And Betty Carbol, who remembers her own life with the "Bird Girl" as just one more interesting chapter of her life at Crow Island School, made the trip to Savannah in the week of Christmas of 1995. There she met Jack Leigh at his photography studio, and the two of them shared the experiences that they both had had with this statue made by Sylvia Shaw Judson.

(Part of this account relies on conversations with Betty Williams Carbol by the author in January of 2005.)

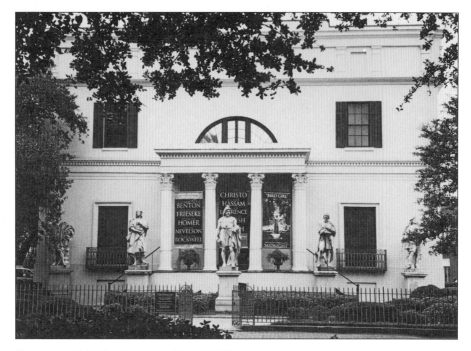

Illustration 19. Telfair Museum of Art (1818) at
Telfair Square, Savannah, Georgia. Facade.

The Telfair Museum
of Art: A Safe Haven

In July of 1997, members of the Trosdal family offered the little bronze
statue now know popularly as the Savannah "Bird Girl" as a loan to the
Telfair Museum of Art in Savannah. The loan was accepted, gratefully, for
at least a couple of reasons. First, interest in the sculpture had not abated in
the time since it had been removed from Bonaventure Cemetery in 1994,
and the museum could offer just what this little statue needed: protective
custody. Second, this statue by a woman, an artist of considerable accom-
plishment, would join a fine collection of American art of the early twenti-
eth century, so this "Bird Girl" could take her place among some familiar
company.

This sculpture by Sylvia Shaw Judson was now nationally famous, if
not internationally famous. Savannah was increasingly a popular tourist
destination, and Europeans were often promised that this was "the most
beautiful city in the United States" (not least because it was "the most Euro-
pean"). Whenever a foreign language edition of *Midnight in the Garden of
Good and Evil* was graced with "The Photograph" on the cover, a certain

result would be tourists speaking many languages who came to Savannah looking for "the little girl in the cemetery."

And now she was a resident of what is arguably Savannah's finest address, 121 Barnard Street, the former home of a most singular woman, Mary Telfair.

Art museums are curious enterprises. Sometimes called "temples of culture," they are largely the invention of the late eighteenth century and the nineteenth century, when, as a result of great social revolutions, the beautiful arts, once the prerogatives and possessions of only the rich and royal, were claimed by the common folk. The history of public museums is filled with the stories of the transformation of great palaces and grand homes into places where, usually for a small fee, anyone is welcome. Sometimes the transformation was unbidden and violent, as in the case of the rowdy gang that stormed the Palace of Versailles during the French Revolution.

Sometimes the transformation was the result of a generous gift, as it was in the case of Mary Telfair's decision that, at her death, the beautiful family home, filled with beautiful things, should become the Telfair Academy of Arts and Sciences "in which the books, pictures and works of Art herein bequeathed and such others as may be purchased out of the income rents and profits of the bequest hereinafter made for that purpose, shall be permanently kept and cared for, to be open for the use of the public." ("The Last Will and Testament of Mary Telfair" quoted in Johnson 2002, 396) That Mary Telfair's gift was almost thwarted by greedy relatives who challenged her will is a fascinating story told by Charles J. Johnson, Jr., in his biography of this interesting woman. Happily, the gift was allowed, and the result was the establishment of the oldest art museum in the South. (Johnson 2002, 368-92)

A fine museum is made of an interesting building and a worthy collection of objects. The Telfair qualifies as a fine museum on both of these counts.

The building was commissioned in 1818 by Alexander Telfair, son of a Revolutionary patriot and governor of Georgia, Edward Telfair. In 1818, Alexander was the only surviving son of Edward. He was unmarried, and the home would provide for him and his two unmarried sisters, Margaret and Mary. At his death in 1832, the house was inherited by the two women, and Mary outlived both her sister and the man her sister would marry in 1842. As Johnson says, it was clear that Mary's gift to the city was by way of preserving the family name. (Johnson 2002, 4-5)

The commission for the design of the house went to William Jay, an English architect who had come to Savannah in 1817 to build a grand home for a wealthy cotton merchant, Richard Richardson, and his wife, Francis Bolton, Jay's sister-in-law. Family connections were certainly responsible for this commission; and the success of his design for this home, now known as the Owens-Thomas House, led him to other commissions in Savannah, including that of the Telfair mansion. Jay arrived in this country

as a professionally trained architect when professionally trained architects were in short supply on these shores. He is remembered for the elegance of his designs in a style now known as Regency, named for the term of the Prince Regent from 1811 to 1820, later King George IV. As it is portrayed in the Telfair mansion, the Regency style depends on the architectural vocabulary of classicism, but it is rendered with a certain delicacy of effect, including curved elements in ornamentation and in the shapes of rooms.

For all museums, there are particular individuals who may be credited with defining the character of the art collections. In the case of the Telfair, according to Holly Koons McCullough, Curator, there are two persons who had a significant influence over this collection: Carl Ludwig Brandt, who served as director from 1883 until his death in 1905; and the American artist Gari Melchers, who served as a consultant and purchasing agent for the museum in the years 1906 to 1916. (McCullough 2002)

Brandt was born in Germany in 1831, trained as a painter in the academies of Europe, and came to the United States in 1852, where he established a studio in Hastings-on-Hudson, New York. He exhibited frequently at the National Academy of Design in New York City, and, while he painted a variety of subjects, he became well known as a portrait painter for the socially prominent. He had spent time in Savannah in the years before the Civil War, and he was known to the Telfair sisters. In 1883 he was appointed to the position of director of the Telfair Academy of Arts and Sciences, to prepare for its opening as a museum in 1886.

According to McCullough, Brandt formed the early collection of more than one hundred works by traveling abroad and purchasing what he understood to be works of great quality by prominent European academic masters of the day. (McCullough 2002) Many of these grand academic paintings have been continuously on display since the opening of the museum, and to this day they remain among the favorites of visitors to the Telfair. Brandt also collected a number of plaster casts of ancient Greek and Roman statues, a convention for museums in the nineteenth century that wished to display the finest examples of Classical art. A few of these casts remain on display, a reminder of this early desire to educate the public to the high standards of culture embodied in the ancient Classical tradition.

As part of the embellishment of this new museum, Brandt commissioned five statues to stand at the front of the building, to announce, quite proudly, the dedication of this place to the finest traditions of the arts (Illustration 19). Each of the statues stands seven feet and six inches high, and they are, from left to right: Rubens, the great Flemish painter of the seventeenth century, the master of the Baroque style, the progenitor of the Romantic tradition; then, Raphael, the sixteenth century Italian painter of the High Renaissance, the master of the Classical style; then, at the center, Phidias, the greatest Athenian sculptor of the Classical age, the fifth century B.C.; then, Michelangelo, the great sixteenth century Italian sculptor, painter, and architect of the High Renaissance; and, at last, Rembrandt, the seven-

teenth century Dutch painter, master of the style of naturalism. The sculptures were commissioned of Victor Oskar Tilgner, born in Slovakia but who studied at the Vienna Academy and established his studio there. Now best known for a grand monument to Mozart in Vienna, Tilgner was a popular and prolific sculptor in the late nineteenth century. In the view shown here (Illustration 20), the banner announcing the presence of the Savannah "Bird Girl," a sculpture by Sylvia Shaw Judson, is seen flanked by the figures of Phidias, the greatest sculptor of The Ancient World, and Michelangelo, the greatest sculptor of The Modern World.

The second person to be credited with forming the essential character of the collection of the Telfair Museum is Gari Melchers. An American painter of extraordinary accomplishments, Melchers was born in Detroit in 1860, but took his training in Düsseldorf, then in Paris. He stayed in Europe, establishing a studio in Holland, and gaining recognition at important expositions in Paris in the late 1880s. In 1903 he married Corinne Mackall of Savannah, and, through connections with her family, from 1906 until 1916, Melchers served as an advisor and purchasing agent to the Telfair. In this period of time, he gathered more than seventy works of art for the collection, most of

these representing the traditions of American Impressionism and the Ashcan School, by artists with whom he had formed professional and social relationships. It is this collection of fine early twentieth century painting for which the Telfair is best known. (McCullough 2002)

So here, in the best of all possible company, lives the Savannah "Bird Girl," on loan from the descendants of Lucy Boyd Trosdal. The people who see her here are respectful, as one is obliged to be in the halls of art museums. If you stand to her side as visitors pass by, you will hear, over and over, how lovely it is to see her, at last.

Illustration 20. Telfair Museum of Art (1818) at Telfair Square, Savannah, Georgia. Facade, detail.

"I Love This
Little Statue"

Since 1999 the estate of Sylvia Shaw Judson has authorized the making of commercial representations of the "Bird Girl," and thousands of these have been sold. They come into homes and gardens of "Bird Girl" admirers who are glad to confess: "I love this little statue." The story of how these commercial copies came to be made is as interesting as the other "chapters" in the life of this sculpture.

In 1998, four years after the appearance of "The Book," the affection for the "Bird Girl" seemed not only undiminished but in full blossom. In the previous autumn, members of the Trosdal family had brought her out of hiding, provided for her restoration, and offered her on loan to the Telfair Museum of Art in Savannah. Her debut at the museum was met by general joy and celebration. She looked lovely, and it was a thrill to see her because so few people had known her other than as an actress in a morality play set in sweet Savannah, portrayed on the cover of a book and in a bit part in a movie.

"Bird Girl" souvenirs had flourished from the earliest moments of the *Midnight* phenomenon, to the very considerable distress of the artist's daughter, Alice Judson Hayes. In an effort to protect her mother's invention, Hayes had consulted and engaged lawyers, hoping to bring an end to all of the pirated images. But it had proved to be quite hopeless.

So in 1998 when Hayes receive a telephone call from Brian Caldwell, a successful wholesaler in the gift industry with a specialty in garden ware, she had a quick response to his proposal that a commercial version of the "Bird Girl" be made for sale. Her quick reply: "No." She regarded all such proposals as a terrible invasion of her mother's artistic legacy, and she would have none of it. But she was struck by his response. Caldwell said: "Others are going to do this anyway, and they won't do it right. I want to do it right."

Hayes agreed to continue the discussion, and they planned to meet at Ragdale in March. In the meantime, Caldwell drafted a plan for the manufacture and distribution of these garden statues, and acquired a twenty-four inch plaster model that had been made by a copy artist. He had already assessed the interest in such a product. In particular there was interest from a person who worked in product development for a prominent national catalog that specialized in gift items having some connection with American

history and culture. The judgment was that this could be a successful product because this statue had "a story."

As a result of their meeting in the spring of 1998, Hayes requested that the copy artist come to Ragdale to stay for a couple of weeks so that a new model could be made from direct observation of the original sculpture, the casting she had commissioned for Ragdale after the discovery of the original plaster model at Crow Island School. That work was done, and a satisfactory model was produced. As one certain means of protecting Judson's original invention, none of the authorized commercial copies are made to the exact scale of the original, which is fifty inches tall. The first commercial version was twenty-four inches tall, and subsequently two other versions were introduced at thirteen and twenty-eight inches tall. The distribution of these commercial copies made in resin is managed by Caldwell through Potina, his wholesale business based in North Carolina.

In 2003 Hayes passed responsibility for the management of copyright for Judson's sculpture to her daughter, Francie Shaw, Judson's granddaughter and a working artist. Shaw researched the problem of how to convey to the commercial copies with greater accuracy the resemblance and sensitivity of the original sculpture. She commissioned a model for the "next generation" of commercial copies that was made by using lasers to scan an original. The result of such a process is that these copies come closer to the proportion and detail of Judson's invention.

The laser scan was done at the Johnson Atelier Technical Institute of Sculpture, near Trenton, New Jersey. The process is used most often to translate small models made by artists into large-scale works commissioned for public display. It replaces an old method of copying or enlarging statues through the use of calipers, or measuring tools, that could not in any case allow for the duplication of the "artist's touch," the surface texture.

Shaw had the pleasure of watching the process of making this new model. She says: "The scanning is done the same as with two-dimensional images, only, of course, the computer can go around the whole thing. Then the size you want to 'reproduce' is programmed into the computer, and another machine runs over a piece of very dense foam, cutting away many tiny bits until the form is completed. The foam is then used to make a mold, and a plaster model is cast. The surface of the plaster model needs to be worked again, by hand, to eliminate the texture of the foam. I helped do that, and I loved it. I felt like I was talking to my grandmother. Her work has such a characteristic surface, which is the mark of her thumb." The first of this version appeared in late 2004, a forty-one inch figure made of fiberglass.

And what of Hayes' original apprehension about the manufacture of mass-produced copies of her mother's work? It is true that Judson wished to preserve her editions in small numbers. A few works, such as the "Bird Girl" and the "Gardener," were issued in editions of six; but most of Judson's sculptures were limited to four castings. Judson abhorred the prospect of

works produced in great and indiscriminate numbers. Still, she could not have imagined what would come of the "Bird Girl."

All of the royalties from these commercial representations of the "Bird Girl" are turned to the benefit of Ragdale, now a retreat for artists and writers. As Hayes has said: "An amazing number [of these reproductions] have been sold. They are good copies, and the royalties on them help the Ragdale Foundation. Sylvia's father built his Ragdale house the year she was born, 1897, and she lived and worked in her studio there for many years. She was extremely pleased when it became an artists' retreat several years before she died. So, although she would not want the 'Bird Girl' to become like a flamingo on every lawn, I don't think she would mind helping Ragdale in this way." (Hayes 2001, n.p.)

(Some of this account relies on a telephone interview with Brian Caldwell by the author, February 8, 2005.)

Conclusions

If the director of tourism for the City of Savannah stood at the side of the road on any busy day in the tourist season (which in Savannah is pretty much all year long), holding the sign "Wave, if you love the 'Bird Girl'," the breeze would be felt halfway to Atlanta. This figure of a little girl holding two shallow bowls aloft is loved by visitors to this city, and by those who have only visited in "spirit" by reading "The Book" and admiring "The Photograph." And she is loved by more than a few native Savannahians, some of whom are proud to confess that they have never read "The Book" (and "never will") but all of whom have seen "The Photograph" (it simply cannot be avoided).

What accounts for this outpouring of affection for this bronze statue by Sylvia Shaw Judson? On rare occasions in the history of art a particular image has captured the popular imagination to such an extent that the artwork comes to be familiar to a wide public, an audience well beyond the ordinary crowds of appreciators of art who make regular visits to museums and galleries. Usually such an image gains popularity because it is immediately recognizable as standing for some element of the humanity we all share. And, more often than not, such an image commands our attention because it surprises us. Both of these conditions apply to the "Bird Girl."

Left on her own in anyone's garden, the "Bird Girl" is a captivating figure. She is the irresistible image of a sweet, young child, the very picture of diligence in fulfilling the duty she has been given to offer treats to the birds. We love her grace, and her charm. And her serenity. As Judson said, very often, the garden should be a place of retreat, of rest. And garden sculpture should add to that sense of quiet, of calm. In all of these ways, the "Bird Girl" is a very successful example of the art of garden sculpture. We're glad, and not very surprised, to see her in a garden.

But we are surprised to see her in a cemetery.

While cemeteries have changed in their character over the centuries, our present conception of them is that they are quiet places which house the dead. We want them to be pleasant, even beautiful, landscapes, places that can comfort us as we wander in them to think about the loss of loved ones. And we expect that there will be monuments, the furniture of the cemetery. In newer style cemeteries, these may be the earth-hugging plaques

that name the dead and allow the grounds crew to trim the grass with great efficiency. In nineteenth and early twentieth century cemeteries, we come upon great heaving piles of marble, in mausoleums and obelisks, and row upon row of headstones, and here and there the carved figures of weeping angels.

What we don't expect to see in such an environment is the child-size figure of a diligent young girl, colored in the dark green-black patina of weathered bronze, not weeping or worn down by grief. She is sweet, and stoic, and stalwart. And she surprises us.

What Jack Leigh did that day at dusk was to discover this "surprise." His photograph shares with the rest of us the delight he certainly experienced in that moment, finding this most unusual resident of Bonaventure Cemetery.

How then to account for her fame? Fundamentally it is the ingenious invention of Sylvia Shaw Judson. Next it is the decision by Mrs. Lucy Boyd Trosdal to pose this statue as the centerpiece of a family burial plot because she saw in the spirit of this little figure something that she loved. And it is the "eye" of Jack Leigh. Prompted by the portrait of some of Savannah that had been painted by John Berendt, Leigh found in this sculpture at dusk in Bonaventure Cemetery a child version of Lady Justice, weighing in the tipsy tilt of her shallow bowls the measures of right and wrong. She waits, between light and dark, for the truth of a tale that is richly embroidered by both good and evil.

But, here is the real truth. The "Bird Girl" is, as Judson hoped she would be, a good sculpture, carefully composed, well made, and well suited for life in a garden. A figure that stands solidly and quietly, a strong and simple form. A surface that catches light and invites touch (even when we are forbidden to do that). A dark patina that echoes the greens and browns of nature. A human presence in a human scale (a child, child-size). And a serene spirit that offers us in this troubled age the tranquility we find too seldom.

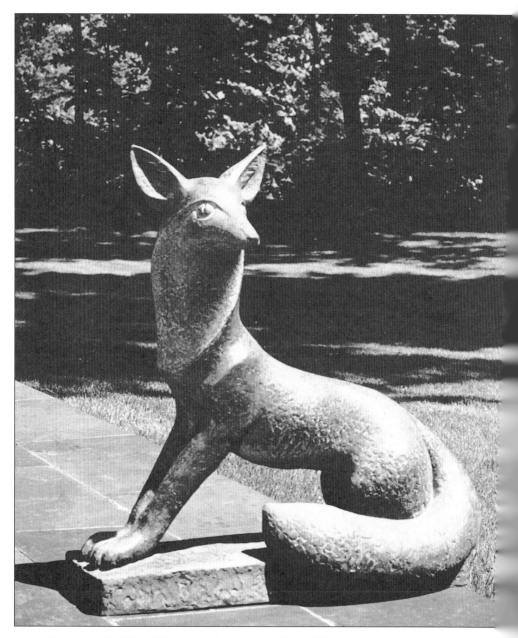

Illustration 21. "Vixen" by Sylvia Shaw Judson (circa 1957, bronze) at the residence of Mr. and Mrs. Edward McCormick Blair, Lake Bluff, Illinois, photographed in 1957 by Hedrich-Blessing, Chicago. *Courtesy of the Chicago Historical Society.*

Selected Works by Sylvia Shaw Judson on Public View

Admirers of the "Bird Girl" will want to see other works by Sylvia Shaw Judson. Because most of her sculpture was done for the gardens of private homes, relatively few of her works are located in public places. The following is a select list of Judson's works commissioned as public monuments or placed on public view:

District of Columbia, Washington: The White House
"Gardener"
1929 designed, 1964 cast in bronze
Collection of the White House, gift of Mr. and Mrs. Paul Mellon
Located in the Jacqueline Kennedy Rose Garden, outside the East Wing
of the White House. Access to this garden is allowed only on the
public garden tour held twice yearly; for information about these
tours, contact the White House.

Illinois, Brookfield: Chicago Zoo
"Farm Children" ("Girl with Piglet" and "Boy with Chicken")
1960, bronze
Memorial to Clay Judson (The artist's first husband, who died in 1960, was
for a time president of the Chicago Zoological Society.)
Located at the entry to the Children's Zoo, in the southeast sector of the Zoo.

Illinois, Deerfield: Ryerson Woods Forest Preserve
The Ryerson "Bird Girl"
1936 designed, 1938 cast in bronze
Commissioned by Mr. and Mrs. Edward L. Ryerson, Jr., for their sum-
mer home in Marion, Massachusetts
Located at the former family country home in Deerfield, Illinois, now
Ryerson Woods, part of the Lake County Forest Preserve District.

Illinois, Glencoe: Chicago Botanic Garden
"Merchild"
1925, bronze
Located in the Education Center, North Gallery.

"Naughty Faun"
n.d., Bedford stone
Located in the Home Landscape Garden.

"Birds on Eggs"
1959, cast aluminum
Located in the Fruit and Vegetable Garden, at the entry to the Stone Orchard.

Illinois, Highland Park: Highland Park Public Library
"Harbor Seal"
1945 (dedicated 1962), bronze
Memorial to Helen Kuh Kuhns
Located outside and behind the library in a pond area.

"Boy Reading"
1946 designed, 1961 cast in bronze
Located in the front lobby, facing the main entrance of the library.

Illinois, Highland Park: Ravinia Festival Park
"Ravinia Fountain" ("Girl with the Violin" set in a drinking fountain basin)
1955, bronze
Memorial to Norman Ross, Sr.
Located on Festival grounds, inside the West Gate, near the Pavilion.

"Dancing Figure" (set in a drinking fountain basin)
1974, bronze
Gift of Clifford Moos
Located on Festival grounds, inside the West Gate, near the Pavilion.

Illinois, Lake Forest: Lake Forest Public Library
"Apple Tree Children" ("Girl Reader" and "Boy Reader" posed in the branches of an apple tree)
1967, bronze and applewood
Located in the Children's Library.

Illinois, Lake Forest: Market Square (designed by Howard Van Doren Shaw)
"Dancing Boy" (free-standing figure positioned in a niche of a building gable)
1975 dedicated, bronze
Located in the niche of a gable on the north side of the square, above Nine West.

"Girl with Baby on Her Shoulder" (center element of a fountain designed by Howard Van Doren Shaw)
1982 installed (designed in the 1960s)
Located in the center of Market Square.

Illinois, Lake Forest: Ragdale
There are several works by Judson at Ragdale, the home she enjoyed as a child and again as an adult. Among the works located on the inside of the home are:

"Dog"
n.d., cast stone
Located in the living room.

"Two Bears"
1948, black granite
Located in living room.

Works located on the grounds of Ragdale include:

"Baboons"
1966, bronze

"Deer Lying Down"
n.d., cast stone

"Geese"
n.d., bronze

"Harbor Seal"
1945, cast stone

"Summer"
1939, limestone

"Twin Lambs"
1949, grey granite

"Two Cats"
1951, black granite and red granite

"Wood Chuck"
1947, mahogany granite

Because Ragdale is operated as a retreat for artists, it is not open to the public. However, occasionally the grounds and house are open for special tours; for these dates, inquire at the Ragdale Foundation.

Massachusetts, Boston: State House
"Monument to Mary Dyer"
1958-59 designed, cast in Italy; dedicated July 9, 1959; bronze figure on stone base
Inscription: "Mary Dyer/ Quaker/ Witness for Religious Freedom/ Hanged on Boston Common 1660/ "My Life Not Availeth Me/ In Comparison to the/ Liberty of the Truth"
Located on the grounds of the State House.

Pennsylvania, Philadelphia: Fairmount Park
"Greek Dog"
1966, granite
Located at the West Fairmount Park Horticulture Center, interior.

"Greek Goat"
1966, granite
Located at the West Fairmount Park Horticulture Center, interior.

"Greek Lambs"
1949, granite
Located at the West Fairmount Park Horticulture Center, interior.

Pennsylvania, Philadelphia: Free Library of Philadelphia, Lovett Memorial Library (on Germantown Avenue)
"Boy Reading"
1946 designed, 1962 installed, bronze
Located on the interior of the library.

Pennsylvania, Philadelphia: Friends Center and Meeting House
"Monument to Mary Dyer"
1958-59 designed, 1960 cast (the second of two casts made by the artist), installed 1975, rededicated April 23, 2002; bronze with granite base
Located on the grounds of the Friends Center and Meeting House.

South Carolina, Murrells Inlet: Brookgreen Gardens
"Girl with Squirrel"
1932, bronze
Located in the Brown Sculpture Court, an indoor-outdoor exhibition area in the center of the sculpture gardens.

Posthumous Castings of the "Bird Girl"

The statue now known as the "Bird Girl" was designed in 1936 by Sylvia Shaw Judson. The original was made in clay, then cast in plaster from which a mold was made at the Roman Bronze Works foundry in New York City. In the years 1937-40, one lead and five bronze castings of this sculpture were made at the direction of the artist, and each of these six statues is understood to be an original in the edition of six.

Authorized copies of the "Bird Girl" were made in a limited edition after 1994, after the statue had become quite famous with its appearance on the cover of John Berendt's book, *Midnight in the Garden of Good and Evil*; and after the original plaster model had been discovered at the Crow Island School in Winnetka, Illinois. While these copies were made using the artist's original plaster model, and with the consent of the artist's estate (first managed by her daughter, Alice Judson Hayes, and subsequently by her granddaughter, Francie Shaw), castings produced after the death of the artist are not considered to be originals. These posthumous copies include the following:

Georgia, Savannah: Savannah History Museum
A plaster cast made in 1995 and painted to resemble bronze, for the 1995 spring garden display at Macy's in Herald Square, New York City. This copy was returned to Alice Judson Hayes and subsequently sold by her to Jack Leigh, the Savannah photographer responsible for "The Photograph" on the cover of "The Book." Leigh commissioned a diorama featuring this copy in a setting evocative of "The Photograph," which he gave on loan to the Savannah History Museum at the Visitors Center.

Illinois, Winnetka: Crow Island School
A plaster cast made in 1995 for the Crow Island School in Winnetka, Illinois, to replace the artist's plaster model. Judson had given the model of this figure to Crow Island School sometime after 1950. After the eruption of the fame of the "Bird Girl," the school made the plaster model available to the artist's daughter for the casting of a limited number of copies.

Illinois, Lake Forest: Ragdale

A bronze copy for Ragdale commissioned in 1995 by Alice Judson Hayes and cast in 1996.

Illinois, Chicago: Cliff Dwellers Club

A fiberglass copy made in 1997 for Clint Eastwood's film version of *Midnight in the Garden of Good and Evil.* By agreement, this copy was returned to Hayes, and in 2000 she presented it to the Cliff Dwellers Club in Chicago, a private club of members interested in the arts.

The Ragdale Foundation

A bronze copy cast in 2003 at the direction of Francie Shaw, for sale to benefit Ragdale.

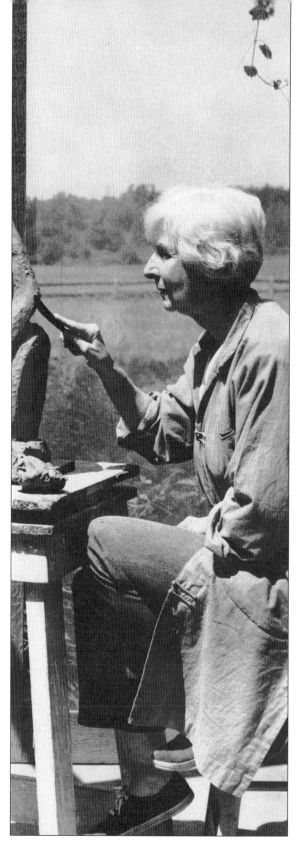

Illustration 22. Sylvia Shaw Judson (circa 1967), working at her studio, Ragdale, Lake Forest, Illinois. *Courtesy of Alice Judson Hayes.*

Summary of the Life and Work of Sylvia Shaw Judson

1897. Born on June 30 in Chicago to Howard Van Doren Shaw, an architect, and Frances Shaw, a poet

1906-10. Laboratory School, University of Chicago (ages 8-12)

1911-13. University School for Girls (ages 13-15)

1914-15. Westover School, Middlebury, Connecticut (ages 16-17)

1915. Sculpture internship at the studio of Anna Hyatt, Annisquam, Massachusetts

1915-16, 1918. School of The Art Institute of Chicago (study with Albin Polasek)

1917. Trip to China and Japan with her father

1919. Maintains a studio in New York City

1920-21. Paris, Académie de la Grande Chaumière (study with Antoine Bourdelle)

1921. Marries Clay Judson, an attorney

1922. Begins her professional work as a sculptor

1922. Birth of a daughter, Alice

1926. Birth of a son, Clay, Jr.

1938. One-person show at The Art Institute of Chicago (circulated to museums in Milwaukee, Wisconsin; Indianapolis, Indiana; Flint, Michigan; Dayton, Ohio; and Zanesville, Ohio)

1940. One-person show at Arden Gallery, New York City

1942. Moves permanently to Ragdale, Lake Forest, Illinois, the family summer home built in 1897 by Howard Van Doren Shaw; builds studio there

1942. First of four grandchildren born (the four children of Alice Judson Ryerson Hayes)

1949. Joins the Society of Friends

1952. Helps to establish the Friends Meeting at Lake Forest, Illinois

1954. Publication of *The Quiet Eye: A Way of Looking at Pictures*

1957. One-person show at the Sculpture Center, New York City

1958. Works in Florence, Italy, while supervising the bronze castings of "Mary Dyer"

1960. Clay Judson, Sr., dies

1960. Works in Florence, Italy, while supervising the bronze casting of "Stations of the Cross" (fourteen plaques destined for the Sacred Heart Church, Winnetka, Illinois)

1963. Teaches sculpture at the American University, Cairo, Egypt

1963. Marries Sidney Haskins, an English Quaker and an old friend

1967. Publication of *For Gardens and Other Places: The Sculpture of Sylvia Shaw Judson*

1971. Moves to a Quaker retirement community in Kennett Square, Pennsylvania

1977. Returns to Ragdale for the summer

1978. Dies at Ragdale in September

Professional Memberships

National Sculpture Society
 Elected Sculptor Member in 1940; advanced to Fellow in 1946

The oldest organization of professional sculptors in the United States, the National Sculpture Society was founded in 1893 to promote figurative and realist sculpture. Membership is by nomination. The society is located in New York City.

National Academy of Design
Elected Associate Member in 1948; advanced to Academician in 1965
Now known as the National Academy, this organization was founded in 1825 as an honorary association of professional artists (painters, graphic artists, sculptors, and architects) who are elected to membership by their peers. The academy maintains a museum, an art school, and a program of exhibitions in an historic building on Fifth Avenue in New York City.

Selected Prizes and Awards

1929. Logan Prize, The Art Institute of Chicago

1949. Purchase Prize, Philadelphia International Sculpture Show

1956. Honor Award, "For Excellence in Fine Arts Allied with Architecture," American Institute of Architects and the Chicago Association of Commerce and Industry

1957. Speyer Prize, National Academy of Design

1957. Millbrook Garden Club Medal, Garden Club of America

1959. Mrs. Oakleigh Thorne Medal, "For Outstanding Achievement in Garden Design," Garden Club of America

Selected Group Shows

Chicago: Art Institute, Arts Club
New York: Museum of Modern Art, Whitney Museum, National Academy of Design
Philadelphia: Museum of Art
World's Fairs: Chicago 1933-34, New York 1935-36, San Francisco 1937-38

List of Works Consulted

In the following list, these abbreviations are used for archival entries:

Roman Bronze Works Archives, Amon Carter Museum Archives, Fort Worth, Texas. Cited here as RBW, CMA.

Sylvia Shaw Judson Papers, Archives of American Art, Smithsonian Institution, Washington, D.C. Cited here as SSJ, AAA.

Allen, Patrick, ed. 1998. *Literary Savannah.* Athens, Georgia: Hill Street Press.

Ambrose, Grace. 1923. "Presenting Sylvia Shaw Judson, Second Vice President of The Three Arts Club." *Motif: A Magazine of the Three Arts,* published by The Three Arts Club, Chicago, 1, no.3, 14-16.

Arden Gallery, New York.

[1940a] "The Exhibition of Sculpture by Sylvia Shaw Judson," April 23-May 4. Draft catalog copy. SSJ, AAA, roll 1494.

1940b. Exhibition of Sculpture by Sylvia Shaw Judson, April 22-May 4. Exhibition catalog. SSJ, AAA, roll 1494.

Art Digest. 1940. "Important Sculpture Festival Presented at the Whitney Museum," April 15.

Art Institute of Chicago.

1938a. "Special Exhibition, The Art Institute of Chicago." Inventory for the exhibition, n.d. SSJ, AAA, roll 1494.

1938b. "Sylvia Shaw Judson." Bulletin of the Art Institute of Chicago, April-May, 59.

1938c. "The exhibition of Sculpture by Sylvia Shaw Judson at the Art Institute of Chicago, from July 28 to October 9." News release for September 7. SSJ, AAA, roll 1492.

Bach, Ira J. 1983. *A Guide to Chicago's Public Sculpture.* Chicago: University of Chicago Press.

Bell, Bret. 2004. "A Life Calling" [Jack Leigh]. *Savannah Morning News,* May 20.

Bennett, James O'Donnell. 1931. "New Structure Marks 20 Years for Child Home." *Chicago Daily Tribune,* May 17.

Berendt, John. 1994. *Midnight in the Garden of Good and Evil: A Savannah Story.* New York: Random House, Inc.

Bertelli, Riccardo.

 1937. Corona, Long Island, letter to Mrs. Sylvia Shaw Judson, June 14. SSJ, AAA, roll 1492.

 1940. [Corona, Long Island], letter to Mrs. Sylvia Shaw Judson, March 1. RBW, CMA.

Brettell, Richard R., and Sue Ann Prince. 1990. "From the Armory Show to the Century of Progress: The Art Institute Assimilates Modernism." In *The Old Guard and the Avant-Garde: Modernism in Chicago, 1910-1940,* ed. Sue Ann Prince, 209-25. Chicago: The University of Chicago Press.

Brooks, H. Allen. 1972. *The Prairie School: Frank Lloyd Wright and His Midwest Contemporaries.* New York: W. W. Norton and Co. (1996).

Brown, J. Carter.

 1966a. Washington, D.C., letter to Mrs. Haskins, October 7. SSJ, AAA, roll 1492.

 1966b. Washington, D.C., letter to Miss Judson, October 11. SSJ, AAA, roll 1492.

Brown, Milton W. 1963. *The Story of the Armory Show.* Joseph H. Hirshhorn Foundation Publication.

Bumstead, Henry. 1997. "Midnight in the Garden of Good and Evil: Production Office." Interview at www.goodandevil.warnerbros.com.

Carbol, Betty Williams. 1991. *Still a Special Place: A History of Crow Island School, Winnetka, Illinois.* Winnetka, Illinois: Crow Island School.

Chicago Daily Tribune.

 1937a. "Laura Schweppe Dies; Art Patron, Philanthropist," April 21.

 1937b. "Mrs. Schweppe Leaves Estate of 3 1/4 Millions," April 30.

Dart, Susan. 1984. *Market Square, Lake Forest, Illinois.* Lake Forest, Illinois: Lake Forest-Lake Bluff Historical Society.

DeBolt, Margaret Wayt. 1984. *Savannah Spectres and Other Strange Tales.* Virginia Beach, Virginia: The Donning Company, Publishers.

Downs, Gene.

 1994a. "How THE Book Got THE Photo." *Savannah Morning News,* March 19.

 1994b. "Portrait of an Artist." *Savannah Morning News,* July 10.

 1997. "Telfair Heralds Return of Bird Girl." *Savannah Morning News,* August 17.

Falk, Peter Hastings, ed. 1990. *The Annual Exhibition Record of the Art Institute of Chicago, 1888-1950.* Madison, Connecticut: Sound View Press.

Gray, Mary Lackritz. 2001. "Sylvia Shaw Judson Haskins." In *Women Building Chicago 1790-1990: A Biographical Dictionary,* eds. Rima Lunin Schultz and Adele Hast, 450-52. Bloomington: Indiana University Press.

Greene, Virginia A. 1998. *The Architecture of Howard Van Doren Shaw.* Chicago: Chicago Review Press.

Groskoph, Dorothy Andresen. 1964. Massapequa, New York, letter to Miss Judson, November 30. SSJ, AAA, roll 1492.

Hayes, Alice Judson Ryerson.

2001. "The True Story of the Bird Girl." *Off the Cliff*, April. A publication of the Cliff Dwellers Club, Chicago.

2004. "How Savannah Made My Mother Famous." Unpublished manuscript.

2005. Notes to the author, March 28.

Hayes, Alice, and Susan Moon.1990. *Ragdale: A History and Guide*. Berkeley: Open Books.

Jewett, Eleanor.

1938a. "Sylvia Judson Is Sculptor of Great Talent." *Chicago Daily Tribune*, July 27.

1938b. "Exhibition of Sculpture at Art Institute." *Chicago Daily Tribune*, August 7.

Johnson, Charles J., Jr. 2002. *Mary Telfair: The Life and Legacy of a Nineteenth-Century Woman*. Savannah, Georgia: Frederic C. Beil, Publisher.

Judson, Sylvia Shaw.

1914a. "My Furor." Student essay written by Sylvia Shaw. Westover School. SSJ, AAA, roll 1490.

1914b. "Serious Considerations." Essay by Sylvia Shaw. *The Lantern: Westover School Magazine*, March. SSJ, AAA, roll 1490.

1924. "Modern Sculpture." *Motif: A Magazine of the Three Arts*, published by The Three Arts Club, Chicago, 2, no. 1, 16-18. SSJ, AAA, roll 1494.

1939a. Lecture at the Dayton Art Institute, March 7. SSJ, AAA, roll 1490.

1939b. Chicago, letter to Mr. [Rufus] Jones, December 27. SSJ, AAA, roll 1492.

[1940]. Chicago, letter to Mr. Bertelli, February 27. RBW, CMA.

[1949a]. "Adventures Among the Quakers." Unpublished manuscript. SSJ, AAA, roll 1490.

1949b. Lake Forest, Illinois, letter to Anna Brinton, August 7. SSJ, AAA, roll 1492.

1954. *The Quiet Eye: A Way of Looking at Pictures*. Washington, D.C.: Regnery Publishing, Inc. (1982).

1955. "Westover Talk." Speech at Westover, May 9. SSJ, AAA, roll 1490.

1956. Lake Forest, Illinois, letter to Mr. S. P. Shiavo, August 20. RBW, CMA.

1957. Sylvia Shaw Judson, April 1 to April 30 [exhibition catalog]. New York: Sculpture Center.

1959. Lecture for Garden Clubs at the Palmer House, Chicago, n.d. SSJ, AAA, roll 1490.

1960. "My Life With Clay." Presentation with slides for The Scribblers. SSJ, AAA, roll 1490.

1963. "Universal or Particular." The Jonathan W. Plummer Lecture for the Illinois Yearly Meeting of Friends. Draft copy. SSJ, AAA, roll 1490.

1964. Lake Forest, Illinois, letter to Mrs. Mildred McCauly, September 17. SSJ, AAA, roll 1492.

1965. "Sculpture Is My Work" by Sylvia Shaw Judson Haskins. Westover Alumnae Magazine, Summer. SSJ, AAA, roll 1494.

1967a. *For Gardens and Other Places: The Sculpture of Sylvia Shaw Judson.* Chicago: Henry Regnery Company.

1967b. [Lake Forest, Illinois], letter to Mrs. Crouch, Office of the Curator, The White House, Washington, January 28. SSJ, AAA, roll 1492.

1972. "Friday Club Speech," May. SSJ, AAA, roll 1490.

1975. Kennett Square, Pennsylvania, letter to Mr. Schiavo, January 31. RBW, CMA.

[1977]. Lake Forest, Illinois, letter to Mr. Schiavo, n.d. SSJ, AAA, roll 4189.

Kelley, Charles Fabens. 1929. "Chicago's Annual American Show." *Christian Science Monitor,* November 23.

Kent, Norman. 1968. New York, letter to Miss Sylvia Shaw Judson, May 8. SSJ, AAA, roll 1492.

Kloss, William. 1992. *Art in the White House: A Nation's Pride.* Washington, D.C.: White House Historical Association.

Lamb, Brian. 1997. C-SPAN "Booknotes" interview with John Berendt, August 28. Transcript at www.booknotes.org.

LaPeter, Leonora. 1999. "Warner Bros. OK To Use Its Bird Girl Photo." *Savannah Morning News,* October 14.

Leigh, Jack. 1994. Savannah, Georgia., letter to John [Berendt], June 9. Jack Leigh Gallery Archives.

Leroux, Charles. 1999. "Born in Chicago, Raised in Savannah: 'Bird Girl' Story Migrates from North to South–and Back Again." *Chicago Tribune,* August 25.

Mandel Brothers Galleries, Chicago. 1949. Art Exhibition: Edward H. Bennett, Laura Harvey, Sylvia Shaw Judson, Marianne S. Magnuson, Burnett H. Shryock, Vicci Sperry, James Swann. Exhibition Catalog, September. SSJ, AAA, roll 1494.

McCauley, Mildred Steil.

1940a. New York, letter to Mrs. Judson, March 26. SSJ, AAA, roll 1491.

1940b. New York, letter to Mrs. Judson, May 2. SSJ, AAA, roll 1491.

1941. New York, letter to Mrs. Judson, May 16. SSJ, AAA, roll 1491.

McCullough, Hollis Koons. 2002. "Telfair Museum of Art." *New Georgia Encyclopedia,* at www.georgia encyclopedia.com.

Melrose, Alice G. 1968. New York, letter to Miss Sylvia Shaw Judson, October 23. SSJ, AAA, roll 1492.

Miller, Arthur H., and Shirley M. Paddock. 2002. *Lake Forest: Estates, People, and Culture.* Chicago, Illinois: Arcadia Publishing.

Platt, Barbara. 1973. "Artist Gives New Statue to School." *A.P.T. News*, published by the Lake Forest Association of Parents and Teachers, Winter.

Polasek, Albin. 1951. Chicago [Winter Park, Florida.], letter to Sylvia, n.d. SSJ, AAA, roll 1491.

Proske, Beatrice Gilman. 1968. *Brookgreen Gardens Sculpture.* Murrells Inlet, South Carolina: Trustees of Brookgreen Gardens.

Rich, Daniel Catton. 1938. Chicago, letter to Mrs. Judson, October 10. SSJ, AAA, roll 1491.

Riedy, James L. 1981. *Chicago Sculpture.* Urbana: University of Illinois Press.

Roman Bronze Works. 1937-40. Ledgers and summary documents related to Sylvia Shaw Judson's "Girl with Bowls." Roman Bronze Works Archives in the Amon Carter Museum Archives. Amon Carter Museum, Fort Worth, Texas.

Rosenfeld, Lucy D. 2002. *A Century of American Sculpture and the Roman Bronze Works Foundry.* Atglen, Pennsylvania: Schiffer Publishing.

Rubinstein, Charlotte Streifer. 1990. *American Women Sculptors: A History of Women Working in Three Dimensions.* Boston: G. K. Hall and Co.

Ruskin, John. 1853. "The Nature of Gothic," *The Stones of Venice,* vol. II. Reprinted in *The Art Criticism of John Ruskin*, ed. Robert L. Herbert, 93-108. Gloucester, Massachusetts: Peter Smith (1964).

Sales, Leigh. 2003. "Sounds of Summer: Savannah Story." "The World Today," ABC Australia radio broadcast, January 9. Transcript at www.abc.net.au.

Satterfield, Jay. 2002. "The Great Ideas: The University of Chicago and the Ideal of Liberal Education." An Exhibition in the Department of Special Collections, The University of Chicago Library, May 1-September 6, at www.lib.uchicago.edu.

Savannah Morning News.

 1932a. "Trosdal Confers About Shipping," February 26.

 1932b. "His Vision Persists" [editorial/obituary for E. S. Trosdal], July 21.

 1971. "Cultural Leader Is Dead at 90" [news report/obituary for Mrs. Lucy Boyd Trosdal], September 6.

Shaw, Howard Van Doren. 1920. Paris, letter to Miss Sylvia Shaw, October 26. SSJ, AAA, roll 1490.

Tatnall, Elizabeth Jeanes. 1941. Whitemarsh, Pennsylvania, letter to Mrs. Judson, April 2. SSJ, AAA, roll 1491.

Telfair Museum of Art Archives.

 1884-85. Reports of sculptures commissioned from Victor Oskar Tilgner.

 [1997a]. Notes concerning the "Bird Girl," n.d.

 1997b. Conservation report for the "Bird Girl," October 1.

Toledano, Roulhac. 1997. *The National Trust Guide to Savannah: Architectural and Cultural Treasures.* New York: John Wiley and Sons, Inc.

Weng, Siegfried R. 1939. Dayton, Ohio, letter to Mrs. Sylvia Shaw Judson, April 5. SSJ, AAA, roll 1491.

Wheeler, Perry H.

 1964a. Washington, D.C., letter to Mrs. Sidney Haskins, June 23. SSJ, AAA, roll 1492.

 1964b. Washington, D.C., letter to Mrs. Sidney Haskins, August 5. SSJ, AAA, roll 1492.

 1964c. Washington, D.C., letter to Mrs. Sidney Haskins, September 2. SSJ, AAA, roll 1492.

 1965. Washington, D.C., letter to Mrs. Sylvia Shaw Judson, June 23. SSJ, AAA, roll 1492.

Wilson, Amie Marie, and Mandi Dale Johnson. 1998. *Historic Bonaventure Cemetery: Photographs From the Collection of the Georgia Historical Society.* Charleston, South Carolina: Arcadia Publishing.

General References Online

American National Biography Online, at www.anb.org.

Grove Art Online, at www.groveart.com.

Inventory of American Sculpture, Smithsonian American Art Museum, Smithsonian American Art Museum, Smithsonian Institution. See Art Information Resources at www.americanart.si.edu.

"Midnight in the Garden of Good and Evil," at www.savannahnow.com/goodandevil.

New Georgia Encyclopedia, at www.georgia encyclopedia.com.

Savannah Area Convention and Visitors Bureau, at www.savannahvisit.com.

Telfair Museum of Art, Savannah, Georgia, at www.telfair.org

Acknowledgments

To Sylvia Shaw Judson's daughter and granddaughter, Alice Judson Hayes and Francie Shaw, who have supported this project by the generous offer of time to share their knowledge of Judson's work, in general, and the "Bird Girl," in particular.

To Judy Throm, Chief of Reference Services at the Archives of American Art, Smithsonian Institution, Washington, D.C., who simply may know more secrets about American artists than any person on the face of the earth and who is a very old friend (over three hundred years in dog years).

To Paula Stewart, Archivist and Records Manager, Amon Carter Museum, Fort Worth, Texas, whose direction of the rescue and cataloging of the Archives of the Roman Bronze Works, and whose interest in this project, made it possible to gather important new information about the "Bird Girl."

To Lorraine Greenman Ganz, who at the age of nine posed for the "Bird Girl," and whose generosity in sharing her memories of this experience added an important chapter to this story.

To Susan Page Tillett, Executive Director of the Ragdale Foundation, Lake Forest, Illinois, who helped to point me in the right directions at the start of this adventure; and Sylvia Brown, Director of Programming for the Ragdale Foundation, whose gracious tour of Ragdale was essential for the telling of this story.

To the special "friends" of the "Bird Girl," whose lives came to be caught up in the *Midnight* tumult, and who helped to restore the rightful reputation of the artist: Judy Gummere, who sent back to Savannah the information needed to identify the artist; Betty Carbol, who revealed to the artist's daughter the existence of the original plaster model at Crow Island School; and Susan A. Laney, Director, Jack Leigh Gallery, Savannah, who helped assuage my regret at not having met Jack Leigh by being the able and respectful narrator of his history with the "Bird Girl."

To the custodians of special collections honoring the teachers of Sylvia Shaw Judson, who provided important information about what she

might have learned from these teachers: Robin R. Salmon, Vice President and Curator of Sculpture, Brookgreen Gardens, Murrells Inlet, South Carolina; and Karen Louden, Curator, Albin Polasek Museum and Sculpture Gardens, Winter Park, Florida.

To the custodians of works of art by Sylvia Shaw Judson held in public collections, who offered information about where these works are now displayed: staff at the Design Center of the Chicago Zoological Society, Brookfield, Illinois; Roger A. Vandiver, Curator of Art Collections, Chicago Botanic Garden, Glencoe, Illinois; Susan Dennison, Community Relations Coordinator, and Julia A. Johnas, Reference Department, Highland Park Public Library, Highland Park, Illinois; Amy Schrage, Communications Manager, Ravinia Festival Association, Highland Park, Illinois; Cindy Infantino, Lake Forest Public Library, Lake Forest, Illinois; Michael T. Stieber, Library Administrator and Special Collections, The Morton Arboretum, Lisle, Illinois; Carole Peterson, Registrar, Illinois State Museum, Springfield, Illinois; Lillian Phipps Johnston, art teacher, Crow Island School, Winnetka, Illinois; Michelle Robinson, Curator, Figge Art Museum, Davenport, Iowa; Tuliza Fleming, Associate Curator of American Art, Dayton Art Institute, Dayton, Ohio; Laura S. Griffith, Fairmount Park Art Association, Philadelphia, Pennsylvania; and staff of the White House Curator's Office, Washington, D.C.

To the "special investigators" of the search for the mystery "Bird Girl" believed to have been the centerpiece of the Laura Shedd Schweppe Memorial Fountain at the Country Home for Convalescent Children at Princes Crossing, Illinois: Daniel Meyer, University Archivist, University of Chicago Library, Chicago, Illinois; David B. Malone, College Archivist, Wheaton College, Wheaton, Illinois; and Sally DeFauw, Curator, West Chicago City Museum, West Chicago, Illinois.

To Holly Koons McCullough, Curator of Collections at the Telfair Museum of Art, Savannah, Georgia, who tends to the works in her custody with rare grace and intelligence; and Beth Moore, Assistant Curator of Collections at the Telfair, whose knowledge of the collection and its archives is invaluable.

To Catherine Cardarelli, Professor of Photography at the Savannah College of Art and Design, whose sensitive photographs of the Savannah "Bird Girl" may be the best reason to own this book.

To Tina Skinner, President, Lifestyles Division, Schiffer Publications, who thought that this was an interesting project and helped me to accomplish it; and Jeff Snyder, Editor, for his careful review of this manuscript.

To my husband, John, who provided the necessary encouragement and good cheer; and brought all of his very considerable skills as an academic administrator to this project, being production manager, accountant, first reader, and general factotum, and discovering his new-found talent for narrative photography.